PAINTING IN THE NORTH

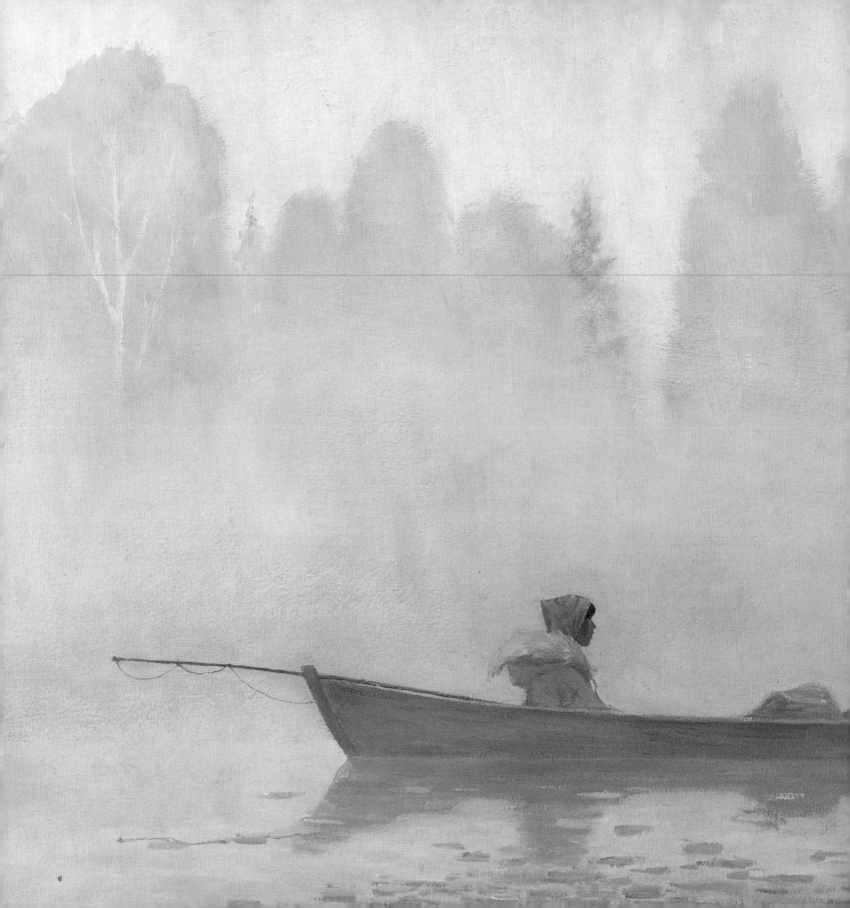

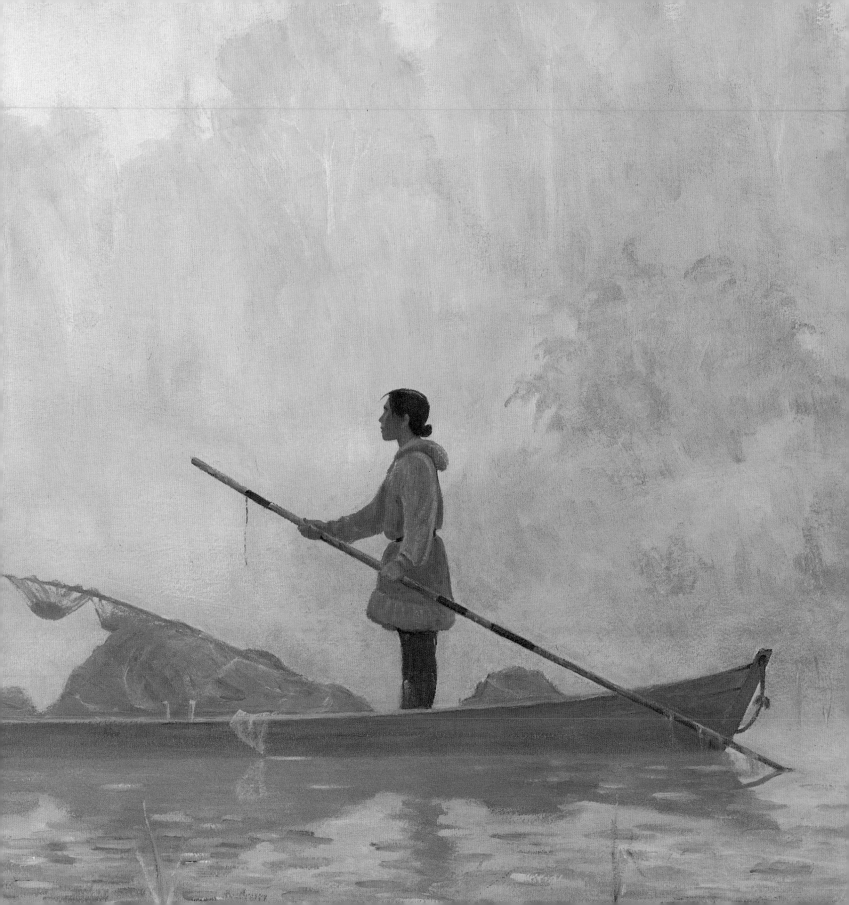

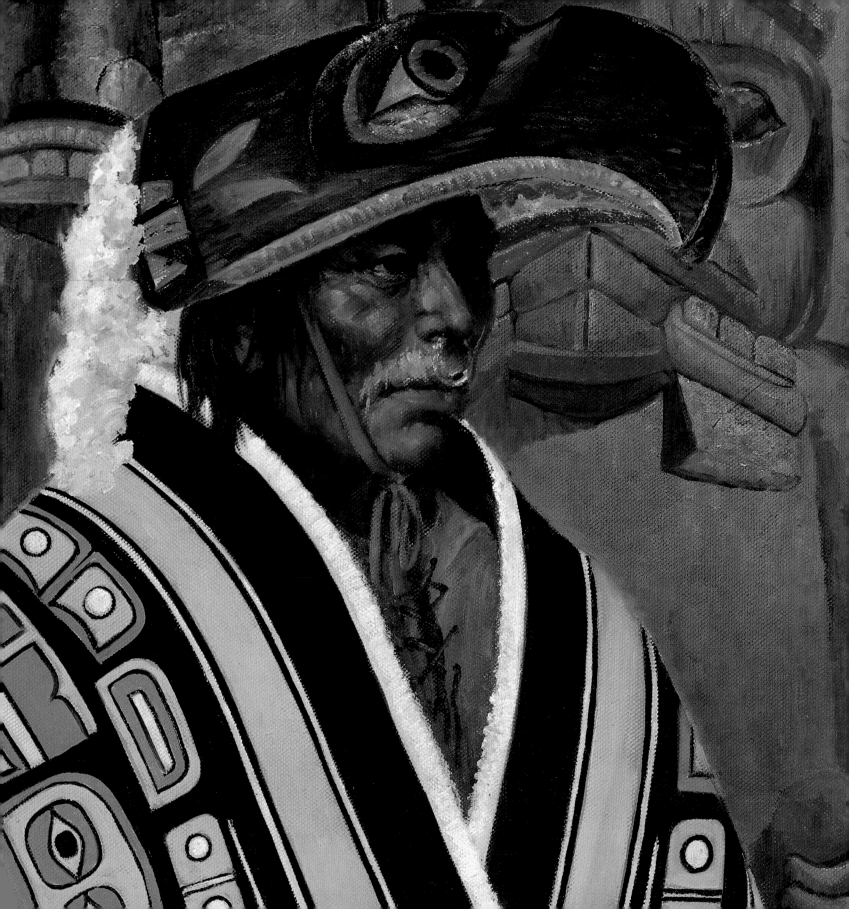

PAINTING IN THE NORTH

ALASKAN ART IN THE ANCHORAGE MUSEUM OF HISTORY AND ART

Kesler E. Woodward

ANCHORAGE MUSEUM
OF HISTORY AND ART

distributed by

University of Washington Press

Seattle and London

Copyright © 1993 by the Anchorage Museum Association
Distributed by the University of Washington Press

Produced by Marquand Books, Inc., Seattle
Edited by Patricia Draher
Designed by Ed Marquand with assistance
from Tomarra LeRoy and Marie Weiler
Photographs by Chris Arend
Printed in Hong Kong

Library of Congress Cataloging-in-Publication Data
Anchorage Museum of History and Art.
 Painting in the North : Alaskan art in the Anchorage Museum of History
and Art / Kesler E. Woodward.
 p. cm.
 Includes bibliographical references and index.
 ISBN 0-295-97319-6 (cloth). — ISBN 0-295-97320-X (paper)
 1. Alaska in art. 2. Art, American. 3. Eskimos—Art. 4. Anchorage Museum
of History and Art. I. Woodward, Kesler E., 1951– . II. Title.
N8214.5.U6A53 1993
760'.04499798—dc20 93-21556

Cover/jacket: Rockwell Kent, *Resurrection Bay, Alaska,* 1965 (no. 51)
Back cover/jacket: Sydney Mortimer Laurence, *Mount McKinley,* 1913 (no. 53)
Pages 2–3: Magnus Colcord (Rusty) Heurlin, *After Fishing,* ca. 1960 (no. 61)
Page 4: Harvey Goodale and Ellen Henne Goodale, *Indian Chief,* 1975 (no. 83)
Page 8: Edwin Boyd Johnson, *Mount Kimball, Alaska,* 1938 (no. 72)
Page 12: Eliot O'Hara, *Cape Saint Elias, Alaska,* 1940–41 (no. 70)
The graphic motifs that appear at chapter openings are details of woodblock
prints by Rockwell Kent.

Painting in the North: Alaskan Art in the Anchorage Museum of History and Art, a catalogue of the art collection, celebrates the twenty-fifth anniversary of the Anchorage Museum of History and Art and is published in recognition of the enlightened leadership of Elmer and Mary Louise Rasmuson, who have supported the development and growth of the museum from 1968 to the present.

This catalogue is published with the generous support of

National Bank of Alaska

and

National Endowment for the Arts, a federal agency

Alaska State Council on the Arts

Skinner Foundation

 Alpac Corporation

 N C Machinery Co.

Anchorage Museum Association

Municipality of Anchorage

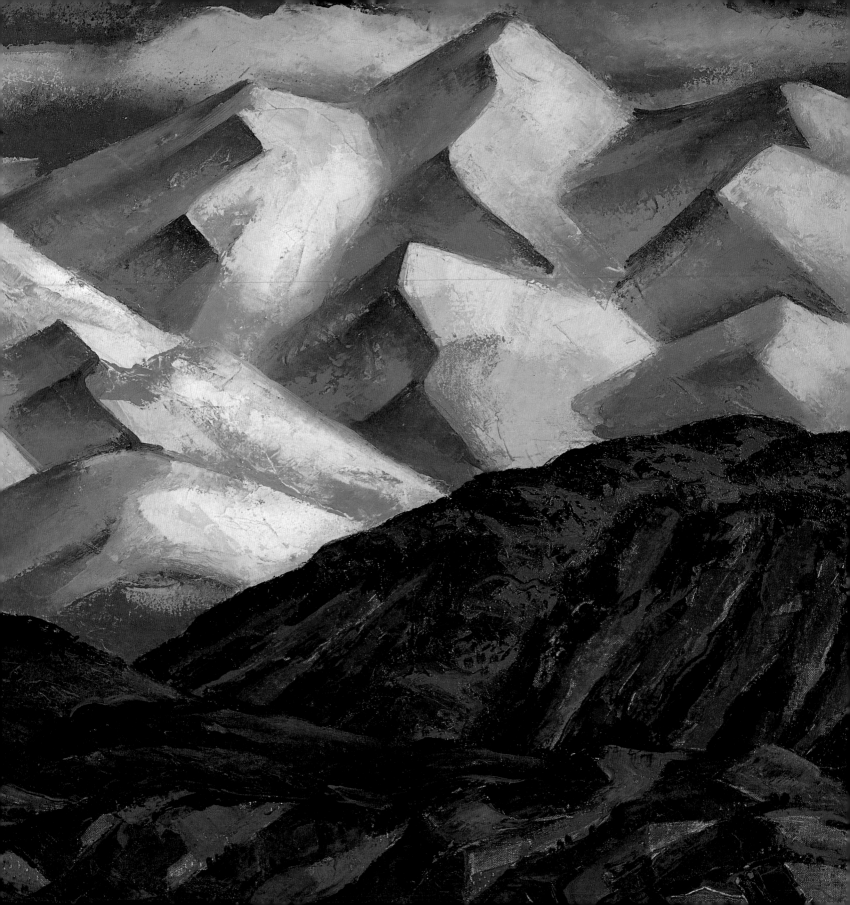

CONTENTS

FOREWORD

I am pleased to introduce the first catalogue of the art collection of the Anchorage Museum of History and Art. The museum's twenty-fifth anniversary is an appropriate occasion to recognize how the permanent collection has grown from only five paintings when the doors opened in July 1968 to more than three thousand art objects.

Since its modest beginning, the museum has been blessed with extraordinary community support. The Municipality of Anchorage has played a vital role in continuously funding the operations of the museum. Particularly during the early 1980s, when public funds were more available, the city made significant contributions to acquisitions. Many Anchorage citizens have contributed their treasures, and the Anchorage Museum Association has led in raising funds for acquisitions. Special acknowledgment is owed Mary Louise and Elmer Rasmuson, the Rasmuson Foundation, and the National Bank of Alaska, our largest donors over the years.

The Anchorage Museum would not be what it is today were it not for the leadership of Mary Louise and Elmer Rasmuson. As founders of the museum and leaders of private-sector support, they have nurtured the institution and its collection through their personal commitment, hard work, and generosity. The community of Anchorage has benefited immeasurably from their singular efforts.

Mention should be made of the first two museum directors: Michael Kennedy, who initiated the collection, and Robert Shalkop, who from 1972 to 1987 developed the broad survey of Alaskan art detailed in this publication. Following their lead, I have set the goals of increasing the depth of the collection and placing Alaskan art in a northern context by displaying it with works from Canada, Greenland, Russia, and Scandinavia.

A catalogue such as this is a milestone. The publication would not have been possible without a generous grant from the National Bank of Alaska. I am grateful to Edward B. Rasmuson, chairman of the board of the National Bank of Alaska, for his support of the catalogue and collection. Thanks are also extended to the Skinner Foundation, which has a long history of involvement in Alaska. The Alaska State Council on the Arts and the National Endowment for the Arts have also provided financial support for the catalogue and for museum programs over the past twenty-five years.

I also want to acknowledge the important contribution of the museum's staff. Diane Brenner, archivist since 1975, was extremely helpful in coordinating the project. Walter Van Horn, curator of collections since 1977, assisted with the selection and documentation of the objects. Chris Arend, who has worked with us for many years, deserves applause for his excellent photography of the collection.

Finally, I would like to thank Kesler Woodward, the author and a respected colleague. Kes has been associated with the museum since he moved to Alaska in 1977. His curatorial positions at the Alaska State Museum in Juneau, the Visual Arts Center of Alaska in Anchorage, and most recently his teaching career at the University of Alaska in Fairbanks have ensured a productive relationship among the Anchorage Museum and those institutions. I am pleased that he took the time from his own creative endeavors to work on this project for the Anchorage Museum and hope that his research has been as beneficial to him as it has been to us.

Patricia B. Wolf
Director

PREFACE

I moved to Alaska sixteen years ago, straight out of graduate school, to take a curatorial position at the Alaska State Museum in Juneau. I fell in love almost immediately with the North, and almost as quickly developed an intense interest in the way artists had depicted its land and people. With some embarrassment I now remember the combination of youthful enthusiasm and cocky ignorance that led me to think I could learn all there is to know about Alaskan art in five years—ten at the most. I have since recognized how presumptuous that goal was and realize that it will remain beyond my reach. So I feel very honored to have the opportunity to reflect on the history of Alaskan art as it is expressed in the remarkable collection of the Anchorage Museum of History and Art.

Scores of books have examined Alaska's Native art traditions, and new ones continue to do so. The history of Native art in Alaska goes back several millennia, and its richness dwarfs that of the shorter-term, smaller-scale accomplishments of non-Native artists in Alaska. But no single volume has been devoted to the history and development of painting, drawing, printmaking, and sculpture in this part of the North. While that tradition may pale beside the richness of timeless Native cultures, it is nevertheless extensive and worthy of examination.

This publication is a survey of Alaskan art, from the first European contact with Alaska and its Native people in 1741, past the opening of the Anchorage Museum of History and Art in 1968. It is organized so as to give the reader not just a sense of the highlights of the collection, but an understanding of how the works of art represent an evolving artistic response to the peoples and landscape of the North. Most of the artists discussed are included in the collection, and the majority of the works reproduced are on long-term exhibition at the Anchorage Museum. I have mentioned artists not yet represented in the collection only when their contribution to Alaskan art seemed too significant to ignore.

In my sixteen years as an Alaskan, I have seen the Anchorage Museum triple in physical size and, more important, seen it grow many times more than that in public appreciation, service to an ever-expanding community, and range of ambition and accomplishment. I have watched it grow from a small municipal museum with a tiny collection and narrowly local focus to an increasingly respected member of the larger American and international museum world, and I have seen the Alaskan art community grow along with it. I feel lucky to be a part of this growing community and to have the opportunity to attempt one of the first comprehensive discussions of its development.

I am grateful to the many people who have provided information, advice, and support in the writing of this volume. Patricia Draher, Marvin Mangus, Saradell Ard, and Len and Jo Braarud read early drafts and made invaluable suggestions and corrections. Virtually the entire professional staff of the Anchorage Museum made extensive contributions. Diane Brenner, librarian/archivist of the museum, and Walter Van Horn, curator of collections, have been full partners in every aspect of this undertaking, and I continue to be grateful for their friendship, enthusiasm, and patience, and to marvel at their unfailing good humor. I am especially grateful to Director Patricia Wolf for her energy and her steadfast devotion to this project and the many others on which we have worked together over the past sixteen years.

Finally, I would like to thank my wife, Missy Woodward, for her insightful reading of the manuscript, but even more for her understanding and support of my long infatuation with Alaska and its art.

Kesler E. Woodward
Associate Professor of Art
University of Alaska Fairbanks

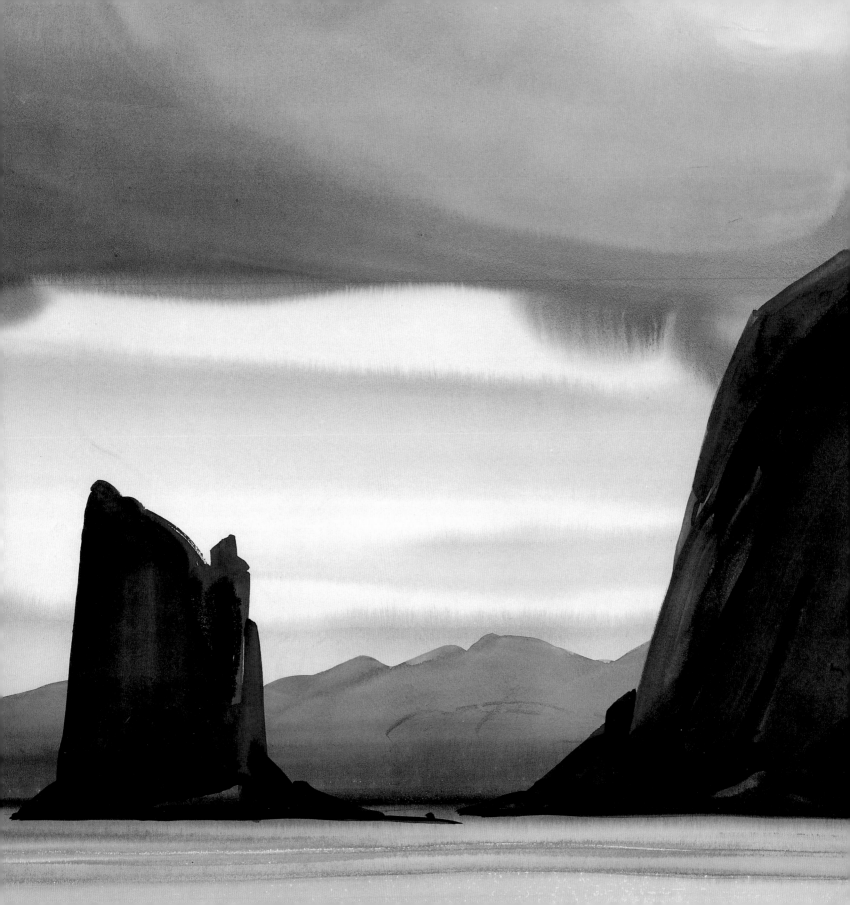

INTRODUCTION

The country itself . . . it's grand. It's so damn grand. It is so much grandeur that it is impossible to encapsulate that either in words or in a painting. It's like trying to paint Niagara Falls or a brilliant sunset or the Grand Canyon or some other visual aspect of nature which can only be described by people who have lived in it, have soaked it up, have been in that environment long enough to assimilate and understand it. I was overimpressed by it, and it is very hard to look at something with your mouth open and at the same time try to think in technical terms: how do you control this image, how do you present it? How do you compose it so that it is the most effective?

—Karl Fortess (Binek 1987, p. 10)

Anyone who has traveled in Alaska, much less tried to paint its landscape, can sympathize with the sentiments expressed by the artist Karl Fortess, who visited the territory to record the scenery for the WPA in 1937. Looking back fifty years later on his stay in Alaska, Fortess was still shaking his head in wonder. He was undoubtedly right in asserting that time and commitment to the land make a difference, but for most Alaskan artists the wonder and sense of inadequacy in the face of it never go away. Those feelings can be an inspiration or an obstacle, but they are almost impossible to ignore.

Not just the land itself but its people, animals, climate, culture, and spirit have been the subjects of Native Alaskan artists' representations for millennia, and of artist-visitors and non-Native residents for two and one-half centuries. The earliest non-Native images of Alaska's landscape and people are the work of the artists who accompanied the great official exploring expeditions of the eighteenth and nineteenth centu-

ries. These not only offer striking early images of Alaska but cast light on the way the unconscious cultural biases of European artists regularly surfaced in their depictions of Alaska's Native people. Native artists in turn portrayed the Europeans who invaded their land, in their traditional arts and in early postcontact drawings.

By the late nineteenth century, as travel to and within Alaska became less fraught with danger and more people were able to visit the region, explorer-artists gave way to visiting artists and finally to tourists. That transition paralleled the flowering of landscape painting in America and Europe.

Prominent American painters visited the territory in the late nineteenth and early twentieth centuries. These painters were working in a very different artistic tradition and for very different purposes than either the early explorer-artists or the topographically and ethnographically oriented visitors of the mid-nineteenth century. Fine Alaskan landscape paintings were done by such important American painters as Thomas Hill, Albert Bierstadt, William Keith, Belmore Browne, and Rockwell Kent as well as by a number of lesser-known artists of regional reputation. Each artist, visiting from a few days to a few months, tried to adapt the late nineteenth- and early twentieth-century American landscape painting traditions to the large scale, unfamiliar light, and harsh climate encountered in the Alaskan landscape.

By the turn of the century, the first well-trained, ambitious resident painters made their home in Alaska. The best known of them—Sydney Laurence, Eustace Ziegler, Theodore Lambert, and Jules Dahlager—each carved out a personal style of painting and an enduring place in the affections of Alaskans. But other early resident painters, as artists committed to living in the North, also made substantial contributions to the development of a vision of Alaska. Notable artists visiting

between World War I and World War II added their own interpretations.

Several Eskimo artists gained prominence in Alaska between the world wars for their drawings and paintings. Florence Nupok Malewotkuk, from Saint Lawrence Island; George Aden Ahgupuk, from Shishmaref; James Kivetoruk Moses, from Cape Espenberg; and Robert Mayokok, from the village of Wales are among the best-known Eskimo artists who produced striking images in india ink, colored pencil, watercolor, and paint on paper, board, and sometimes on sealskin, reindeer hide, and moose hide.

Both the Great Depression and World War II, paradoxically, brought exciting influxes of accomplished artists to the territory. The Works Progress Administration (WPA) organized the Alaska Art Project in 1937 as part of an effort to publicize the territories and possessions of the United States. Twelve artists were sent to travel throughout southeast, southcentral, and interior Alaska, painting as they went.

Another significant body of work is the military art of World War II. Official and unofficial artists chronicled the war in the Aleutians as well as the larger war effort and military buildup throughout the state. Such well-known artists as Henry Varnum Poor, Ilya Bolotowsky, Joe Jones, and Ogden Pleissner made Alaskan images during the period.

The population of Alaska skyrocketed after World War II, and the number of artists boomed as well. Many serious, well-trained painters, sculptors, and crafts makers came to the various college and university campuses in Fairbanks, Anchorage, and Sitka during this period. These artists, and those they inspired, assumed the mantle of leadership in postwar Alaskan art and helped foster the growth of art institutions statewide. The modern art works, exhibitions, and ideas they brought to Alaska have joined, not supplanted, the romantic imagery of pioneer Alaska that remains popular.

The story of Alaskan painting, drawing, printmaking, and sculpture, from the first European contact to the opening of the Anchorage Museum and beyond, provides an important counterpoint to the better-known Native art of Alaska. It is a chronicle more than two centuries old of artists' responses to wonder.

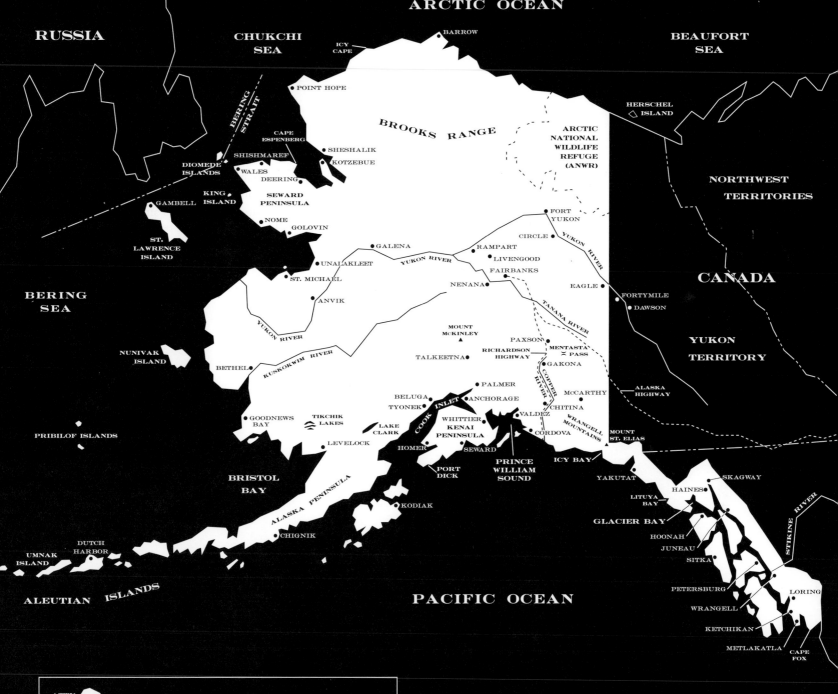

ARCTIC OCEAN

RUSSIA CHUKCHI SEA BEAUFORT SEA

BARROW
ICY CAPE
POINT HOPE
 BROOKS RANGE ARCTIC NATIONAL WILDLIFE REFUGE (ANWR)
BERING STRAIT HERSCHEL ISLAND
CAPE ESPENBERG NORTHWEST TERRITORIES
SHISHMAREF SHESHALIK
DIOMEDE ISLANDS KOTZEBUE
WALES
DEERING
GAMBELL KING ISLAND SEWARD PENINSULA FORT YUKON
 CIRCLE YUKON RIVER
 NOME CANADA
ST. LAWRENCE ISLAND GOLOVIN RAMPART
 GALENA LIVENGOOD
 UNALAKLEET YUKON RIVER FAIRBANKS EAGLE
BERING SEA ST. MICHAEL NENANA FORTYMILE
 ANVIK DAWSON
 YUKON TERRITORY
 YUKON RIVER MOUNT McKINLEY PAXSON TANANA RIVER
NUNIVAK ISLAND RICHARDSON MENTASTA PASS
 KUSKOKWIM RIVER TALKEETNA HIGHWAY GAKONA
 BETHEL COPPER RIVER
 PALMER McCARTHY ALASKA HIGHWAY
 BELUGA ANCHORAGE CHITINA
 TYONEK COOK INLET VALDEZ
GOODNEWS BAY TIKCHIK LAKES WHITTIER KENAI CORDOVA WRANGELL MOUNTAINS
 LAKE CLARK PENINSULA MOUNT ST. ELIAS
PRIBILOF ISLANDS LEVELOCK SEWARD PRINCE WILLIAM SOUND ICY BAY
 HOMER SKAGWAY
 PORT DICK PRINCE WILLIAM SOUND YAKUTAT HAINES
BRISTOL BAY LITUYA BAY
 ALASKA PENINSULA KODIAK GLACIER BAY
 HOONAH
 CHIGNIK JUNEAU STIKINE RIVER
UMNAK ISLAND DUTCH HARBOR SITKA
 PETERSBURG LORING
ALEUTIAN ISLANDS PACIFIC OCEAN WRANGELL
 KETCHIKAN
 METLAKATLA CAPE FOX

ATTU ISLAND ALEUTIAN ISLANDS
KISKA ISLAND

ALASKA

MILES
100 200 300

(MAP BY KATHY DOOGAN/THE ALASKA GEOGRAPHIC SOCIETY)

CHAPTER 1

ARTIST-EXPLORERS: IMAGES OF EARLY EUROPEAN CONTACT

Unlike the rich tradition of Native art in Alaska, which is thousands of years old, European images of Alaska have a precise and much more recent starting point. Beginning with the Russian voyage led by the Danish navigator Vitus Bering in 1741, American, English, French, Spanish, and Russian explorers made more than one hundred voyages to Alaska in the eighteenth and nineteenth centuries. The fabled Northwest Passage, a navigable shortcut across the top of the world between Europe and the Far East, would not be proven a practical impossibility until the mid-nineteenth century.

Pre-nineteenth-century official expeditions to Alaska were relatively few. They include, in addition to that of Bering, the Russian expeditions led by Petr Krenitsyn (1768–70) and Joseph Billings (1787–92); the English excursions of Captain James Cook (1776–80), Nathaniel Portlock and George Dixon (1785–88), and George Vancouver (1791–95); the ill-fated French voyage of Comte de La Pérouse (1785–88); and the Alejandro Malaspina expedition from Spain (1789–94). Despite these early forays, it was not until the early years of the nineteenth century that the vast territory of Alaska, with its array of natural wonders, its seemingly inexhaustible mineral and animal resources, and its wealth of diverse Native cultures made its first full appearance on the world stage.

The motivations for mounting expeditions to Alaska and other parts of the circumpolar North varied over time and from one country to another, but almost all of the voyages were fueled by different mixtures of the same incentives. Most abstract, but perhaps most pervasive, was European curiosity about the map at the top of the globe. The early explorers wanted not just to establish the outlines of the then-unknown landmasses of the western and central Arctic, but to discover what kind of people lived there and what plants and animals flourished in those exotic lands.

Other inducements included the intertwined desires for financial gain and national or personal prestige. The exploitation of natural resources for financial gain was a powerful motivating factor. Individual prestige was an impetus as well, although by the nineteenth century most major expeditions had become too expensive to be privately mounted and were instead undertaken at the behest of governments. Great honor and notoriety were accorded leading explorers. These men were among the most celebrated national heroes of their day.

Although the making of artistic images was not a primary motivation for voyages, virtually all of the official expeditions included documentary artists in their crews. Unlike the typical privately funded fur-trade or whaling voyage to Alaska, official exploring expeditions during the first century of contact almost invariably engaged artists to document the discoveries made by the captains and their crews.

The training, talent, and ambition of expedition artists varied widely. Some of the most interesting and accomplished images were produced by expedition members who were not motivated by official directive but who nevertheless possessed the skills and the desire to portray the people and places they encountered.[1] But the majority of the surviving images were produced by trained, professional artists of some reputation. We must remember when looking at their work that they labored under an unvaryingly strict injunction against willful

distortion, embellishment, and interpretation. This firm directive makes the variety of images, the range of expression, and the regular appearance of interpretive cultural biases all the more interesting.

Early Images of Northern Natives

It is important to view the early images of Native Alaskans in context. The first European images of northern Natives come not from Alaska but from the eastern Arctic and predate the earliest Alaskan views by two centuries. The first known images of Inuit, or Eskimos, are products of artistic imagination[2] that appear on Olaus Magnus's *Carta Marina,* a map of Scandinavia and the North Atlantic islands, including Greenland, issued first as a woodcut in 1539.

The earliest known European depiction of Inuit clearly drawn from life is a woodcut of a Labrador woman and her child who were kidnapped in 1566 by European sailors and taken to Europe for display. The image was used in a 1567 handbill printed in Augsburg which served as an advertisement for the exhibition.[3]

A work in the National Museum of Denmark by an unidentified artist is the earliest known painting of Greenland

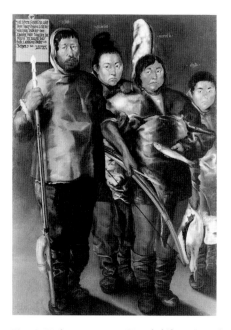

Fig. 1. Unknown artist, *Untitled* (four Greenlanders in Bergen), 1654; oil on canvas, H. 168 cm. National Museum of Denmark, Department of Ethnography.

Eskimos (fig. 1). It also depicts captives—a man, two women, and a girl kidnapped in 1654 near what is now Nuk and taken to Bergen by David Dannel. Their names appear above their heads, and the German inscription beside the man reads, "In their small leather ships, the Greenlanders sail hither and thither on the ocean, from animals and birds they get their clothes. The cold land of Midnight. Bergen, September 28, 1654."

These sixteenth- and seventeenth-century images of northern Natives from the eastern Arctic are important because they share many characteristics with depictions of Native Alaskans done by artist-explorers up to three centuries later. The first known image of an Alaskan Native dates from Vitus Bering's voyage of discovery in 1741—a drawing of an Aleut man in a bidarka, a small, portable skin boat. Attributed to Bering's second in command, Sven Waxell, the figure appears on a 1744 chart of the voyage and closely matches the description given by expedition naturalist Georg Wilhelm Steller of an encounter with the Native. This and other vignettes on Waxell's charts, along with several views of sea otters, fur seals, and other marine mammals attributed to Friedrich Plenisner, Steller's assistant and Bering's chief clerk, are the only known surviving images from Bering's expedition.[4]

Eighteenth-Century Views of Alaska

The Bering expedition's discovery of the marine mammal resources available in Alaskan waters, especially the rich pelt of the sea otter, brought expeditions not only from Russia but from other nations in the following decades. The first sizable body of pictorial material derives from the voyage of the Russians P. A. Krenitsyn and M. D. Levashov from 1768 to 1770. An atlas containing more than fifty of Levashov's drawings is housed in the Soviet Marine Ministry in Saint Petersburg. The drawings include detailed studies of the clothing, housing, and implements of the Aleut people. Known by Westerners only through photocopies until recently, this important early work may be among many such treasures awaiting discovery and study in the new era of intellectual exchange between the countries of the former U.S.S.R. and the United States.

The earliest images of the exploration of Alaska in the Anchorage Museum date from the 1780s. John Webber (1751–93), official artist on Captain James Cook's landmark third voyage of discovery from 1776 to 1780, is undoubtedly

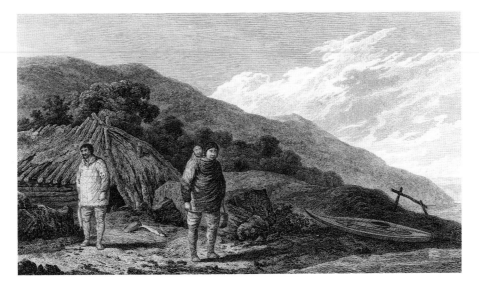

1. John Webber, *Inhabitants of Norton Sound and Their Habitations,* 1784
From *A Voyage to the Pacific Ocean . . . by Captain James Cook . . .* (London, 1784)
Engraving, 39.3 × 54.8 cm; Municipal Acquisition Fund purchase, 80.95.1

the best-known artist-explorer who depicted Alaska. Captain Cook's third voyage was intended to find a northwest passage by sea from the Pacific Ocean to the Atlantic. The expedition arrived in Alaskan waters in 1778 on the ships *Resolution* and *Discovery.* Cook and his crews explored Prince William Sound, sailed past the Kenai Peninsula into what is now known as Cook Inlet, and then progressed north through the Aleutian Islands beyond the Bering Sea into the Chukchi Sea, where they were stopped by ice at a latitude of 70°44' N. The expedition then returned to explore the Aleutians for two months before sailing to Hawaii, where Cook was killed in a conflict with Natives at Kealakekua Bay on February 14, 1779. Under Cook's second in command, Captain Charles Clerke, the expedition sailed north again in the spring. They reached Avacha Bay on the coast of Kamchatka and were stopped by ice once again, just a few miles south of the previous summer's highest latitude.

This famous voyage enjoyed the services of several capable draftsmen, including the later infamous William Bligh who drew coastal profiles on this voyage, and William Ellis, a talented artist who served as the expedition surgeon's second mate. But it is the much-published imagery of the prolific ship's artist John Webber that has been most widely associated with early Alaskan exploration. The Anchorage Museum collection includes thirty-nine engravings and aquatints of Webber's Alaskan images (no. 1).

Webber was born in London in 1751 to an emigrant Swiss sculptor. He was sent to study art from 1767 to 1770 under J. L. Aberli in Bern, Switzerland. After further training in Paris, the artist returned to London, where one of his paintings in the annual exhibition of the Royal Academy impressed the Swedish botanist Daniel Solander. Solander had accompanied Cook on his two previous voyages of discovery, and his recommendation of the young artist eventually led to Webber's employment as artist for the third expedition. The choice was a good one, as Webber produced an astounding number of high-quality images. He was retained after the voyage to supervise the production of the engravings that would illustrate the published journal of the voyage (Cook 1784). These images have been widely reproduced in subsequent editions of the journals and in nearly every book on early Alaskan exploration or the search for the Northwest Passage. Webber was elected to the Royal Academy in 1785. He died of kidney disease in 1793 at the age of forty-one.[5]

A number of other fine eighteenth-century exploration images are to be found in the museum's collection. The major British expeditions after Cook are well represented. An engraving after Joseph Woodcock's *A View in Coal Harbour in Cook's*

2. Joseph Woodcock, *A View in Coal Harbour in Cook's River*, 1789
From *A Voyage Round the World, But More Particularly to the Northwest*
Coast of America, . . . by Captains Portlock and Dixon (London, 1789)
Engraving, 15.6 × 21.3 cm; Municipal Acquisition Fund purchase, 83.52.3

3. Harry Humphrys, *Port Dick, near Cook's Inlet*, 1798
From *A Voyage of Discovery to the North Pacific Ocean, and Around the World . . .*
under the Command of Captain George Vancouver (London, 1798)
Engraving, 15.4 × 23 cm; Municipal Acquisition Fund purchase, 81.118.1

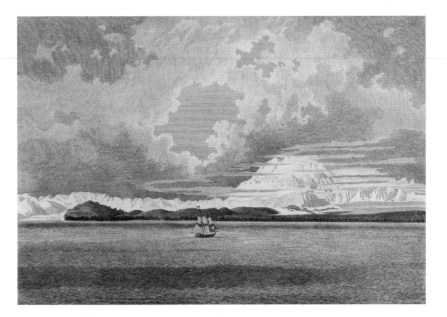

4. Thomas Heddington, *Icy Bay and Mount Saint Elias,* 1798
From *A Voyage of Discovery to the North Pacific Ocean, and Around the World . . .*
under the Command of Captain George Vancouver (London, 1798)
Engraving, 15.4 × 23.1 cm; Municipal Acquisition Fund purchase, 81.118.2

River (no. 2) appeared in Nathaniel Portlock's account of his 1785–88 voyage to the Northwest Coast, an expedition intended to follow up on the discoveries of Captain Cook. Joseph Woodcock (b.1750) was retained as expedition artist and navigation instructor on the voyage. Exploring Cook Inlet and Prince William Sound, the expedition acquired a substantial cargo of furs and helped establish the commercial attractiveness of such trade to British interests.

A hand-colored copper engraving after a drawing by Harry Humphrys (ca. 1767–99), *Port Dick, near Cook's Inlet* (no. 3), and an engraving after a drawing by Thomas Heddington (1776–1860), *Icy Bay and Mount Saint Elias* (no. 4), stem from George Vancouver's 1791–95 voyage. Vancouver's great voyage fell short of its goal of finding the Northwest Passage but did admirably achieve its secondary aim of charting much of the shoreline of the Northwest Coast. Humphrys's view of Cook Inlet is especially interesting as an example of the way in which scenes were sometimes dramatically changed by engravers from the original sketches done on the spot by expedition artists. A comparison of this engraving to the original drawing (now housed in the British Ministry of Defense) reveals the wholly unrealistic addition of the kayaks, which

perhaps were inserted to correspond with an earlier encounter in a different location.[6]

Art from the French voyage of Jean-Francois Galaup de La Pérouse, from 1785 to 1788, is represented in the collection by five engravings after drawings by the official expedition artist Gaspard Duché de Vancy (no. 5) and three engravings and aquatints after those of Lieutenant de frégate Blondela (no. 6). Duché de Vancy had studied art in Vienna, exhibited in Paris and at the Royal Academy in London, and completed portraits of European royalty and architectural views of Naples and Rome. He was a young, well-trained artist living in London when he was chosen as "draughtsman of landscapes and figures" for La Pérouse's ill-fated voyage. The expedition first met disaster in 1786 with the death of twenty-one men in the tide rips of Alaska's Lituya Bay, southeast of Yakutat. Ten more crew members were killed by Samoan Natives on the return trip in 1787, and finally the entire remaining crew disappeared at sea without a trace in January 1788. From various locations on the voyage, La Pérouse had forwarded to Paris his journals and the drawings by Duché de Vancy and others, but the vast majority of the drawings done on the trip must have been lost with the vessels and crew.

5. Gaspard Duché de Vancy, *Costumes of the Inhabitants of Port des Francais . . .* , 1797
From *Voyage of La Pérouse around the World . . .* (Paris, 1797)
Engraving, 25.1 × 39.9 cm; Municipal Acquisition Fund purchase, 81.11.1

Fig 2. Gaspard Duché de Vancy, original drawing for engraving,
Costumes of the Inhabitants of Port des Francais . . . , 1786. Service
Historique de la Marine, Vincennes.

A comparison of the original drawing by Duché de Vancy
(fig. 2) and the engraving *Costumes of the Inhabitants of Port
des Francais . . .* provides striking insights into the cultural bias
behind the manipulation of the images published in the late
eighteenth and first half of the nineteenth century.[7] The draw-
ing depicts a group of Tlingit Natives examining a mirror,
beads, cloth, ax, and pewter plate acquired from the La Pérouse
expedition by gift or trade. As was the case in many of the ear-
liest images of Eskimos, most of the figures are of decidedly
European body and facial type, although their clothing is accu-
rately rendered. The prominent distended lips of both the fore-
ground figure and the larger female background figure are also
consistent with ornamental facial disfigurement characteristic
of the time and place. Such distensions and other decorations
such as facial tattooing are almost always portrayed, and often
exaggerated, in the work of artist-explorers. There is an at-
tempt in at least two of the figures to render the characteristic
high cheekbones and general facial structure of the Tlingit,
which makes it all the more remarkable that three of the other

6. Lieutenant de frégate Blondela, *View of the Village of the Inhabitants of Port des Francais,* 1797
From *Voyage of La Pérouse around the World . . .* (Paris, 1797)
Engraving, 24.8 × 40 cm; Municipal Acquisition Fund purchase, 82.45.1

figures, also presumably Tlingit, should be so typically European in everything but their dress.

Duché de Vancy, like other European artists depicting "exotic" Native peoples, bares the breast of the woman in an exaggerated and contrived manner, presumably emphasizing his view of the Natives' "uncivilized" state. This device was also commonly employed by both artists and engravers to differentiate the sexes.

If the original drawing by Duché de Vancy contains such evidence of cultural bias at work, how much more so does the engraving based on the drawing! The most striking change is in the figure holding the trade ax and pewter plate. Already European in facial structure and body type in the original, he is further transformed in the engraving into "a statuesque Greek athlete holding a discus" (Henry 1984, p. 147). More subtle, but perhaps even more telling, is the transformation of the tenor of the scene. In the drawing, the seated figure regarding his image in the mirror is amused, whereas in the engraving, he is disconcerted at his image, and the entire scene has taken on a mood of concern and awe at these "magical" contrivances.

The tendency to Europeanize some Native features while highlighting or even exaggerating the non-European character of others; the emphasis on exotic clothing, artifacts, and dwellings; and the practice of portraying the "uncivilized" character of Native life would persist in explorer art throughout much of the nineteenth century.

Early Nineteenth-Century Exploration Images

Some of the most beautiful nineteenth-century images of the exploration of Alaska come from the hand of Louis Choris (1795–1828), the official artist of Otto von Kotzebue's Russian voyage of circumnavigation from 1815 to 1817 which explored the then-unknown northwest coast of Alaska. Chosen to accompany the Kotzebue voyage at the age of twenty, Choris already enjoyed a reputation among the artists of Saint Petersburg. Encouraged to publish his drawings on return from the voyage, he produced and sold by subscription a beautiful volume of color lithographs under the title *Picturesque Voyage around the World . . .* (1822). The Anchorage Museum collection includes twenty striking and ethnographically rich Alaskan and Siberian images from this volume (no. 7).

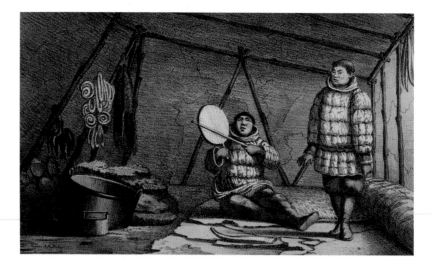

7. Louis Choris, *Interior of a House on Saint Lawrence Island,* 1822
From *Picturesque Voyage around the World, with Portraits
of the Natives of America* . . . (Paris, 1822)
Lithograph, hand tinted, 11.8 × 19.3 cm; Gift of the
Anchorage Museum Association, 75.77.2

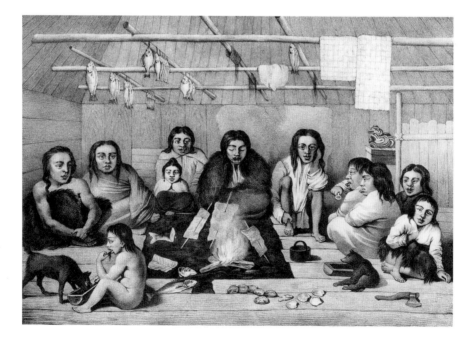

8. Aleksandr Filippovich Postels, *Interior of a Kolosh Cabin,* 1835–36
From *Voyage around the World . . . on the Naval Sloop Seniavin . . . with an Atlas of
Lithographs from the Original Drawings by Messrs. A. Postels and Baron Kittlitz*
(Saint Petersburg, 1834; prints published in Paris, 1835, 1836)
Lithograph, 23.7 × 33.6 cm; Municipal Acquisition Fund purchase, 81.61.3

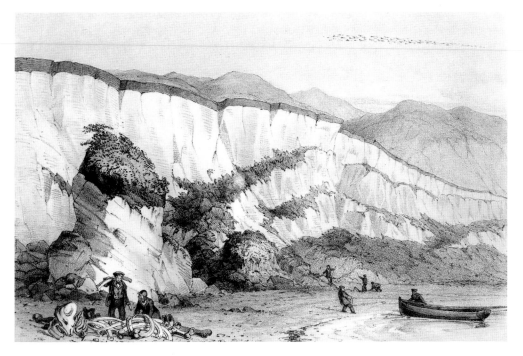

9. Thomas Woodward, *The Ice Cliffs in Kotzebue Sound*, ca. 1850
Lithograph, 25.1 × 32 cm; Gift of Roger Pike, 72.121.13

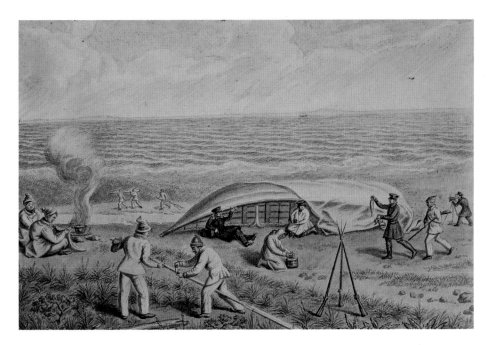

10. Unknown artist, *Untitled* (view of Kashevarov expedition of 1838?), ca. 1838
Watercolor on paper, 21.1 × 30.8 cm; Gift of the Anderson Gallery, 85.12.1

Other notable engravings from major early nineteenth century expeditions include a lithograph by Aleksandr Filippovich Postels (1801–71), *Interior of a Kolosh Cabin* (no. 8), and two lithographs by Friedrich Heinrich von Kittlitz (1799–1874), *The Establishment of New Archangel, Sitka* and *View of the Bay of Sitka*. All three images derive from the published account of Feodor Lutke's voyage of 1826 to 1829, the last of the major Russian scientific expeditions to Alaska. Disturbed by the changes the engravers and lithographers made to his drawings, Kittlitz learned engraving and almost twenty years later illustrated his own volume on the voyage.[8]

Just as intriguing and attractive but less well-known is Thomas Woodward's *The Ice Cliffs in Kotzebue Sound* (no. 9), a charming colored lithograph of a spot very much like one drawn earlier by Choris. Woodward (1811–51) was purser on HMS *Herald*, a survey ship of the British Royal Navy. He almost certainly produced this image on the 1845–51 voyage of the *Herald*, an expedition that circumnavigated the globe and included three cruises to the Arctic in search of the missing Sir John Franklin.[9]

An especially lovely, detailed watercolor by an unidentified artist is thought to derive from a Russian exploring party, possibly the Kashevarov expedition of 1838 (no. 10).[10] The painting shows several officers and sailors, and what appears to be a Native in a gut parka, encamped on a beach near the shelter of an overturned Native skin boat. Surveying operations are under way; a campfire burns; a meal is being prepared; and other preparations for setting up camp are evident. Although questions have been raised as to whether the officers would be in full military garb (identified as early nineteenth-century Russian artillery uniforms), it seems clear that the image is a documentary composite intended to provide information on dress, activity, and location rather than a "snapshot" view of an actual scene. The tentative attribution seems entirely plausible, especially as "the number of men, the prominent positioning of surveying gear, the boat, as well as the landscape" nicely fit the known facts of the Kashevarov expedition.[11]

The Late Nineteenth Century: From Explorers to Tourists

By mid-century, the "heroic" period of Arctic exploration by European powers was ending. The disappearance of Sir John Franklin's expedition in 1845 marked a major turning point in the history of Arctic exploration. Franklin was the most famous explorer of the day, and few doubted the eventual success of his attempt to discover the Northwest Passage. His disappearance in the central Arctic along with a crew of 134 men fueled an unprecedented ten years of Arctic exploration from 1849 to 1859, first in an effort to rescue the expedition and finally to solve the mystery of its fate. Public interest in the Arctic surged as the mystery deepened with time, and as each unsuccessful relief expedition returned with new knowledge of the Arctic but with no news of Franklin's fate.

When remains of the expedition were found by Leopold J. McClintock in 1859, it was finally made clear that all of Franklin's men had died horribly of starvation and disease after abandoning their ice-bound ships and marching south. The knowledge gained in searching for the missing men had ruled out the possibility of a practical Northwest Passage, and the grisly solution to the mystery seemed to sour many Europeans and their governments on the Arctic enterprise. Exploration and exploitation of Alaska in particular were increasingly taken up by the Americans, and with the purchase of the territory from Russia in 1867, those interests were furthered.

By the final quarter of the nineteenth century, not only had the "heroic" period of Alaskan and Northwest Coast exploration by European powers ended but the number of non-Native residents and tourists was growing. Much of the exploration of the region and its people was done under less stressful conditions by Americans and Canadians.

Several mid- to late nineteenth-century visitors to Alaska made substantial commitments to exploring and portraying the region. Such regular or long-term visitors, as well as several artists who accompanied late exploring expeditions, stand in contrast to the more prominent painters who would visit the territory briefly during the same period and a little later. In their topographic and occasional ethnographic interests, artists like the Cleveland painter Henry Wood Elliott (1846–1930) have more in common with the artist-explorers of the first century of Alaskan exploration.

Even before serving as official artist for F. V. Hayden's United States Geological Survey expedition to the West from 1869 to 1871, Elliott had visited Alaska in connection with a Russian-American telegraph expedition for Western Union, a failed attempt to lay a telegraph line across the Bering Strait. But he is far better known today as the savior of Alaska's fur seals. Appointed as special agent of the United States Treasury to supervise the Alaska Commercial Company's management

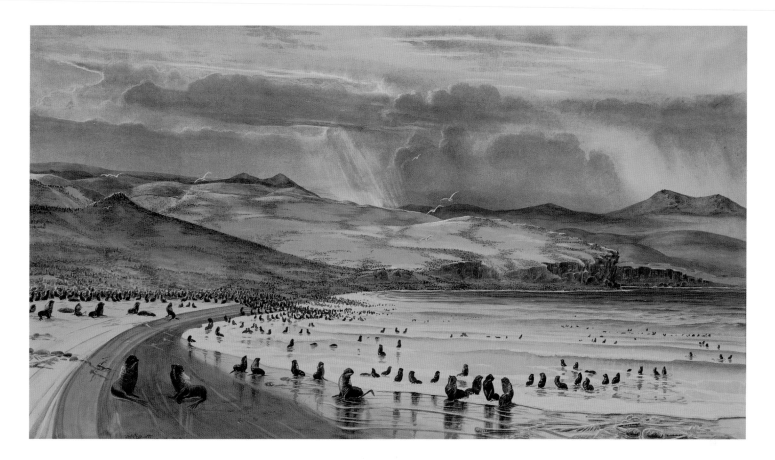

11. Henry Wood Elliott, *The Fur Seal Millions,* 1872
Watercolor on paper, 31.8 × 57.2 cm; Gift of the Anchorage Museum Association, 87.48.1

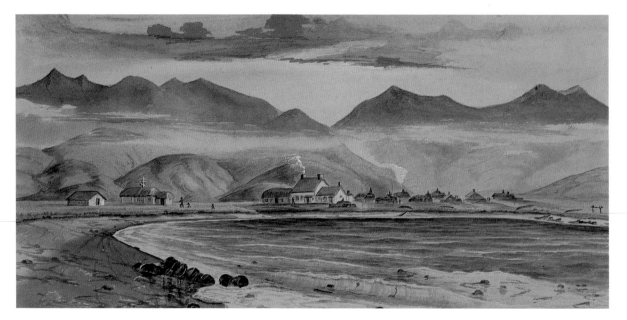

12. Henry Wood Elliott, *Attou Island, Aleutian Chain*, 1879
Watercolor on paper, 14.9 × 29.2 cm; Municipal Acquisition Fund purchase, 82.81

of the fur seal industry in the Pribilof Islands, he was sent to that region of Alaska in 1872. Although he went back to Cleveland the following year, he returned to Alaska several times, and he spent most of the remainder of his life fighting in Congress to reverse the practices that were leading to the disastrous decline of the fur seal species.

During his time in Alaska, Elliott traveled extensively, making fascinating watercolors and drawings not just of the Pribilof and Aleutian islands, but of Saint Lawrence Island, the Arctic Ocean, Icy Cape, and southeast Alaska as well. Among the first Americans to visit Alaska, Elliott was perhaps better traveled throughout the territory than any other artist of the late nineteenth century. He was also one of the most prolific, "reported to have shipped back to Washington between two and three hundred paintings and drawings after his first year on the Pribilof Islands, from early 1872 to the summer of 1873" (Shalkop 1982a, p. 5). The museum's five examples of Elliott's work depict fur seals on the Pribilofs and landscapes of the Aleutian Islands (nos. 11, 12).[12]

Another artist who visited Alaska in 1866 in connection with the telegraph survey was the English painter Frederick K. Whymper (b. 1838). He was the son of a London artist and brother of British artist, explorer, and author Edward

Whymper. He worked with his brother and father on several alpine books before coming to America (Harper 1970, p. 331). Whymper was among the first visiting artists to portray interior Alaska. His two watercolors in the collection include a depiction of the village of Inglutalik (no. 13) and a landscape of Plover Bay in Siberia.[13] Whymper also painted many watercolors in the San Francisco environs, where he was reported to have been active as late as 1882 (Hughes 1986, p. 501).

Yet another artist to visit the North as a result of the telegraph survey was the California painter George Albert Frost (1843–1907), who accompanied George Kennan and the Siberian party of the expedition. Frost made watercolors of the Cascade Range in the Pacific Northwest and of British Columbia[14] before traveling extensively in eastern Siberia, where he made numerous paintings of the landscape and the life of the Koryak reindeer herders of the region. He also provided illustrations for Kennan's account of the Siberian expedition, *Tent Life in Siberia* (Kennan 1910). A native of Boston, Frost attended the Royal Academy of Belgium. He was an active participant in the California art scene from 1872 to 1879. His four oil paintings and one watercolor of Siberian scenes in the collection are accomplished and evocative images of the little-known region and people (no. 14).

13. Frederick K. Whymper, *Untitled* (village of Inglutalik), ca. 1866
Watercolor on paper, 14.2 × 41.2 cm; Municipal Acquisition Fund purchase, 82.84.1

14. George Albert Frost, *Koryak Village, Siberia,* 1892
Oil on canvas, 55.9 × 80 cm; Gift of Dr. and Mrs. Lloyd Hines, 76.29.3

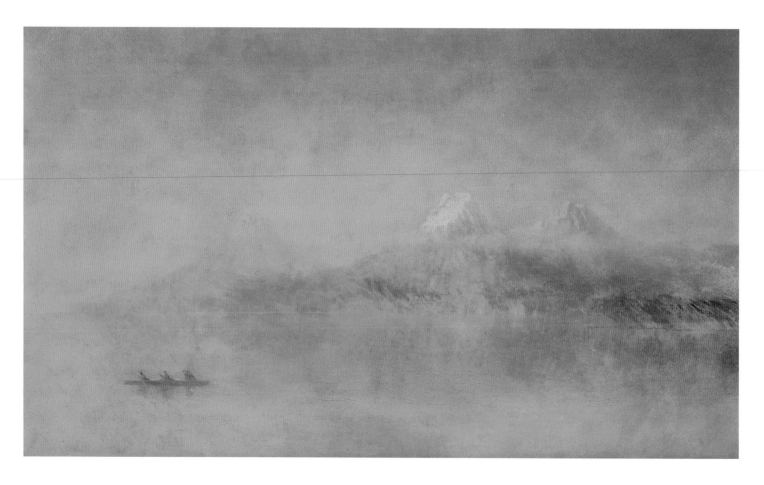

15. Vincent Colyer, *Aleutian Islands, North Pacific Ocean, Alaska Territory,* ca. 1880
Oil on canvas, 34.2 × 59.7 cm; Gift of the Anchorage Museum Association, 76.40.1

Among the visitors to the territory who produced solid artistic work while engaged in official activity was Vincent Colyer (1825–88), who visited Alaska as secretary to the Indian commissioners in 1869. Colyer was concerned with promoting the establishment of schools for the Indian tribes of the territory. A serious painter as well as government official, Colyer studied at the National Academy of Design in New York and with painter John R. Smith for four years, and he exhibited large paintings from his sketches of the West at the National Academy and the Philadelphia Centennial Exhibition. While engaged in governmental assignments in Alaska, he made paintings of the Native people and the landscapes he encountered, including an oil on canvas, *Aleutian Islands, North Pacific Ocean, Alaska Territory* (no. 15).

The last great exploring venture to Alaska was the Harriman expedition of 1899, which traveled up the coast of Alaska and as far as Plover Bay in Siberia. Sponsored by the railroad and mining magnate and sportsman Edward Harriman, the elaborately outfitted expedition included, in addition to Harriman family members, such well-known scientists and naturalists as John Burroughs and John Muir. The artists Frederick S. Dellenbaugh (1853–1935) and Robert Swain Gifford (1840–1905) were retained to record landscapes; Louis Agassiz Fuertes was employed to paint birds; and Edward S. Curtis (1868–1952), then a little-known young photographer, was brought by Harriman to photograph scenery and the crew. Curtis later became famous for his twenty-volume work, *The North American Indian*, which included several images of Native Alaskans (no. 16). But the early work that the young photographer did for the Harriman expedition was quite different from the examples in his later masterwork. The Harriman-sponsored work focuses on the landscape and the activities of expedition members, and the relatively few images of Native Alaskans have none of the self-conscious romanticizing of Native people for which Curtis was later revered, and in more recent times criticized.[15]

Dellenbaugh was born in Ohio and educated in the public schools of Buffalo and at art schools in New York, Munich, and Paris. More than two decades before joining the Harriman expedition, he had accompanied John Wesley Powell on his mapping excursion to the Grand Canyon. Dellenbaugh traveled extensively throughout the West and wrote and illustrated numerous books on its history and character. He also exhibited widely, including at the Paris Salon in 1883 and 1884.

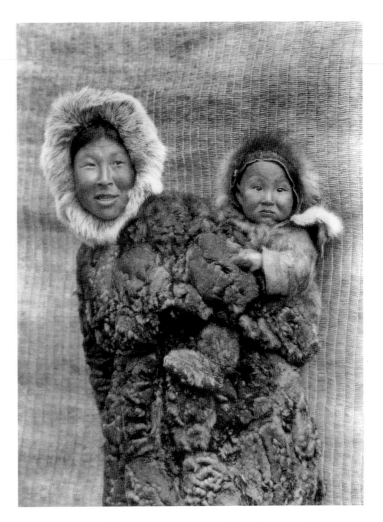

16. Edward S. Curtis, *Mother and Child—Nunivak,* 1928
From *The North American Indian*
(Norwood, Mass., 1930), vol. 20, pl. 694
Photogravure, 39.5 × 29.2 cm; Gift of the
Rasmuson Foundation, B73.96.29

17. Frederick S. Dellenbaugh, *Log Houses, Kodiak Village,* 1899
Oil on board, 13.5 × 22.2 cm; Gift of Mr. and Mrs. Elmer E. Rasmuson, 77.62.9

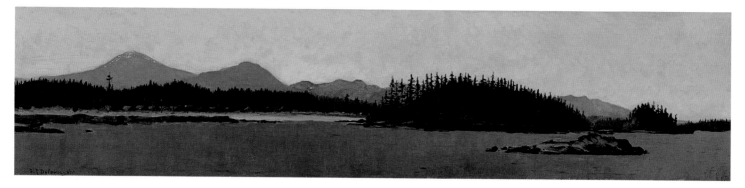

18. Frederick S. Dellenbaugh, *Foggy Bay, Cape Fox,* 1899
Oil on board, 18 × 78 cm; Gift of Mr. and Mrs. Elmer E. Rasmuson, 77.62.20

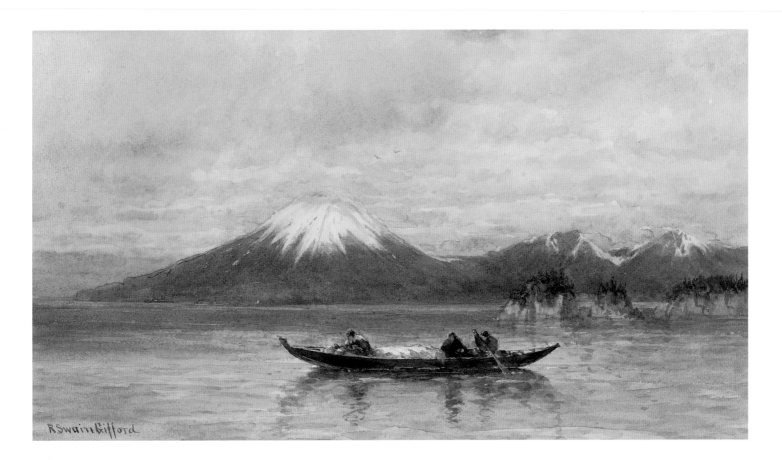

19. Robert Swain Gifford, *Mount Edgecomb Volcano, Sitka, Alaska,* ca. 1899
Watercolor on paper, 23.6 × 42.8 cm; Joint purchase,
Anchorage Museum Association and Municipal Acquisition Fund, 92.52.1

20. W. C. G., *Saint Michael's, Alaska, Western Fur Trading Co. Post,* 1882
Pencil on paper, 22.7 × 30.4 cm; Joint purchase, Anchorage Museum Association
and Municipal Acquisition Fund, 88.61.3

21. Willis E. Everette, *Winter Scene, −55 Degrees (Saint Michaels, 1884),* 1884
Colored pencil and pencil on paper, 29.5 × 34.8 cm; Gift of Heidi and
Robert Ely in memory of Joseph Rudd, 88.67.1

22. Unknown artist, *Untitled* (shipwreck), ca. 1880
Pen and ink on paper, 20.5 × 28 cm; Joint purchase, Anchorage Museum Association
and Municipal Acquisition Fund, 88.61.8

Dellenbaugh's unassuming but deft landscapes serve as a visual travelogue of the Harriman expedition's coastal route (nos. 17, 18). The museum has twenty-four Dellenbaugh oil paintings from the expedition.

Robert Swain Gifford's watercolor *Mount Edgecomb Volcano, Sitka, Alaska* (no. 19) is virtually identical to an oil painting the artist produced for the expedition (Old Dartmouth Historical Society 1974, p. 30). Gifford, born on the island of Nonamesset, Massachusetts, grew up in New Bedford, where he studied with William Bradford and Albert van Beest. He moved to Boston in 1864, already a successful painter, and to New York two years later, where he taught for three decades at Cooper Union. In 1869, Gifford was hired with several other artists to illustrate the two volumes of William Cullen Bryant's *Picturesque America*. The trip he took cross-country, as well as the time he spent sketching in California and the Pacific Northwest, opened up new vistas for the eastern painter and provided material for many later paintings. The artist was almost sixty years old when he was engaged as one of the two landscape painters on the Harriman expedition. He died in 1905 in New York.

Documentary Drawings by Untrained Artists

In addition to the work of well-trained artists and draftsmen (official expedition artists as well as trained draftsmen who were otherwise employed as officers, seamen, or, later, civil servants), many images of nineteenth-century Alaska were produced by individuals who sought to record a visual impression but who had little or no formal training. These images are interesting for their historical, documentary value, but in that respect are often less accurate and less detailed than contemporary photographs of the era. What makes them worthy of collection and exhibition is something else—an undeniable charm and directness that often render them not just delightful but insightful.

Many of the examples of this kind of drawing come from western Alaska and date to the first few decades following the purchase of Alaska from Russia in 1867. A pair of drawings by an unknown artist, simply signed "W.C.G. 1882," depicts the old Russian-American Company buildings and the Western Fur Trading Company post at Saint Michael (no. 20). Another scene of Saint Michael, a colored pencil drawing of the Alaska Commercial Company building, was drawn by

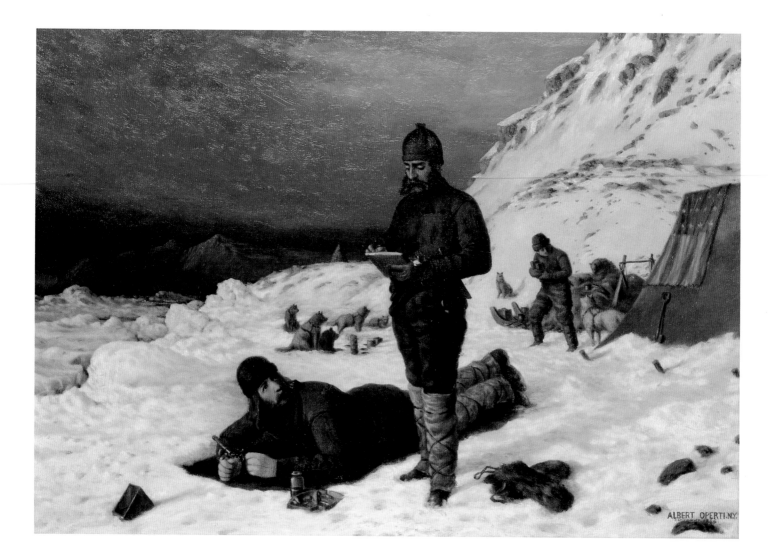

23. Albert J. Operti, *Farthest North,* 1886
Oil on canvas, 35.6 × 51 cm; Joint purchase, Anchorage Museum Association
and Municipal Acquisition Fund, 91.48.1

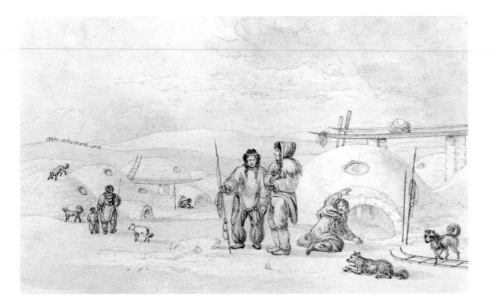

24. George Francis Lyon, *Snow Village*, 1821–22
Pencil and ink wash on paper, 17.6 × 24.1 cm;
Municipal Acquisition Fund purchase, 83.47.4

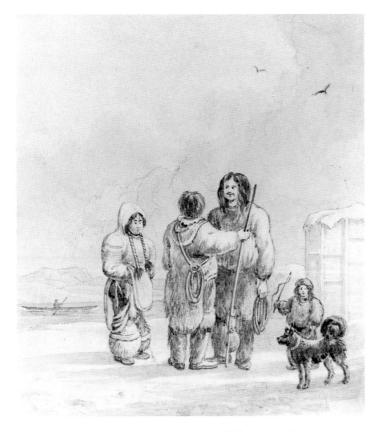

25. George Francis Lyon, *Group of Eskimaux*, 1821–22
Ink wash, 21.5 × 18.6 cm; Municipal Acquisition Fund purchase, 83.47.5

Dr. Willis E. Everette, who was employed by the United States Army in 1884 to survey the Yukon River. Everette carefully noted the primary use of each building depicted (no. 21). Yet another charming group of six drawings by one or more unidentified artists consists of one additional view of Saint Michael, two cartoons showing relations between the Western Fur Trading Company and the Alaska Commercial Company, and three drawings depicting commercial whaling activities in Alaska, including a shipwreck (no. 22).

Nineteenth-Century Images of the Eastern Arctic

Some of the most fascinating depictions of Arctic exploration in the late nineteenth century come from the hand of Albert J. Operti (1852–1927), who painted many canvases chronicling significant events in polar exploration of the era, and who was himself a member of the 1896 and 1897 expeditions of Robert E. Peary. Two Operti paintings, a gouache entitled *Fort Conger* and an oil entitled *Farthest North*, are based on the ill-fated A. W. Greely expedition of 1881–84 to Ellesmere Island.

Operti was born in Italy and raised in England. Schooled in Dublin and Paris, he specialized in scene painting and portraiture. By 1875 he had moved to the United States, and in the following decade he designed sets for the Metropolitan Opera in New York. Influenced by the famous Arctic paintings of William Bradford, he took a serious interest in the polar regions (Muller 1976, p. 98).

One of Operti's first Arctic paintings, *Found*, chronicles the finding of the remains of the tragic Jeannette expedition in 1882 by George W. Melville, who was with the A. W. Greely expedition of the United States Navy. Soon after, the artist was commissioned by the secretary of the navy to make historical paintings commemorating the naval rescue of the Greely expedition itself at Lady Franklin Bay, on the northeast coast of Ellesmere Island in Canada's Northwest Territories. The Greely expedition, which had set up scientific exploring operations on Lady Franklin Bay in August 1881, was beset by ice and was beyond the reach of relief ships until June 22, 1884, by which time all members of the expedition but Greely and six others had died of starvation.

Operti's paintings of the expedition include a scene of the rescue itself, made from photographs and portrait sittings of the principals involved (Operti n.d.), and the Anchorage Museum oil depicting three men of the Greely expedition on May 13, 1882, on Lockwood Island, North Greenland, the expedition's farthest north attainment (no. 23).[16] The museum's canvas, signed and dated 1886, is a 14-by-20-inch version of the 90-by-120-inch painting once owned by the United States government (now in the Shelburne Museum, Vermont) and may have been a study for that imposing work, which is dated the same year.

Operti illustrated three books by explorer Robert Peary, *Nearest the Pole* (Peary 1907), *Northward over the Great Ice* (Peary 1898), and *Snowland Folk* (Peary 1904), as well as one by Peary's rival Frederick Cook, *Through the First Antarctic Night* (Cook 1900). Operti published *The White World* (Operti 1902) about his experiences with Peary. Beginning in 1912, he worked as artist and cartographer for the American Museum of Natural History in New York, producing murals and backdrops for museum installations.

Another well-known Arctic painter of the same period is also represented in the museum's collection. Frank Wilbert Stokes (1858–1955) studied with Thomas Eakins at the Pennsylvania Academy of the Fine Arts as well as at the École des Beaux-Arts and Académie Julian in Paris. He was best known for the Arctic and Antarctic scenes he painted while on polar expeditions with Robert Peary, Dr. Otto Nordenskjold, and others. The museum's untitled oil probably dates from either the 1892 Peary relief expedition or the 1893–94 north Greenland expedition led by Peary.[17]

The famous British explorer Captain George Francis Lyon (1795–1832) was an accomplished draftsman with a sharp documentary eye (nos. 24, 25). His drawings and subsequent prints depict Inuit people and habitations of the central Arctic and include an imaginary sketch of the North Pole. Lyon commanded the *Hecla* in an 1821–23 expedition led by William E. Parry that attempted to find the Northwest Passage by passing through Hudson Strait and exploring the northwest coast of Hudson Bay. Both men published accounts of the expedition; like their written accounts, Lyon's drawings serve as an excellent source of ethnographic data on the Eskimos of the Iglulik region.[18]

Postcontact Images by Native Alaskans

Although the long, rich history of Native Alaskan art is a separate subject from the European tradition of painting and drawing that is our focus, it should be considered briefly in the context of early Western contact. The facility and flexibility of Native artists led some to make pictures of the very Europeans who were struggling to describe them. European and American visitors and settlers, their settlements, and their paraphernalia not only provided novel subject matter for Native artists but introduced new materials and techniques, which they were eager to explore and adapt to their own ends.

Native artists made many carved representations of the Europeans and Americans they encountered, in forms ranging from ivory carvings to argillite pipes to totem poles. Haida argillite pipes depicting ships and sea captains appeared frequently in the nineteenth century, and American and European figures were even occasionally incorporated into storytelling totem poles in southeast Alaska. But images of the newcomers and their strange implements and way of life flowered most fully in the art work of the Alaskan Eskimo.

As Eskimo art authority Dorothy Jean Ray notes, "The first two decades of the twentieth century were probably the most bizarre in the history of Eskimo art in the transfer of subject matter from one medium to another" (Ray 1977, p. 43). Ray has explored extensively the flood of new objects that Eskimo artists began carving in ivory, from gavels and napkin rings to cribbage boards and vases. She and others have also studied the Alaskan Eskimo tradition of pictorial engraving on ivory, tracing the progression from techniques predating European contact to the contemporary style.[19]

26. Angokwazhuk (Happy Jack),
Untitled (cribbage board), ca. 1900
Walrus ivory, brass, black pigment, 7 × 61.2 × 3.7 cm;
Municipal Acquisition Fund purchase, 82.97.1

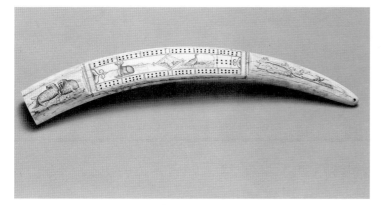

27. Guy Kakarook, *Untitled* (cribbage board), 1899
Walrus ivory, black pigment, 7.8 × 66 × 5 cm;
Municipal Acquisition Fund purchase, 81.40.1

Two of the most famous Eskimo engravers are Angokwazhuk, better known as Happy Jack (d. 1918; no. 26), and Guy Kakarook (no. 27). Angokwazhuk was the first carver in Nome to be identified as an individual artist, and often signed his work "Happy Jack, the ivory carver." Kakarook, originally from the village of Atnuk near Golovin, was one of the few other carvers who signed their engraved ivory; most carvers are unidentified.

As paper and a variety of drawing materials became more widely available, a number of Eskimo artists made drawings of their way of life and that of the newcomers to the territory. Guy Kakarook is especially well known for his drawings in watercolor, ink, and crayon on paper, such as the museum's pen and ink wash drawing of Saint Michael (no. 28). Sheldon Jackson, a Presbyterian missionary and the education agent for Alaska at the turn of the century, acquired two notebooks of more than thirty watercolor sketches by Kakarook. Now in the Smithsonian Institution, Washington, D.C., they depict life in Saint Michael and along the Yukon River between 1894 and 1903, when the artist served as a deckhand on the riverboat that appears in many of the sketches.[20]

Many other Eskimo artists of the era made sketches of the new settlements, their own daily activities and ceremonies, and the animals and landscape of the region, although relatively few of their images have been preserved.[21] In this century Native Alaskan artists have continued to draw upon their traditional images and materials, and have eagerly adopted and adapted new materials and techniques. Their contribution to the development of painting, drawing, sculpture, and fine crafts in Alaska has been substantial, and Native artists from all cultural groups in the state are among the most prominent artists working in the region today.

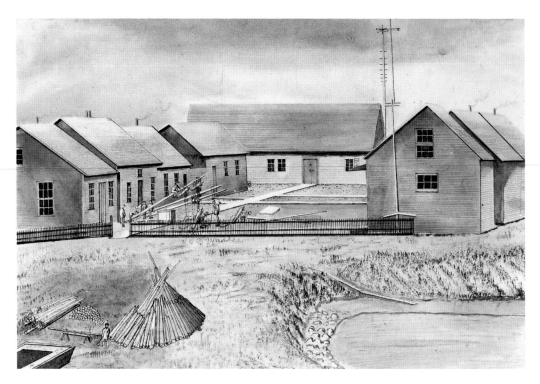

28. Attributed to Guy Kakarook, *Untitled* (view of Saint Michael), ca. 1900
Pen and ink wash on paper, 26.5 × 36.7 cm; Gift of the Anchorage Museum Association, 88.28.3

After a half century of exploration and settlement, the nineteenth century had dawned with the landscape and Natives of Alaska still seen as exotic and mysterious subjects for artist and explorer alike, subjects difficult for the European artist to portray with objectivity. The earliest European images of Alaska are an attempt to understand and describe these new people and this place, to fit them into a more familiar vision of the world. As the century ended, the Native Alaskans' traditional culture was under siege, and non-Native artists—European, Canadian, and American—were attempting to recapture by selective vision and representation a lost exoticism, mystery, and *other*ness. They eventually turned away from the portrayal of Native people to tackle the seemingly more straightforward but still challenging subject of the landscape itself.

1. Henry 1984, p. xi. See Henry's excellent introduction to the work of artist-explorers on the Northwest Coast.

2. These earliest depictions have been extensively discussed in the ethnographic literature by Edward Lynam (1949), Kaj Birket-Smith (1959), William C. Sturtevant (1976), Wendell Oswalt (1979), and others, all of whom note that the Inuit depicted appear to be products of the artist's imagination, as neither the people nor the vessel have any distinguishably Inuit characteristics.

3. This image, by an unknown artist, has also been extensively explored from an ethnographic view, most thoroughly by William Sturtevant (1980) and David Beers Quinn (Sturtevant and Quinn 1987).

4. The attribution of these images to Waxell and Plenisner is debated. Several vignettes are reproduced and discussed in Henry 1984, pp. 6–10.

5. See Cole 1979 and Joppien 1985–88 for more on Webber.

6. See Henry 1984, pp. 106–7, for side-by-side reproductions of the drawing and engraving.

7. See also ibid., pp. 146–47, for a comparison of the drawing and engraving.

8. Kittlitz says in the introduction to his narrative: "It is perhaps not generally known how extremely difficult it is to obtain from the hands of an engraver or lithographer a correct copy of a picture . . . but proofs are furnished by a series of expensive illustrations in works of travel, which convey no idea of the scenes represented, though it was not from want of good original drawings" (quoted in Henry 1984, p. 54).

9. For an account of this voyage, and details of its botanical and zoological accomplishments, see Seemann 1853, 1852–57; and Richardson 1854.

10. Walter Van Horn, curator of collections, Anchorage Museum of History and Art, has made the attribution.

11. Personal correspondence with Walter Van Horn, August 27, 1991.

12. For more on Elliott's art, see Robert L. Shalkop's catalogue of a retrospective exhibition of Elliott's work at the Anchorage Museum (Shalkop 1982a) and Elliott's own extensive description and account of Alaska, *Our Arctic Province* (Elliott 1886), which reproduces a great many of his drawings and watercolors.

13. For more on Whymper's Alaskan experience and numerous examples of his drawings, see *Travel and Adventure in the Territory of Alaska* (Whymper 1868).

14. For more on Frost's travels in British Columbia, including reproductions of several of his watercolors of the Cascades and British Columbia landscapes, see Render 1974.

15. Curtis's photographs from the Harriman expedition are discussed in relation to his later work at some length in William H. Goetzmann and Kay Sloan, *Looking Far North: The Harriman Expedition to Alaska, 1899* (1982), a highly readable overall account of this altogether remarkable expedition. The official account of the expedition and its findings runs to thirteen volumes (Merriam 1901–14), of which the first two volumes provide a narrative of the voyage and many reproductions of the work of Curtis and Dellenbaugh as well as paintings by Fuertes and Gifford.

16. Operti evidently produced a catalogue of his own Arctic historical paintings (now in the Special Collections of the Dartmouth College Library, Hanover, New Hampshire), for presentation to Dr. F. A. Lucas, director of the American Museum of Natural History in New York. Both this source and the Shelburne Museum identify the officers as Lieutenant James Lockwood and Sergeant David Brainard, and the Inuit man in the background as Frederick Christiansen (Operti n.d.; Muller 1976, p. 98).

17. Stokes showed polar paintings in New York at the American Art Association in 1891, the Wunderlich Gallery in 1893, and the Lotos Club in 1904. He also exhibited at Saint Botolph's Club, Boston, in 1896 and again in 1905; the Saint Louis Museum of Fine Arts in 1898; the Detroit Museum of Art in 1899; and the Buffalo Academy of Fine Arts in 1907. Catalogues for all of these exhibitions are available on microfilm from the Archives of American Art, Smithsonian Institution. For more on Stokes's career and polar images, see his obituary in the *New York Times*, February 15, 1955; a narrative interview with the artist (*The Studio* 1895, pp. 208–14); and his own privately published 1925 catalogue of his Arctic and Antarctic images (Stokes 1925).

18. For more on Lyon, including reproductions of many of his central Arctic images, see his 1824 and 1825 accounts of the voyage (Lyon 1824, 1825). A very readable account of this and other eastern and central Arctic expeditions, with an excellent introduction to much of the imagery produced on those voyages, is Wendell Oswalt, *Eskimos and Explorers* (1979).

19. Ray has illustrated a progression of four stages: an "old engraving style" on ivory bow drills prior to and immediately following European contact; the "modified engraving" used on large ivory pipes and walrus tusks sold as souvenirs in the Saint Michael area in the late nineteenth century; the "western pictorial engraving" from the 1890s, with its more intricate details for realistic representation; and the "modified pictorial" or "contemporary" style of this century, employing line drawing with occasional shading and more stylized surface treatment (Ray 1961, 1967, 1969, 1977).

20. For more on Kakarook, see "Kakarook, Eskimo Artist" (Ray 1971, pp. 8–15).

21. For a discussion of another group of late nineteenth-century Eskimo drawings, also in the collection of the Smithsonian Institution, see Phebus 1972.

C H A P T E R 2

TOURISTS AND TRAVELERS: VISITORS' PERCEPTIONS

For artists making images of Alaska in the first century after European contact, travel to and within the region was a dangerous adventure. During the eighteenth century and much of the first half of the nineteenth, whole expeditions occasionally disappeared, and the completion of a voyage without major hardship was an accomplishment rather than an inevitability. At best, conditions were spartan, and the voyages long and taxing. The only artists with practical access to the region were those attached to official exploring expeditions and the few commercial operations.

Although travel into the Arctic regions of northwest Alaska remained an expensive and dangerous proposition for quite some time (much of the New England whaling fleet was beset by ice and its ships crushed off the northwest Alaska coast in 1871), the period immediately following the purchase of Alaska from Russia in 1867 saw a gradual rise in boat traffic to the milder climate of the territory's southeastern portions. Regular service from United States ports to Sitka began immediately following the purchase. Monthly sailings out of Portland, Oregon, were soon followed by an increasing number of vessels out of San Francisco, but still the northbound passengers were primarily those with real or hoped-for commercial interests.

The last two decades of the nineteenth century saw the meteoric rise in visitors to the southeastern "Panhandle." By the early 1880s, the *Ancon* and *Idaho* of the Pacific Coast Steamship Company of San Francisco were making monthly runs to the region. A small party of tourists was guided through southeast Alaska's relatively protected Inside Passage in 1882;

in the summer of 1883, Captain James Carroll took a group of visitors on the *Idaho* into Glacier Bay. That most dramatic of southeast Alaska's scenic attractions had been discovered just four years before by the naturalist John Muir and brought to wide public attention through his writing.

In 1885 a member of the group that had been escorted to Glacier Bay by Carroll published the first guidebook to Alaska. Eliza Ruhamah Scidmore's *Alaska, Its Southern Coast and the Sitkan Archipelago* (Scidmore 1885) sang of Alaska's wonders and made the prospect of a pleasure trip to the state seem much more real and inviting to adventurous American travelers. By 1889 over five thousand tourists were making the trip up the Inside Passage in a single season. With the onset of the Klondike Gold Rush less than a decade later, not enough ships were available to take the crowds of fortune hunters north, and by the turn of the century tourism was a thriving industry in southeast Alaska.[1] Among those thousands of tourists seeking new sights and new experiences were many amateur and professional artists, ranging from Sunday watercolorists to some of the best-known landscape painters of the day.

Sitka: Alaska's Cultural Capital

Much of the artistic activity immediately following the purchase of Alaska was centered around Sitka, formerly the Russian territorial capital and for some time the largest town as well as the cultural and political capital of Alaska. Many of the late nineteenth-century artists discussed in the preceding chapter spent time in Sitka. Both Frederick K. Whymper and Henry W. Elliott passed through before the purchase, while

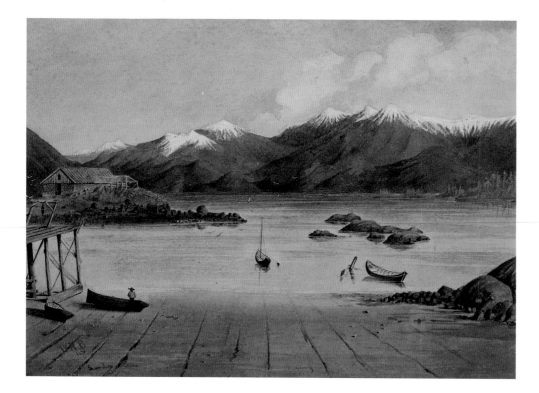

29. W. H. Bell, *Low Tide at Sitka*, 1870
Watercolor and gouache on paper,
25 × 35 cm; Joint purchase, Anchorage
Museum Association and Municipal
Acquisition Fund, 90.20.1

engaged with the Western Union telegraph expedition of
1865–66. Whymper spent August 8–22, 1865, in the town
and was as intrigued by its picturesque character and his
party's reception by the Russians as he was dismayed by the
rainy weather:

> The colouring of the town is gay, and the surroundings
> picturesque. The houses yellow, with sheet-iron roofs
> painted red; the bright green spire and dome of the Greek
> Church, and the old battered hulks, roofed in and used
> as magazines, lying propped up on the rocks at the
> water's edge, with the antiquated buildings of the Rus-
> sian Fur Company, gave Sitka an original, foreign, and
> fossilized kind of appearance . . . [but] Sitka enjoys the
> unenviable position of being about the most rainy place
> in the world. Rain ceases only when there is a good
> prospect of snow. (Whymper 1868, pp. 74, 75)[2]

Henry Elliott, too, made note of southeast Alaska's noto-
rious rainy weather. In an inscription appended to a water-
color of Sitka, Elliott described missing his southbound ship
from the town, in October 1866, and engaging an Indian
canoe to take him back to Victoria, British Columbia, a
twenty-one-day trip during which it rained continuously
(Shalkop 1982a, p. 10).

Vincent Colyer made watercolor sketches while in Sitka
in September 1869, following his appointment as special
United States Indian commissioner. And when the Harriman
expedition stopped in Sitka three decades later, Frederick
Dellenbaugh painted the old Russian trading post there on
June 17, 1899.

Tourists, Travelers, and Part-time Painters

Other amateur and professional artists who visited Sitka for a
variety of reasons soon after the purchase turned out notewor-
thy pictures. One of the museum's earliest and most interest-
ing is a watercolor attributed to Brevet Major W. H. Bell, *Low
Tide at Sitka* (no. 29). Bell was chief commissary officer of the
United States Army post in Sitka in 1870. The little that we
know of him comes from the journal of Sophia Cracroft, who
accompanied Lady Jane Franklin to Sitka in 1870.[3] Major Bell
gave Lady Franklin a watercolor sketch of the Russian Church
in Sitka, and Miss Cracroft borrowed his sketchbook of Sitka
scenes to make drawings for her own journal. She was im-
pressed with his work:

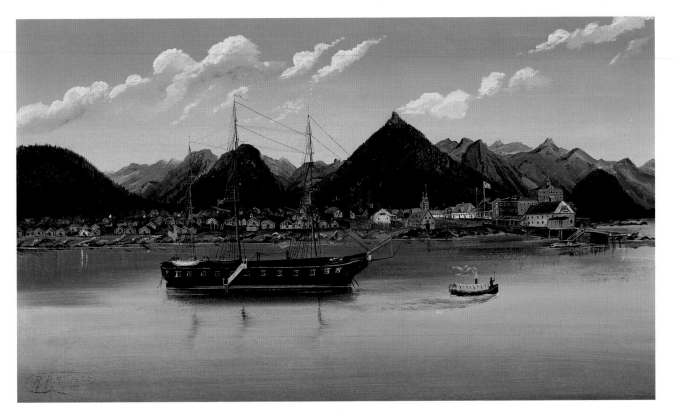

30. Richard Peter Smith, *Untitled* (USS *Jamestown* at Sitka), 1880
Oil on canvas, 40.7 × 71.5 cm; Joint purchase, Anchorage Museum Association
and Municipal Acquisition Fund, 90.32.1

Thence we went to the Quarters of Major Bell, close by and found Mrs. Bell also at home. She too had a fire, but it was neither large nor blazing up, and the room was only pleasant. Major Bell came in before we left and shewed us his sketches, some of wh. are very interesting. He gave my aunt a water colour drawing of the Russian Church and some other houses adjoining it, including ours. I shall make a reduced copy for my next page. I wish I had some others he has taken of this and other places. (DeArmond 1981, p. 20)[4]

An equally rare early view of Sitka is the untitled oil of the USS *Jamestown* in Sitka Harbor by Richard Peter Smith (no. 30). Smith, who was born in Magdeburg, Germany, about 1855, enlisted in the American navy in 1878 and was stationed aboard the USS *Jamestown* when it was posted to Sitka in 1880. Another picture by Smith of the *Jamestown*,

with the Native village in the background, was given to the ship's master, Frank Guertin, and is now in the collection of the Sitka Historical Society (DeArmond 1989, p. 3).[5]

An oil painting from the same period, *Sitka, Alaska,* is from the hand of Walter B. Styles, who lived in Sitka and Hoonah from 1880 until about 1885 (no. 31). Styles arrived in Sitka in March 1880 as a suitor of Henrietta Austin, daughter of Alonzo Austin, a missionary. After marrying, they both worked in the nearby village of Hoonah as missionary-teachers and then joined the staff of Sheldon Jackson School. Walter Styles also served as Sitka's postmaster for two years, after which the couple left Alaska and returned to the East Coast. In New York, Styles did illustrations for *Frank Leslie's Illustrated Newspaper, Harper's Weekly,* and *Scribner's Magazine* (DeArmond 1989, p. 4).

Although little is known about Styles's activities before or after his stint in Alaska, his northern images have appeared

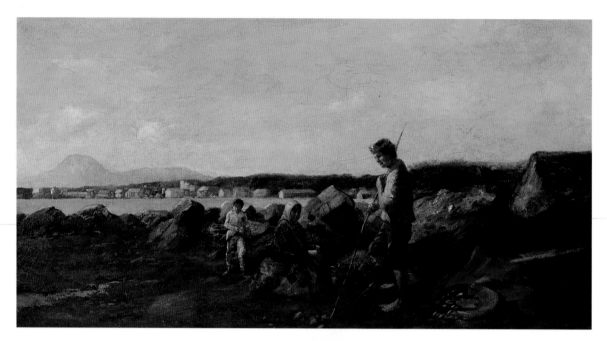

31. Walter B. Styles, *Sitka, Alaska,* ca. 1890
Oil on canvas, 33.2 × 64.1 cm; Gift of Dr. and Mrs. Lloyd Hines, 76.29.1

widely. The famous naturalist John Muir, who was a knowl-edgeable friend of many of the most prominent landscape painters of the day, evidently admired Styles's work. A photo-gravure after a Styles painting of Mount Fairweather and Mount Crillon, in the Glacier Bay area, appeared in 1888 in Muir's *Picturesque California and the Region West of the Rocky Mountains from Alaska to Mexico . . . ,* along with several other reproductions of Styles's southeast Alaska images.[6] The photo-gravure depicts a Tlingit canoe with hunters pursuing seals on a drifting ice floe.

In addition to the wood and steel engravings that Styles produced for East Coast periodicals, his Alaskan paintings con-tinue to surface.[7] Although the quality of his work was some-what uneven, his paintings of Native Alaskan people have been praised for their avoidance of the stereotypes so common in the work of the earlier artist-explorers. His careful documenta-tion of Native costumes, boats, and dwellings has been com-pared to that of the important nineteenth-century American artist William Sidney Mount (Gerdts 1990, p. 218).

Many other artists' early views of Alaska appeared in the pages of East Coast periodicals in the final decades of the cen-tury. One whose work was published in *Harper's Weekly* in 1884 is Charles Graham (1852–1911; no. 32).

Much of the information about artists in Sitka in the years following the purchase comes from brief news items in the weekly Sitka newspaper of the time, *The Alaskan.* Edward L. Chamberlain (d. 1910) went to Sitka in 1886 to serve as busi-ness manager for that paper, and he lived in Sitka until his death. Among his many talents—in 1901 Chamberlain ran an advertisement offering his services at everything from deed and lease preparation to bookkeeping, elocution lessons, and sign painting—he was a skilled watercolorist (DeArmond 1989, p. 5). Although Chamberlain cannot be considered a tourist, given his twenty-four years in Sitka, the relatively few surviv-ing watercolors by him have more in common with the work of Sitka's early visiting artists than that of the later, more recognized resident painters (no. 33).

The Lure of Gold
As the century neared its close, more and more gold miners were passing through southeast Alaska on their way to the Klondike gold fields, Nome, and elsewhere. Among the artists

32. Charles Graham, *Untitled* (old Northwest Coast Indian house), ca. 1883
Watercolor on paper, 46 × 35.8 cm; Gift of the Anchorage Museum Association, 84.27.1

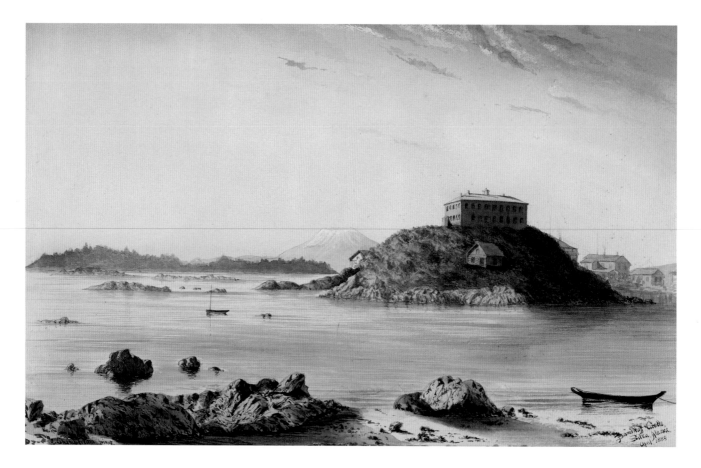

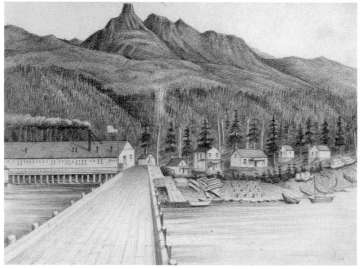

33. Edward L. Chamberlain, *Baranoff Castle,
Sitka, Alaska, April 1889,* 1889
Watercolor and pencil on paper, 26.5 × 41.7 cm;
Municipal Acquisition Fund purchase, 83.63.2

34. George Ogrissek, *Orca, Alaska, Cordova Bay,* 1898
Pencil on paper, 14.5 × 20.2 cm; Municipal Acquisition
Fund purchase, 83.123.12

35. Julius Ullmann, *Bonanza,* 1899
Pencil and ink wash on paper, 36.9 × 52.4 cm; Gift of Mrs. Garland Bell, 85.48.10

who traveled Alaska's coast beyond the Panhandle whose work has survived is George Ogrissek. In 1983 the Anchorage Museum acquired thirteen small pencil drawings done by Ogrissek while on board the steamship *Dora.* Little is known about the artist other than the fact that he was in Alaska to mine gold between 1898 and 1902, but the drawings are delicately rendered and exquisitely detailed, as evidenced by *Orca, Alaska, Cordova Bay* (no. 34). The settings range from Sitka and other southeast Alaska ports to Yakutat, Cordova, Dutch Harbor in the Aleutians, and Cape Nome on the Seward Peninsula. Besides landscapes and seascapes, Ogrissek's subjects include Native villages, churches, and fish-processing factories. Many of the drawings have inscriptions identifying particular buildings and even the time of day in which they were made. Taken together, Ogrissek's drawings provide a delightful travelogue of settings and activities along much of the Alaskan coast.

Julius Ullmann (1863–1952), a German artist in the Klondike, was also lured north by gold. The museum owns twenty-four oils, watercolors, and drawings by Ullmann (no. 35). A number of the pen and ink drawings are political cartoons, which appeared in the *Dawson Daily News* in 1902. Other drawings and watercolors show the mining areas of the Klondike, and some of the oil paintings depict a trip down

the Yukon. The latest images date to 1910 and are from the Juneau area. Ullmann later moved south and worked in Seattle (*Anchorage Museum of History and Art Newsletter,* November 1985).

Early Full-time Painters

With the exception of those artist-explorers who were engaged specifically to make documentary images, the artists we have so far examined did not go to Alaska to paint. However talented they may have been, and despite the fact that many of them had formal training, they did not see themselves primarily as artists. They went as government officials, entrepreneurs, journalists, miners, and missionaries to pursue a host of vocations, and their art work remained in almost all instances an avocation.

But in the last decades of the nineteenth century, the first artists traveled to Alaska specifically to paint its dramatic scenery and, in some cases, what were still considered its "exotic" Native people. We continue to discover with each passing year new artists of local, regional, and even national reputation who made one or more trips to Alaska to see the grand, new, still largely unexplored land that was so much in the news of the day.

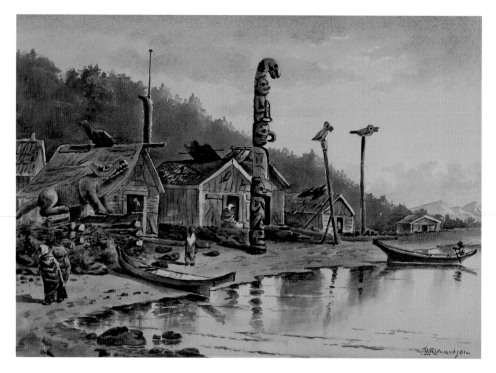

36. Theodore J. Richardson, *Untitled* (Wrangell Indian village), ca. 1900
Watercolor on board, 25 × 35 cm; Gift of the Rasmuson Foundation, 74.52.1

37. Theodore J. Richardson, *Untitled* (glacial bay), ca. 1900
Pastel on paper, 25.7 × 38 cm; Gift of Len and Jo Braarud, 89.14.16

By the 1880s, a traveler such as the young Minnesota artist Theodore J. Richardson (1855–1914) could cruise by steamer up the Inside Passage to Sitka, and there visit and paint the Native people and landscape in leisurely comfort. A photograph in the collection of the Minneapolis Public Library shows the artist contentedly seated in a rowboat on the calm waters of a southeast Alaska fjord, under the shelter of a propped umbrella, at work on a watercolor landscape.[8] Between his initial visit in 1884 and his death in 1914, Richardson became Sitka and southeast Alaska's most faithful and prolific visiting artist.

Richardson was born in Readfield, Maine, grew up in Minnesota, and settled in Minneapolis. He traveled to California and painted frequently there (he married his wife, Flora, who was also an artist, in Monterey), but he is best known for his Alaskan watercolors.[9] Specializing in coastal landscapes and views of tidewater glaciers, Richardson also painted the Native houses, totem poles, and people of southeast Alaska. The museum owns four oil paintings, fifteen watercolors, and twelve pastels by this talented, regular visitor to the territory.

Seen in the context of earlier representations, Richardson's images of Native villages and people are especially enlightening (no. 36). Although Richardson and his contemporaries in late nineteenth-century Alaska at first depicted Native Alaskans in much the same way as did their predecessors, the nature of that representation gradually changed. Like many other artists working during the period of the rapid acculturation of Native Alaskans, Richardson sought and portrayed scenes in which the Natives' dress, housing, and activities were as traditional, as picturesque, or as "exotic" as they had appeared a century before. But by the end of the nineteenth century, traditional Native culture was clearly imperiled, and a conscious process of selective vision was necessary in order to find and portray the Native Alaskan in such a manner. Increasingly, the adjective used by artists and narrators to describe Native people engaged in traditional activity was not "uncivilized," but "unspoiled."

Perhaps in part for this reason, Richardson's more frequent focus on the landscape itself was typical of visiting artists of the period. Whereas in the first century of contact unfamiliar Native cultures had attracted the attention of explorers, and the dramatic landscape frequently served as a mere backdrop for documentary, ethnographic portrayal, by the mid-nineteenth century more and more artists began to focus on the

equally astounding landscape (no. 37). This shift in emphasis is also simply reflective of the changing stylistic preoccupations of artists in America and abroad. The mid-nineteenth century saw the great flowering of the American landscape painting tradition, and energetic, ambitious artists visiting the territory were well aware of such developments and eager to adapt the new styles to the Alaskan landscape.

Richardson grew up in Red Wing, Minnesota, where his early talent caught the eye of his teacher at Winona Normal School. On the strength of the school's promise to hire him as an instructor of drawing, penmanship, and geometry upon graduation, his family was encouraged to send him to Boston Normal Art School for further training. After a brief stint back at Winona, the artist moved to Minneapolis to teach drawing in the public schools and served as supervisor of drawing from 1880 to 1893. Because Richardson remained devoted throughout his career not only to his art but to his teaching, he has been praised in extravagant terms as a positive force in the development of the fine arts in Minneapolis.[10] Richardson was a founding member of the Minneapolis Society of Fine Arts, which was a catalyst for the development of the Minneapolis Institute of Fine Arts.

Painting farther and farther afield from Minnesota during his summers, Richardson journeyed to Alaska in 1884 at the urging of a friend who advanced him the money for the ticket, knowing that the artist could sell his sketches and repay the loan promptly at summer's end (Crane 1915, p. 20). Southeast Alaska seems to have been the perfect place for the flowering of Richardson's talents. He visited nearly every summer thereafter and produced a prodigious volume of work. On at least one occasion, he also conducted a watercolor class in Sitka at the request of a group of women from the town.

The artist was clearly well liked and respected in Sitka. On his return to Sitka in the summer of 1902, after not visiting the community between 1896 and 1901, when he and Flora traveled and studied art in Europe, he was greeted by a reception at the capitol. He was feted at dinner parties throughout his several weeks' stay and seen off by a farewell picnic at Sitka Harbor to which the entire town was invited (DeRoux 1990, p. 11). Frequent praise in the local papers for his art and regular accounts of his comings and goings over the years are further testimony to his positive reception among the Alaskans.

After his studies in Europe, Richardson turned increasingly to oil painting. He remains best known, however, for his

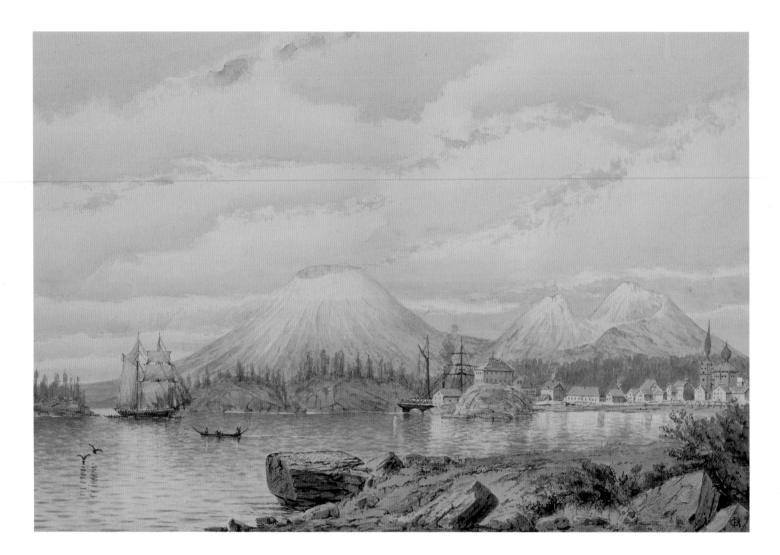

38. Cleveland S. Rockwell, *Untitled* (view of Sitka), ca. 1884
Watercolor on paper, 34.9 × 49.8 cm; Gift of the Anchorage Museum Association, 86.24.1

deft watercolors and pastels, media well-suited to the light, transparent qualities of water, ice, mist, and sky to which he was so attracted. Although he was able to achieve a full range of color in depictions of the often gray, subdued landscape of southeast Alaska, there is in his landscapes a pervasive blue tone that renders his work readily recognizable. Undoubtedly because of Richardson's predilection for blue, his friend the travel writer Eliza Ruhamah Scidmore favored the nickname "Cobalt." In an article for *California Illustrated* magazine, Scidmore tells of embarking in company with Richardson on a trip to Glacier Bay: "Cobalt has minimized his possessions, but was taking all the blue paint he had brought to and could find in Sitka, staking recklessly on this supreme chance to tear the color secrets from the glacier's heart and live up to Nature's most stupendous effort in blue and white" (Scidmore 1894, p. 537).

Richardson's pervasive use of blue and tendency to revisit the same image many times over the years occasionally threaten to make his prolific landscape oeuvre monotonous. But a closer look invariably reveals welcome surprises: warm roses, oranges, and yellows of surprising intensity. Moreover, the artist's many complex scenes of Tlingit house interiors are filled not only with architectural details and a panoply of Native objects, but with a full, rich chiaroscuro. These images demonstrate that his painterly range was wide and that his vision could encompass both the complexity of settlement and the drama of wilderness.

Another artist who came to southeast Alaska in 1884, the year of Richardson's first visit, was little known as an artist at the time but is much respected today. Cleveland S. Rockwell (1837–1907) was chief of the northwest section of the United States Geodetic Survey when he made his tour of Alaska's southern coast. Rockwell was a highly regarded mapmaker who had surveyed the fifty miles of the Oregon coast south of Astoria as well as the Columbia and Willamette rivers to Portland (Stenzel 1963, p. 20). During his Alaskan trip, as on all his travels, he found time to make topographically accurate and exquisitely rendered watercolors of the region.

Born in 1837 in Youngstown, Ohio, Rockwell received early training in art and engineering. He was a mapmaker for the Union Army in the Civil War, after which he made a brief mapping tour of South America, then settled in Portland, Oregon. He conducted surveys in Alaska, British Columbia, California, and Oregon. Although he did not become a full-

time painter until his retirement in 1892, the many sketches he made on his expeditions served as the basis for his later oil and watercolor paintings. He exhibited regularly in San Francisco and Portland and was a founding member of the Portland Art Club.

Rockwell's background in mapping and surveying influenced his work (no. 38). His rendering is tight and accurate, with attention to detail and subdued color. His observations have been described as acute:

> The topographical influence in Rockwell's paintings is unmistakable. . . . Each mountain, tree, and even each rock on the beach is precisely defined and shaped. In a sense it is almost a photographic image that is being shown. Rockwell did not try to generalize or romanticize. His intention was faithfully to record what he saw and knew. (Render 1974, p. 79)[11]

Rockwell nevertheless achieves more than a dry verisimilitude. Despite the accumulation of detail, his touch is light and sure, never labored, and he combines the luminosity we see in Richardson's work with extraordinary accuracy of light, color, and documentary detail. His are perhaps the finest nineteenth-century watercolors of southeast Alaska.[12]

Better known than Richardson and Rockwell at the time was the painter James Everett Stuart (1852–1941). Stuart was a highly successful artist in his day. The grandson of the American portrait painter Gilbert Stuart, he was a well-known figure in the landscape painting community at the turn of the century, and his commercial success enabled him to travel at will and live in a grand style. Much ado has been made of his "invention" of a method of painting on aluminum, a technique he hoped would prove indestructible but which proved to be neither practical nor more stable than work on canvas (Stenzel 1963, p. 26).

Stuart was born in Dover, Maine, and moved with his family to the Sacramento area when he was eight. After lessons with Sacramento artist David Woods, he studied at the San Francisco School of Design (later the California School of Fine Arts) with Virgil Williams and R. D. Yelland. In 1881 Stuart established his first studio, in Portland, Oregon, where he produced scenes of the Pacific Northwest, including all the major peaks of the Cascade Range. In the winter of 1886 he set up a studio in New York, at 145 West 55th Street, and worked there until 1890. During this time, the artist also painted in

39. James Everett Stuart, *Extreme End of Indian Town, Sitka, Alaska,* 1891
Oil on canvas, 61 × 106.4 cm; Joint purchase,
Anchorage Museum Association and Municipal Acquisition Fund, 74.7.1

the Yellowstone region in the summers. In 1892 he established a studio and gallery in Chicago. He returned to San Francisco in 1912 and opened a large gallery and studio on Geary Street, across from Union Square. Stuart remained a resident of San Francisco until his death (Fielding 1965; Dawdy 1985; Hughes 1986; Samuels and Samuels 1985).

Stuart made several trips to Alaska beginning in 1891. Working more often in oils than in watercolor, he was even more prolific than Richardson. The museum's nine oils by the artist depict scenes in southeast Alaska and Prince William Sound and date from 1891 to 1921.[13] Although the quality of Stuart's work is quite uneven, a few of his best paintings approach the level of the major landscape painters of the day: his *Extreme End of Indian Town, Sitka, Alaska* is a fine example (no. 39). Much of his work, however, is unremarkable. A significant number of his small oils clearly were done quickly, almost by formula, for what seems to have been a ready market, and most of his very large paintings are overblown. Without the requisite finesse to carry off the mammoth scale, the artist often produced canvases that are almost lurid in an overeagerness to achieve grandeur.

In contrast to Theodore Richardson, who rarely dated his work, Stuart seemed almost obsessed with documentation of the particulars of his views. On the back of most paintings he noted in his florid hand substantial information about the location, the identification of prominent landscape features, the exact day the scene was painted, and often the price that he expected the work to fetch.

Major American Painters in Search of Scenery

At about the same time that Theodore Richardson and Cleveland Rockwell were making their first visits to southeast Alaska, and even before James Everett Stuart's arrival, several of the country's leading landscape painters made single journeys to Alaska specifically to paint. In 1886 and 1887, prominent California painters William Keith (1839–1911) and Thomas Hill (1829–1908) visited southeast Alaska. They were followed in 1889 by the even more famous Albert Bierstadt (1830–1902).

WILLIAM KEITH'S DREAMS OF ALASKA

William Keith and Thomas Hill were perhaps the most highly regarded painters in California in the late nineteenth century and major national figures in landscape painting. Born in

Scotland, Keith came to New York at the age of eighteen and was apprenticed to a wood engraver. After moving to California in 1862, he set up his own engraving business. In 1864 he opened a studio and began exhibiting paintings in San Francisco. About 1868 he was commissioned to produce a series of scenes along the course of the Northern Pacific Railroad, a body of work that included views of the Columbia River and major peaks of the Cascade Range.

Keith studied in Düsseldorf in the late 1860s and then shared a studio in Boston with William Hahn from 1871 to 1872. He returned to California in 1872 and became famous for his monumental, spectacular California landscapes. From 1883 to 1886 he studied in Munich. His experience in Munich and his contact with the painter George Inness after 1890 influenced him to undertake work more subjective and more subdued in color, detail, and mood. He died in Berkeley in 1911. Keith's work is represented in the collections of most major American museums.[14]

Drawn to Alaska by the urging of his friend John Muir, the artist took a cruise along its southeastern and south-central coasts in the summer of 1886 to paint the landscape. A year after his return to San Francisco, he exhibited at the Bohemian Club the paintings that resulted from the trip, including *Cordova Bay, Prince William Sound* (no. 40).[15] What a contrast to the work of Richardson, Rockwell, and Stuart is this soft-focus image of a quiet cove in the sound. Not only are the color and tonal range subdued, but the paint is handled in a loose, relaxed, sure manner that ignores detail for overall effect. Similar in setting to paintings by earlier artists in Alaska, it bears little formal resemblance to any of their works. However small and quiet it seems, this painting chronicles a change in the way artists would see and deal with the Alaskan landscape.

Although Keith's brief Alaskan sojourn plays a small part in his long and illustrious career, it came at a crucial juncture for the artist. Keith's work changed gradually but dramatically over the course of his long career, from light, airy, topographic canvases to dark, subdued, subjective oils. The 1886 trip to Alaska almost immediately followed Keith's return to America from Munich, where his studies had reinforced his growing desire to paint in a broader, moodier, more evocative style. He was at this time influenced more by the French Barbizon painters than by his contemporaries Thomas Hill, Albert Bierstadt, and Frederic Church. The late 1880s in fact are sometimes characterized as a watershed period for the painter,

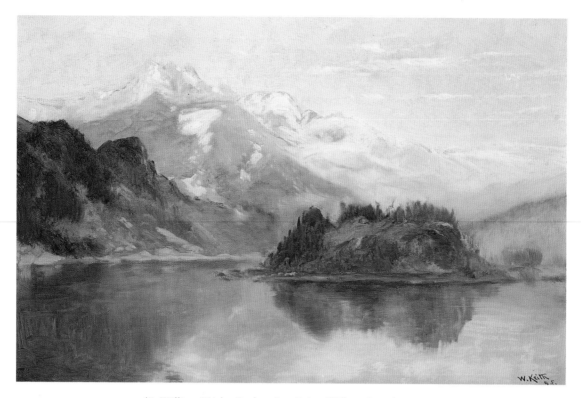

40. William Keith, *Cordova Bay, Prince William Sound,* ca. 1886
Oil on canvas, 41 × 61.1 cm; Gift of the Rasmuson Foundation, 80.115.1

after which his work is increasingly compared to that of the American Barbizon painters and Tonalists.

It is perhaps significant in this regard that Keith called his 1887 exhibition at the Bohemian Club "Dreams of Alaska." As noted in the catalogue of a recent retrospective exhibition of Keith's work, "From this title we are to infer that these paintings are not close transcriptions of actual scenery but fantasies of a poetical nature inspired by Alaska" (Harrison 1988, p. 30). If this is true—and examination of the paintings certainly supports such a reading—these may be the first Alaskan paintings to be inspired by, rather than simply descriptive of, the magnificent northern coastal landscape. Although earlier painters certainly took interpretive liberties with the colors and forms they regarded, we see in Keith's work the beginnings of a primary interest in capturing on canvas the spirit of the Alaskan landscape as opposed to its topography. Although some time passed before Keith's example was followed and expanded, it represented a major break from the documentary tradition in landscape paintings of Alaska.

Thomas Hill in Glacier Bay

One year after William Keith visited Alaska, his famous contemporary and sometimes rival, Thomas Hill, arrived. In his day Hill was challenged only by Keith as the most successful painter of spectacular landscapes of California.[16] Although Hill is best known for his paintings of the Yosemite Valley in California, he was also widely admired for his views of regions as diverse as the Pacific Northwest, the Yellowstone area, the White Mountains in New Hampshire, and Alaska.

Hill was born in Birmingham, England, in 1829. At the age of fifteen, he and his family moved to the United States and settled in Taunton, Massachusetts. During the next few years, Hill worked as a carriage painter and ornamental painter in Taunton and Boston. He married in 1851. He studied at the Pennsylvania Academy of the Fine Arts in 1853 and began painting in the White Mountains the following year. Hill's eastern painting is often overlooked by those who remember him only for his epic western canvases, but the artist exhibited actively in Boston and was a member of the White Mountain

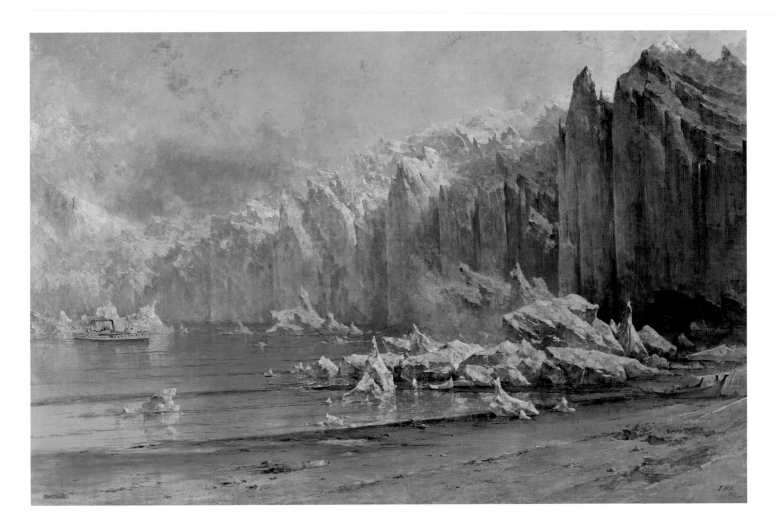

41. Thomas Hill, *Muir Glacier*, 1889
Oil on canvas, 154.9 × 241.2 cm; Joint purchase,
Anchorage Museum Association and Municipal Acquisition Fund, 76.50.1

group of painters, which included such eminent figures as Albert Bierstadt, Benjamin Champney, Asher B. Durand, and George Inness.

Early in his career Hill gained notice for the magnitude of his artistic output, a quality for which he was later both admired and reviled. Champney said of him:

> Thomas Hill has all the faculties of Bierstadt, and can make more pictures in a given time than any man I have ever met. In one afternoon of 3 hours in the White Mountain forest I have seen him produce a study, 12 × 20 in size, full of detail and brilliant light. There is his great strength, and his White Mountain wood interiors have not been excelled. (Champney 1900, pp. 145–46)

In later years, however, the same prolific nature caused him to be described as "in wait for the moneyed tourists, his supply of Yosemites as inexhaustible as their demand" (Larkin 1949, p. 237).

In failing health, the artist moved to San Francisco in 1861 in search of a milder climate. He made his first trip to Yosemite a year later, accompanied by William Keith (Arkelian 1980, p. 13), and painted landscapes throughout Yosemite Valley and the Sierra Nevada range. After studying in Paris in 1866–67, he resettled in New England, although he continued to paint California scenery in his Boston studio. Again experiencing problems with the cold, wet New England climate, Hill moved his family back to San Francisco in 1871.

Hill hit his artistic stride in California during the 1870s. With Frederick Whymper (see chapter 1), he was a founding member of the San Francisco Art Association. He became a member of the Bohemian Club in 1873. His paintings continued to bring higher prices in the 1870s, and he was a wealthy man by 1878. Soon thereafter, however, hard times fell upon the artist, as they did on the San Francisco economy and art market in general, and he struggled through the next decade, moving back and forth to paint in the White Mountains of New Hampshire and his beloved Yosemite Valley in California. During these years he was still acclaimed but experienced increasing financial distress.

When Hill's longtime friend and fellow artist Virgil Williams, director of the California School of Fine Arts, died in late 1886, Hill agreed to take over as director without compensation. By the following summer, running the school had become more than he could handle. John Muir and Alaska provided the means of escape. Muir, who normally preferred the landscapes of his friend William Keith, commissioned Hill to paint Muir Glacier in Glacier Bay, "because he could paint ice better than Keith" (Arkelian 1980, p. 33). Apparently without giving notice, Hill left his position at the School of Fine Arts in the summer of 1887 and took off on a cruise to Alaska that resulted in a number of Alaskan and Canadian coastal pictures.[17]

The commissioned painting of Muir Glacier that Hill completed in the winter of 1887–88, now in the collection of the Oakland Museum, bears a striking resemblance to the Anchorage Museum Muir Glacier painting of 1889 (no. 41). The Anchorage painting is almost exactly twice the size of the earlier version, but the two canvases are remarkably similar in composition: both portray the glacier and foreground beach, in a virtually identical fashion, and a distant steamship in the bay. One difference in the Oakland painting is the foreground group of well-dressed figures disembarking from a rowboat: in the later painting, the beach is empty.

Hill's *Muir Glacier* is certainly the grandest nineteenth-century painting and most important work by a major artist of the period in the Anchorage Museum collection. A smaller Hill painting based on the same trip is also in the collection, a studio construction entitled *Indian Canoes near Muir Glacier.*

Hill's fortunes continued to vacillate until 1896, when he suffered the first of a series of strokes from which he never fully recovered. The artist died in 1908. Although the kind of work done by both Thomas Hill and William Keith has been out of favor for most of this century, the quality and importance of their painting have been rediscovered in the past generation.[18]

Albert Bierstadt in Southeast Alaska

The most famous nineteenth-century artist to visit Alaska was Albert Bierstadt. At the height of his career in the 1860s and 1870s, Bierstadt was perhaps the most successful and renowned painter in America (only Frederic Church seriously rivaled his acclaim), and his huge, romantic, immensely popular paintings of the Rocky Mountains and the American West played a strong role in encouraging westward expansion. Sadly, Bierstadt lived long enough to see his romantic, grandiose, highly detailed paintings of the western landscape go out of favor, replaced by more adventurous, modern sorts of painting, and he died an all but forgotten figure.

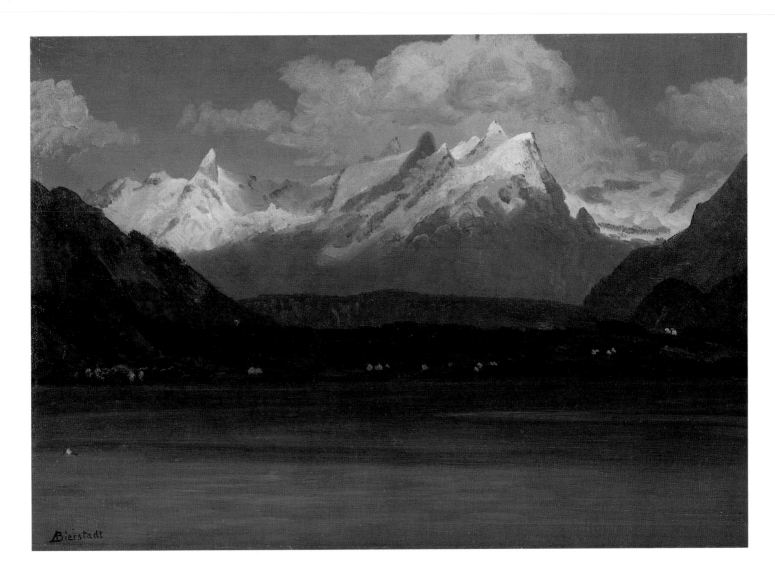

42. Albert Bierstadt, *Untitled* (coastal mountains), ca. 1889
Oil on paper, 33.8 × 48.8 cm; Gift of the Anchorage Museum Association, 86.18.1

Bierstadt's work has again been lionized in this century, only to be reattacked more recently as an embodiment of the American capitalist spirit that led to rapacious development of the West and devastating consequences for Native American cultures. The roller coaster of Bierstadt's reputation, the result of changing political climates as much as stylistic fashion, is ultimately irrelevant to his Alaskan work. His stay in Alaska was brief, it came well after the height of his prominence, and he did not produce work of major significance in his overall oeuvre while there. He did, however, add some fine paintings to the growing number of images of Alaska produced in the late nineteenth century by America's best landscape painters.

The painter was born near Düsseldorf, Germany, in 1830, but grew up in New Bedford, Massachusetts, from the age of two. He returned to Düsseldorf in 1854 for three years' study, and on his return to New Bedford joined other well-known landscape painters of the day in the White Mountains of New Hampshire. The watershed event in Bierstadt's career took place in 1859, when he was invited to join the Lander survey expedition to the Pacific. He was overwhelmed by the mountains of the West, and went on to found his career and reputation on enormous, romantic images that made the region seem even more glorious than its impressive reality.

Bierstadt's rise to fame and fortune with the exhibition of his first large-scale Rocky Mountain pictures was swift. Such paintings as *Rocky Mountains, Landers Peak* (Metropolitan Museum of Art, New York), shown at the Sanitary Fair in New York, strongly influenced Americans' perceptions of the West:

> Without a doubt, Bierstadt had become [by the mid-1870s] the most popular Western painter of his era, yet, perhaps most importantly, his vision and imagination shaped America's attitude towards the West. When New Yorkers who had attended the Sanitary Fair of 1864 thought of the West, they thought of Bierstadt's magnificent vision of the Rockies—they imagined it a place of quiet lakes, grand waterfalls, and peaks which rose to heights rivalling the Alps in scale and beauty. No matter that these images were pieced together from multiple views, sketches, and even stereoscopic pictures. They represented the very essence of the West of the imagination—a West that embodied a sense of sublime scale, of naturalistic wonder, of geological drama, and nationalistic pride which no photograph, not even one by

Watkins or Muybridge, could capture. (Goetzmann and Goetzmann 1986, p. 167)

But that level of success was relatively short-lived. By the early 1880s, Bierstadt's fortunes were waning as the art-loving public turned increasingly to more modern modes of expression. One of the most grievous blows came from his fellow artists when the American selection committee for the Paris Universal Exposition of 1889 rejected his huge painting *The Last of the Buffalo* (Corcoran Gallery, Washington, D.C.). Only a few months after this unexpected refusal, the artist traveled west by train from his home in New York to Victoria, British Columbia, and then north on the steamer *Ancon* to Alaska.

Neither Bierstadt nor the other passengers of the *Ancon* could have known that it would be the ship's last journey. After stopping at Juneau, Fort Wrangell, and Sitka and touring Glacier Bay, the ship returned to the village of Loring, near present-day Ketchikan, on August 28. On departure, the *Ancon* drifted onto a reef in a falling tide and was pierced amidships and irretrievably wrecked (Roppel 1975, pp. 171–72). Bierstadt's *The Wreck of the Ancon, Loring Bay, Alaska* (Museum of Fine Arts, Boston), which depicts the *Ancon* listing helplessly just offshore, is certainly the best-known and most widely reproduced painting of Alaska.

While awaiting the next steamer, Bierstadt wrote to his wife, Rosalie, "I am busy all the time and have sixty studies in color and two books full of drawings of Alaska."[19] Only a very few of these studies have come to light. The Anchorage Museum painting is of an unidentified location on the coast of southeast Alaska (no. 42).[20] The fresh, vigorous brushwork and perception of the sketch are typical of Bierstadt's smaller-scale scenes from nature, which, despite their small size and informality, are often praised as his most accomplished work. Eminent art historian Edgar P. Richardson has been quoted as saying that if he had to reassess Bierstadt's work today, "I would concentrate on the marvelous freshness of eye shown in Bierstadt's sketches from nature. He was a remarkable observer of air, light and the feeling of a place—all set down with superb skill in his sketches" (Hendricks 1988, p. 10).

Early Twentieth-Century Visitors

Prominent and lesser-known American artists continued to flock to Alaska after the turn of the century. The list of artists who we know visited Alaska in the years just before and after

43. Leonard Moore Davis, *Untitled* (coastal mountains), 1915
Oil on canvas, 46.2 × 61.3 cm; Joint purchase,
Mr. and Mrs. Charles A. Schmelzenbach and Municipal Acquisition Fund, 81.31.1

the turn of the century continues to grow, and the museum continues to search for outstanding examples of their work. Two of the more notable visitors in the final years of the nineteenth century were Sanford Robinson Gifford, who made a sketching trip in 1874 to the Pacific Northwest and Alaska, and Joseph Henry Sharp, who traveled as far north as Skagway in 1900, sketching Indian leaders. One of the most famous American painters of the Arctic, New Bedford artist William Bradford, is known to have painted in the Pacific Northwest, and fresh assertions of an Alaskan visit by the artist arise every few years but are so far unproven.

Artists involved with the various turn-of-the-century Alaskan and northwest Canadian gold rushes also continue to be discovered, or rediscovered. Edwin Tappan Adney, an artist and writer, was sent to the Klondike as a correspondent for *Harper's Weekly* in 1897–98 and was a gold rush correspondent for *Collier's* at Nome in 1900.[21]

Among the excellent but lesser-known painters who worked in Alaska in the first years of the new century is Salt Lake City artist H. L. A. Culmer. He sketched and painted the coast of southeast and south-central Alaska as far north as Prince William Sound in 1911, and rode the length of the Copper River and Northwestern Railway into Chitina and McCarthy, traveling in a little passenger car outfitted as a cabin and studio (Riley 1911). Santa Barbara artist Lockwood de Forest painted coastal scenes in southeast Alaska and Prince William Sound in the summer of 1912. The following year, de Forest showed work based on that trip in Santa Barbara as well as at the Saint Louis Art Museum and the Heron Art Institute in Indianapolis.[22]

Other painters in early twentieth-century Alaska, some more prominent than others, are well-represented in the museum's collections. One of the most frequent visitors and prolific painters of the period was Leonard Moore Davis

(1864–1938), who is represented by five oil paintings (no. 43). A 1913 periodical pronounced Davis "A Great Artistic Interpreter of the Frozen North." The article continues:

> Alaska and the lands of the Midnight Sun have found memorable representation in the paintings of Leonard M. Davis. Alike in the East and in the West, Mr. Davis's reputation is growing. When his pictures were shown last year in Seattle, *The Daily Times* of that city published an editorial extolling him as "one of America's masters of the brush." David Paul, the art-critic of the same paper, called him "the first great and truthful interpreter of our far Northern scenery." (*Current Opinion* 1913, p. 274)

Such praise, if a bit hyperbolic in light of Davis's known paintings, nevertheless indicates a warm reception for Davis's canvases not only in Seattle but in the East as well. The same article quotes the *New York Evening Post* as comparing the color of his Alaskan canvases exhibited at the American Museum of Natural History with that of J. M. W. Turner, and cites the *New York Herald* as praising the same exhibition.

Leonard Davis was born in Massachusetts in 1864 and moved to New York at the age of eight. After working as a printer and wood finisher until 1884, he studied at the Art Students League and at the Académie Julian in Paris in 1889. On his return to the United States, he seems to have followed the route of many other adventurous young men of his day and gone to Alaska in search of gold. Taking a steamer directly to Saint Michael, he proceeded upriver to Anvik and then made his way overland to Rampart during the winter of 1898. He lived intermittently in Alaska over the next six years, mining gold and painting, and visited the territory regularly thereafter.

Like William Keith before him, Davis seems to have been intent on capturing the spirit behind the landscape. Working almost entirely with the palette knife rather than brushes, he was more interested in the feeling of the northern wilderness than in its topographic details. Davis said about his intent: "I have struggled . . . for the snap, and the atmosphere, for the spirit of things as they are—for the true impression of the scenic wonders of the North, for the greater glory of Yukon and Alaska . . . expressing a higher spiritual sense, which is the goal of the true artist, rather than the making of pictures" (*Current Opinion* 1913, p. 275). This distancing of himself from the craft that he studied, in the service of responding more directly to the spirit of the landscape, is both Davis's weakness and his strength, as a contemporary review testifies:

> The novelty of color and subject matter of these unknown Northern landscapes have captivated a certain section of the public that is always eager to welcome whatever is different from the general run of things. And Mr. Davis knows his field so well, is so thoroughly saturated with the grandeur and glamor of his unusual subject, that his rendering of it carries more conviction than would the work of an abler painter less familiar with the country depicted. There is something of the stark truthfulness and natural dramatic quality of an uncouth narrative in these portraits of "The Palisades of the Yukon." (*Current Opinion* 1913, p. 275)[23]

The review aptly summarizes the appeal of Davis's canvases in their day, as well as the reasons that they are not well remembered in our own. The world was enamored with the great American-Canadian northland and its riches at the turn of the century, and hyperbole was overlooked, even encouraged, by the popular press of the day. Davis's paintings, somewhat crude to our eyes, were seen by his contemporaries in the gold rush era as a natural outgrowth of the desire to suppress sophisticated artifice in favor of a purer, more direct experience of nature.

In addition to spending extensive time in Alaska, Davis visited and painted landscapes of the Canadian Rockies and United States national parks, although he remains best known for his Alaskan imagery. The artist settled in southern California about 1930 and died in Los Angeles in 1938 (Hughes 1986, p. 118).

Other early twentieth-century visitors were the artists Lydia Amanda Brewster Sewell (1859–1926) and her husband Robert Van Vorst Sewell (1860–1924). Robert Sewell's *Flowers of the Delta, Copper River* (no. 44) and Amanda Sewell's *In Scolai Pass* (no. 45) both resulted from a trip the Sewells took to south-central Alaska in 1914. Skolai Pass is near the town of McCarthy, in the Copper River country of the Wrangell Mountains.

Lydia Amanda Brewster Sewell was born in North Elba, New York. She studied at the Art Students League and Cooper Union in New York as well as at the Académie Julian in Paris. Her work was shown in the Paris Salons of 1886 to 1888, at the Pennsylvania Academy of the Fine Arts, at the World's Columbian Exposition of 1893 in Chicago, and at the Saint Louis Louisiana Purchase Exposition of 1904. She won awards at the National Academy of Design in 1888 and again in

44. Robert Van Vorst Sewell, *Flowers of the Delta, Copper River*, 1914
Oil on canvas, 91.5 × 71.2 cm; Joint purchase,
Anchorage Museum Association and Municipal Acquisition Fund, 91.23.1

45. Lydia Amanda Brewster Sewell, *In Scolai Pass,* ca.1914
Oil on canvas, 122 × 51 cm; Gift of the Anchorage
Museum Association, 87.1.1

1903, when she was elected an associate of the academy. She is better known as a painter of portraits, genre scenes, and flowers than as a landscape painter (Petteys 1985; Fielding 1965).

Robert Van Vorst Sewell is known for quite a different kind of work, mural paintings illustrating classical and medieval themes. Born in New York, Sewell studied at the Académie Julian in Paris from 1883 to 1887, and won an award at the National Academy of Design in 1888. He was elected an associate member of the academy in 1902, and he was a member of the Society of Mural Painters and the Architectural League of New York (Fielding 1965). The work of both Sewells in the Copper River country of south-central Alaska is accomplished, straightforward, and realistic. The copper mining so much in evidence there at the time is often the focus, with the dramatic landscape a backdrop for the activity.[24]

An untitled oil painting of an Alaskan cannery is the museum's only example of the work of the Dutch artist Jan Van Emple (no. 46). Van Emple is best known in Alaska for the large reredos he produced in 1925 for Saint Peter's Episcopal Church in Seward, which depicts the Resurrection of Christ attended by Alaskans against a backdrop of Resurrection Bay. According to one near-contemporary Alaskan source, Van Emple ran away from home and came to America as a cabin boy, was a member of the Whitney Studio Club in New York, and exhibited in the East as well as in Alaska (Davis 1930, p. 201).

An attractive color woodcut, *Indian Village, Alaska,* by California painter and printmaker William Selzer Rice (1873–1963) is a product of the artist's trip up the Alaska coast about 1930 (no. 47). Rice was born in Pennsylvania and studied at the Pennsylvania School of Industrial Art and at Drexel Institute in Philadelphia before graduating from the California College of Arts and Crafts. He was primarily a watercolorist until influenced by the Japanese woodcuts he saw in 1915 at the Panama Pacific Exposition. Completely won over by the medium, he first exhibited his woodcuts in 1918 in San Francisco. He later wrote three books on the medium and produced more than three hundred original woodcut images. Rice died in 1963 in Oakland (Hughes 1986; Samuels and Samuels 1985).

The Philadelphia painter Wuanita Smith (1866–1959) is represented in the collection by the highly stylized print *The Chase,* which depicts a figure in a Norton Sound–style kayak

46. Jan Van Emple, *Untitled* (cannery building and fishing boats), ca. 1925
Oil on board, 24.5 × 34.4 cm; Gift of the Anchorage Museum Association, 89.45.1

47. William Selzer Rice, *Indian Village, Alaska,* ca. 1930
Color woodblock print on Japanese paper, 24 × 19.2 cm; Joint purchase,
Anchorage Museum Association and Municipal Acquisition Fund, 91.22.1

48. Wuanita Smith, *The Chase,* ca. 1925
Color woodblock print, 30.5 × 24 cm; Gift of the
Anchorage Museum Association, 88.3.1

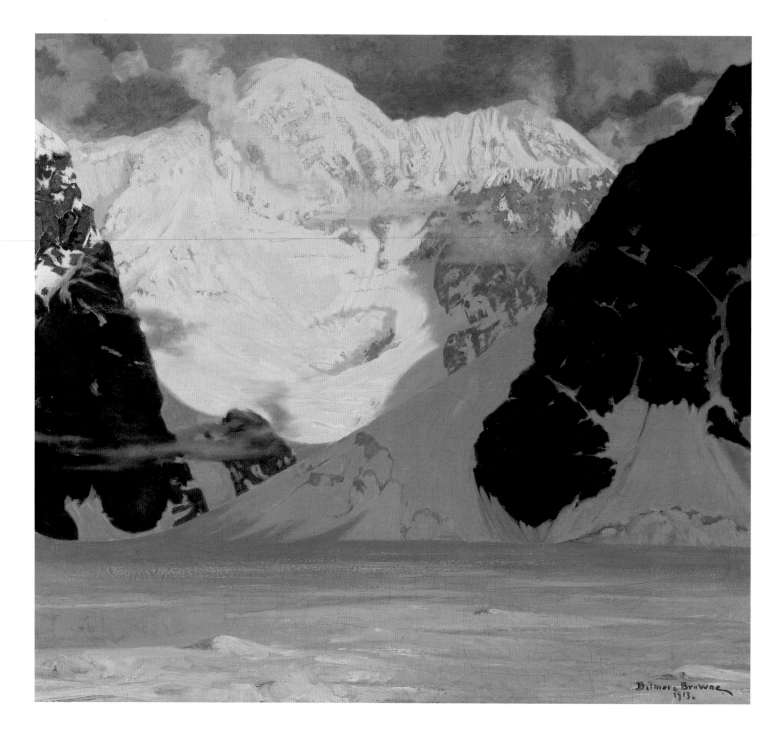

49. Belmore Browne, *Mount McKinley, the South Face,* 1913
Oil on canvas, 90.2 × 100 cm; Municipal Acquisition Fund purchase, 82.63.1

atop tossing waves (no. 48). Smith, a painter, printmaker, and illustrator of children's books, studied at the Philadelphia School of Design for Women, the Pennsylvania Academy of the Fine Arts, the Art Students League in New York, and in Paris as well. Her active exhibition record in the Philadelphia area includes showings at the Pennsylvania Academy and the Philadelphia Print Club. The date and extent of her visit to Alaska are unknown.

Prominent Early Twentieth-Century Visitors

BELMORE BROWNE: MOUNTAINEER-ARTIST

In addition to regionally known artists, two more prominent artists made extended visits to Alaska in the first two decades of the twentieth century. The first was Belmore Browne (1880–1954), who traveled to Alaska in 1888 as an eight-year-old child on a sightseeing trip with his family. He came to know the coun- try in much greater depth between 1902 and 1912, when he made several visits as a member of collecting expeditions for the American Museum of Natural History, and participated in three separate attempts to climb then-unscaled Mount McKinley, North America's highest peak. Browne's 1913 *Mount McKinley, the South Face* is one of his most striking images of the mountain with which he would be obsessed for nearly a decade (no. 49). It is painted with the attention to detail of a naturalist and mountaineer, and the drama and skill of one of our century's best mountain painters.

Browne undertook a remarkable series of adventures as a very young man, distinguishing himself as a hunter, climber, writer, and illustrator. In 1902 and 1903, still in his early twenties, he served as hunter, illustrator, and specimen preparator for the well-known naturalist Andrew Jackson Stone on his Alaska and British Columbia mammal-collecting expeditions for the American Museum of Natural History. With Stone, he explored the landscape and animals of the Stikine River region and parts of the Alaska and Kenai peninsulas. He returned to the Stikine River region of southeast Alaska and British Columbia in 1904 and 1905 to hunt, draw, and collect specimens on his own.

After 1905, Browne turned his energy and attentions to mountaineering. He was part of a group that in 1907 made the first ascent of Mount Olympus in Washington State, but his real prominence as a mountain climber grew out of his three pioneering attempts to climb Mount McKinley. In

1906 he joined Frederick Cook and Herschel Parker's expedition to attempt the peak. It was on this trip that Frederick Cook, after apparently being defeated by the mountain and sending most of his crew in various directions, claimed to have reached the summit and returned in a short time with a lone companion—to the acclaim of the world and the astonishment of his own expedition members.

Four years later, in 1910, Browne and Herschel Parker mounted their own expedition to the mountain, hoping to climb the peak but also seeking to disprove Cook's claim, which they felt certain was impossible to achieve in the time and manner he had described. They were unable to find a route to the summit but did locate the peak on which Cook had posed for a "summit" photograph, a minor promontory at an elevation of 5300 feet, almost twenty miles southeast of the top of Mount McKinley.

Browne's final attempt to scale McKinley came in 1912. He and Parker were turned back by a storm just 125 feet short of the summit. Browne later wrote many articles about his experiences on the mountain and in 1913 published an extensive account of all three climbs, *The Conquest of Mount McKinley* (Browne 1913), illustrated with his own works. Browne continued to write and to avidly pursue mountaineering and hunting, but he settled chiefly on the task of being an artist.

After serving in the Army Signal Corps in World War I, the artist, with his wife, Agnes, moved to Banff, Alberta, where they lived year round at first, later wintering in California. Browne is perhaps best known for his many paintings of the Canadian Rockies, the largest collection of which is in the Glenbow-Alberta Institute, Calgary. In 1930 he became director of the Santa Barbara School of Fine Arts, a post he held for several years. During this time he began producing background paintings for museum displays of mammal habitats. He produced notable examples for the Santa Barbara Museum of Natural History, the Boston Museum of Science, and the American Museum of Natural History.

Browne studied at the New York School of Art and the Académie Julian in Paris. He was elected to membership in the National Academy of Design, and his works are represented in many major American museums. Another of his Alaskan canvases, *Seal Hunters,* is in the collection of the Anchorage Museum. Among several other Alaskan paintings is a fine small oil of Mount McKinley, painted in 1907, which is the earliest known oil painting of the mountain.[25]

In the winter of 1918–19, the artist Rockwell Kent (1882–1971) visited Alaska for reasons quite different from those of earlier artists. Unlike artists who traveled to the region in various official capacities, with tourist excursions, or in search of fortune in the gold fields, Kent and his young son went to then-remote Fox Island in Resurrection Bay, near Seward, for something more intangible. The artist recounted:

> The Northern wilderness is terrible. There is discomfort, even misery, in being cold. The gloom of the long and lonely winter nights is appalling, and yet do you know I love this misery and court it. Always I have fought and worked and played with a fierce energy and always as a man of flesh and blood and surging spirit. I have burned the candle at both ends, and can only wonder that there has been left even a slender taper glow for art. And so this sojourn in the wilderness is in no sense an artist's junket in search of picturesque material for brush or pencil, but the flight to freedom of a man who detests the endless petty quarrels and the bitterness of the crowded world— the pilgrimage of a philosopher in quest of happiness and peace of mind. (Kent 1919)

Here, then, is a new kind of motivation for visiting Alaska. For Kent, the northern wilderness was not just a source of scenery but a haven for his troubled spirit[26] and a purer source of inspiration, a place where he "sensed a fresh unfolding of the mystery of life" (Kent 1919).

The artist and his nine-year-old son found Fox Island by chance. After delays in finishing a commission that would have helped to pay for his trip north, Kent and Rockwell, Jr., left for Alaska in late July. The artist was enchanted by the beauty of the Inside Passage from the decks of the SS *Admiral Schley* but was equally dismayed by the contrast of the rough, young settlements. Kent had planned no specific destination, knowing only that it needed to be a place of wildness yet safe enough for the young boy. After considering and rejecting a stay in the Yakutat area, they pushed on to Seward, arriving August 24. After motoring with a party of berry pickers along Resurrection Bay, father and son took off rowing a dory across the bay.

Kent and his son were fortunate to meet in mid-bay an old man named Olson who, on hearing what they were looking for, towed them to his home on Fox Island. The painter was enthralled with the spot. An abandoned cabin that had once housed goats became their home. Olson was the island's only other inhabitant. Supplies were purchased in Seward, and father and son worked hard to clean and refurbish the cabin for their winter home.

The time on Fox Island was to prove a fertile one for Kent, and he worked furiously. In addition to a rich life of fun and chores with Rockwell, Jr., he painted, drew, wrote, and read. He decided early on to keep a diary, sending pages by mail from time to time to his wife, Kathleen, and writing to other friends as well. Greatly influenced by reading Nietzsche, he made many drawings of Zarathustra. He also read the poetry and prose of William Blake and studied his art. He made beautiful, serene, light-filled paintings of the surrounding landscape and drew personifications of the North Wind.

Kent had planned to remain on Fox Island through the following summer, but Kathleen's pleas and his own desire to see his family brought him home, more than a little ambivalent, in mid-March:

> And now I sit here with our packed household goods about me, empty walls and dismantled home. Still we hardly realize that this beautiful adventure of ours has come to an end. The enchantment of it has been complete; it has possessed us to the very last. How long such happiness could hold, such quiet life continue to fill up the full measure of human desires, only a long experience could teach. The still, deep cup of wilderness is potent with wisdom. Only to have tasted it is to have moved a lifetime forward to a finer youth. (Kent 1920, pp. 215–16)

The work done on Fox Island, and other works begun later, proved pivotal to Kent's fortunes and represented the beginning of his financial and critical success. A show of drawings was mounted at M. Knoedler and Company in New York within a month of the artist's return from Alaska, and it was an immediate triumph.[27] Plans for a book based on the drawings and accompanied by pages from his diary and letters to Kathleen and friends were under way before the show came down. The text was compiled by Kent and in the hands of a publisher before the fall, and the book was published the following spring to coincide with an exhibition of Kent's Alaska paintings at Knoedler's. *Wilderness: A Journal of Quiet Adventure in Alaska* received public and critical acclaim. Although

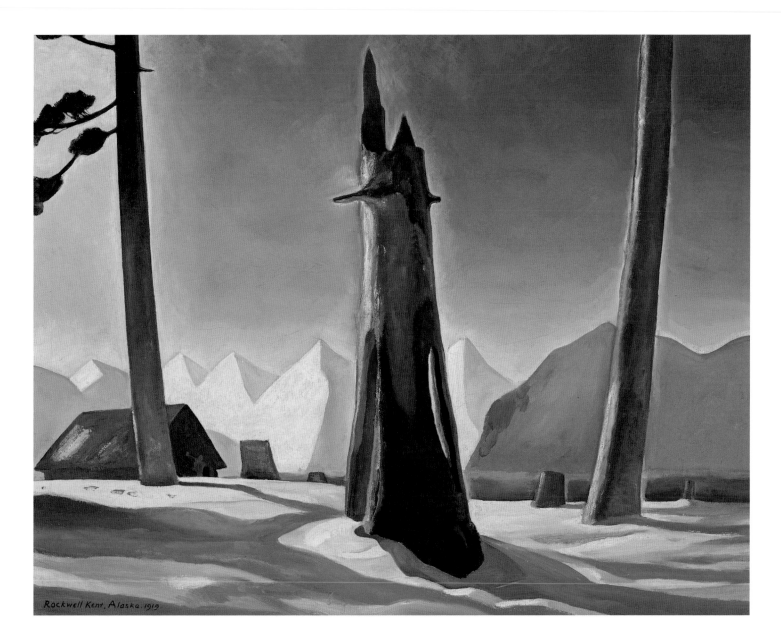

50. Rockwell Kent, *Alaska Winter*, 1919
Oil on canvas, 82.5 × 110.5 cm; Municipal Acquisition Fund purchase, 82.82

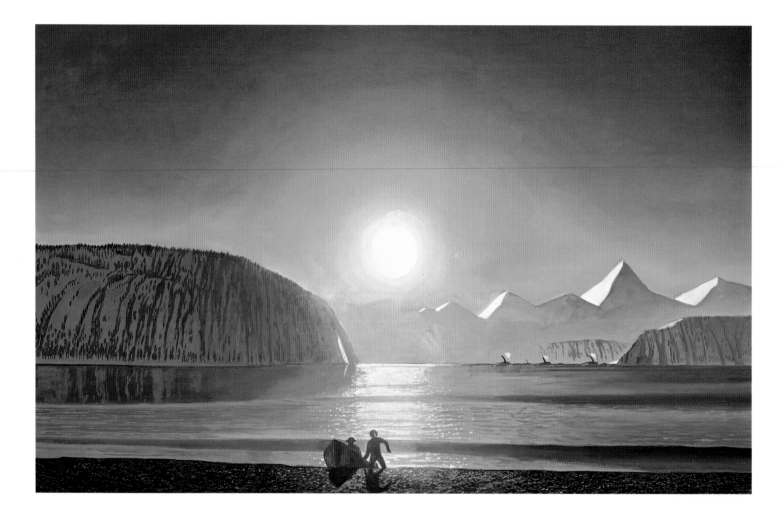

51. Rockwell Kent, *Resurrection Bay, Alaska,* 1965
Oil on canvas, 71 × 111.8 cm; Gift of ATZ Travel, ERA Helicopters,
Dr. and Mrs. Lloyd Hines, Bruce Kendall, and Alyeska Pipeline Service Company, 73.3.1

the paintings at first sold slowly, the exhibition was enthusiastically reviewed and helped establish Kent's reputation as a wide-ranging artist-adventurer (Traxel 1980, pp. 122–23). He did in fact continue to roam, voyaging and painting in Tierra del Fuego, France, Ireland, and Greenland.[28]

Kent's Alaskan work and Greenland paintings are among the finest images ever produced of the Far North. Despite his lifelong insistence that his goal was realism, the term meant to him something quite different from the topographic realism that was the objective of many of his predecessors in Alaska. He would have understood and sympathized with William Keith's intentions for his Dreams of Alaska, but Kent extended those expressive aims beyond anything that Keith would have imagined. And with far greater skills than Leonard Davis, he accomplished much of what that artist attempted and failed to reach.

The museum's collection of work by Kent includes two canvases based on the 1918–19 stay on Fox Island. *Alaska Winter* (no. 50) is a major painting begun on the island, while *Resurrection Bay, Alaska* (no. 51) was done much later, in 1965, from sketches made during the stay. The museum's holdings also include a drawing from the Alaska visit and a number of Kent's Greenland lithographs.

Later in the century, painters of talent and vision would go north to stay. If many of them produced larger bodies of northern work than Kent, and in the end had a greater impact on our image of Alaska, none captured the spirit of the northern landscape with greater passion and clarity than Rockwell Kent. Writing about his Alaskan works, Kent made it clear how much his experience of the North diverged from that of the many other artists who had painted, and would paint, Alaska from tour ships and guided excursions or in off-hours from the pursuit of official duties. His own words serve as the best summary of his unique contribution to our image of the North:

> Alaska is a fairyland in the magic beauty of its mountains and waters. The virgin freshness of this wilderness and its utter isolation are a constant source of inspiration. Remote and free from contact with man our life is simplicity itself. We work, work hard with back and hands felling great trees. We row across thirteen miles of treacherous water to the nearest town; and the dangers of that trip, and the days and nights, weeks and months alone with my son during which time I have learned to see his wonder-world and know his heart—such things are to me the glory of Alaska. In living and recording these experiences I have sensed a fresh unfolding of the mystery of life. I have found wisdom, and this new wisdom must in some degree have won its way into my work. (Kent 1919)

1. For more on the rise of tourism and travel to Alaska in the last two decades of the nineteenth century, see Andrews 1938; Cole 1985; Hinckley 1965; Newell 1966; and McDonald 1984.

2. Whymper made numerous drawings of the Sitka area and of Tlingit ceremonial items, some of which are reproduced in the cited account.

3. Lady Jane Franklin was the widow of the famous explorer Sir John Franklin, discussed in chapter 1. Sophia Cracroft was Sir John's niece and a constant companion of Lady Jane from 1836 (DeArmond 1981, p. xv).

4. The only other Sitka artist mentioned by Sophia Cracroft is John A. Fuller, who worked as the local agent for the American Russian Commercial Company, ran a drugstore, and was Sitka's postmaster from 1869 to 1871. The only work by Fuller in Alaskan collections is a Sitka scene owned by the Alaska State Museum, Juneau (DeArmond 1989, pp. 2–3).

5. For this and much other information on early Sitka artists, we are especially indebted to longtime Alaska historian Robert N. DeArmond (who grew up in Sitka when stories were still being told about the visit of Lady Jane Franklin) for the enormous amount of research he has done on early-day Sitka and its artists.

6. Muir 1888, vol. 1, following page 196. This lavish two-volume work coupled essays on beautiful regions of the West with etchings, wood engravings, and photogravures after paintings by many of the best-known landscape painters of the day. In addition to the full-page photogravure after Styles's painting of Mounts Crillon and Fairweather, other reproductions of Styles's work in the volume include images of *Shaak's* [Chief Shakes's] *House in Fort Wrangel, Mount Edgecombe* [Edgecumbe], *Sitka Sound,* and *Fishing Camp on Takau* [Taku] *Inlet—Morris* [Morse] *Glacier.*

7. For examples of typical works by Styles, see the two reproductions of his illustrations for *Frank Leslie's Illustrated Newspaper* that appear in an article on the Frank Leslie exploring expedition to Alaska, in Sherman 1974. For illustrations of other Styles paintings and drawings, which were offered for sale by Kennedy Galleries in New York, see Kennedy Galleries 1967, pp. 149–51; Kennedy Galleries 1973, pp. 231–34 (four reproductions); and Kennedy Galleries 1976 (two reproductions).

8. The photograph is reproduced in Kennedy 1973, p. 35.

9. For a fuller account of Richardson's life, career, and Alaskan visits see Kennedy 1973; Crane 1915; and the lengthy, insightful section on Richardson in DeRoux 1990.

10. Frank A. Crane's praise for Richardson's role is unstinting. He goes so far as to say that, "Richardson was a pioneer and a founder. The whole splendid outgrowth of art study and teaching in Minneapolis sprang from the seed of his elementary instruction to the public school pupils in the eighties" (Crane 1915, p. 19).

11. Lorne Render discusses Rockwell's work in his guide to western Canadian landscape painting in the Glenbow-Alberta Institute. The institute has several Alaskan watercolors by Rockwell, two of which are reproduced in Render 1974.

12. For more on Rockwell, see Stenzel 1972.

13. The latest canvas in the collection is dated 1921, but Stuart's last known trip to Alaska was in 1907. This canvas, as most of the others, was undoubtedly painted in his urban studio (at that date, in San Francisco) from photographs or sketches.

14. For more on Keith, see Cornelius 1942. Brother Fidelis Cornelius's lengthy biography is the standard work on the artist. A second volume with additional material was published in 1956. For a more recent monograph with reproductions of two Alaskan paintings by Keith from the collection of Saint Mary's College in Moraga, California, see Harrison 1988.

15. James Everett Stuart, although not living in San Francisco at the time, knew Keith and was a member of the Bohemian Club as well, and he might have seen the exhibition.

16. Keith is quoted as saying (at what point in his career is unclear), "I'd be satisfied if I could reach the power and success of Tom Hill" (Larkin 1949, p. 210).

17. The voyage also resulted, in 1889, in the reproduction of two Muir Glacier landscapes among the nineteen pictures by Hill in Muir's *Picturesque California and the Region West of the Rocky Mountains . . .* (Muir 1888), the same publication that included a reproduction of a Glacier Bay painting and other images by Walter B. Styles. William Keith's work was also included in this two-volume publication, but none were from Alaska.

18. Perhaps the best symbol of the rediscovery of the work of the two painters is the central court of the Oakland Museum's Gallery of California Art, where two paintings, each 6 by 10 feet, face each other and dominate the room. One is by William Keith, and the other by Thomas Hill. For a fuller account of the career and changing fortunes of Thomas Hill, see the Oakland Museum exhibition catalogue by Marjorie Dakin Arkelian, *Thomas Hill: The Grand View* (1980).

19. From a letter in the possession of Rosalie Osborne Mayer of Waterville, New York, quoted in Museum of Fine Arts, Boston, 1949, p. 106.

20. The identification of the locales depicted in Bierstadt's known Alaskan sketches is problematic. This piece came to the museum with the identification *Loring Bay, Revillagigedo Island,* but the landscape does not at all match the described location. The misidentification is probably the result of the long-standing misapprehension by both curators and art dealers that the *Ancon* had been wrecked on its way north, before making its tour of southeast Alaska with Bierstadt on board. It then was naturally assumed

that any Alaskan scene by Bierstadt would have to be a depiction of the mountains in or near Loring, the cannery near the southern extreme of Alaska's Panhandle.

21. For more on Adney in the Klondike, see his book *The Klondike Stampede* (1900) or, more briefly, my note on the collection of Adney papers in the Stefansson Collection at Dartmouth College, Hanover, New Hampshire (Woodward 1989).

22. See my essay in *Lockwood de Forest, Alaska Oil Sketches* (Alaska State Museum 1988, pp. 31–40) and that of Molly Lee (pp. 11–29) for different aspects of de Forest's trip to Alaska and the work the artist produced during it.

23. A painting by this title was included in the important exhibition *American Painters of the Arctic,* organized by the Mead Art Gallery at Amherst College, Massachusetts, and Coe Kerr Galleries in New York in 1975. Although far short of encyclopedic, and with only a brief catalogue essay, this was perhaps the first and is still one of the only real surveys of American paintings of the Arctic. *Palisades of the Yukon,* along with two other Alaskan works by Davis, is reproduced in the catalogue of the exhibition (Shepard 1975).

24. Four paintings of Copper River mining activity by Robert Sewell are reproduced in Kennedy Galleries 1976, pp. 218–21.

25. *Mountain Man: The Story of Belmore Browne, Hunter, Explorer, Artist, Naturalist, and Preserver of Our Wilderness,* a fascinating biography, con-centrates on Browne's climbing and hunting activities (Bates 1988). I am completing a book, to be published by 1994, that focuses on the Alaska and British Columbia sketchbooks of the artist and deals more fully with his contribution as a painter.

26. Both a pacifist and a great admirer of German culture, Kent was dismayed by the fervor over World War I and its attendant anti-German sentiment. His career as an artist was also in the doldrums at the time. It was one of the most demoralized periods in the life of this man who was by nature positive and energetic.

27. Kent's introduction to the exhibition catalogue takes the form of "An Imaginary Letter from Rockwell Kent to Christian Brinton." Brinton, a well-known art critic of the day, was the sponsor of the exhibition at Knoedler's.

28. The body of writing on the life and work of Rockwell Kent is voluminous. Both Kent's *Wilderness: A Journal of Quiet Adventure in Alaska* (1920) and David Traxel's *An American Saga: The Life and Times of Rockwell Kent* (1980) provide highly engaging accounts of the Alaskan adventure as well as its planning and aftermath. Traxel's work is also perhaps one of the most readable and insightful accounts of Kent's life and artistic significance, providing a different view of the events described by Kent himself in his autobiography, *It's Me O Lord* (Kent 1955).

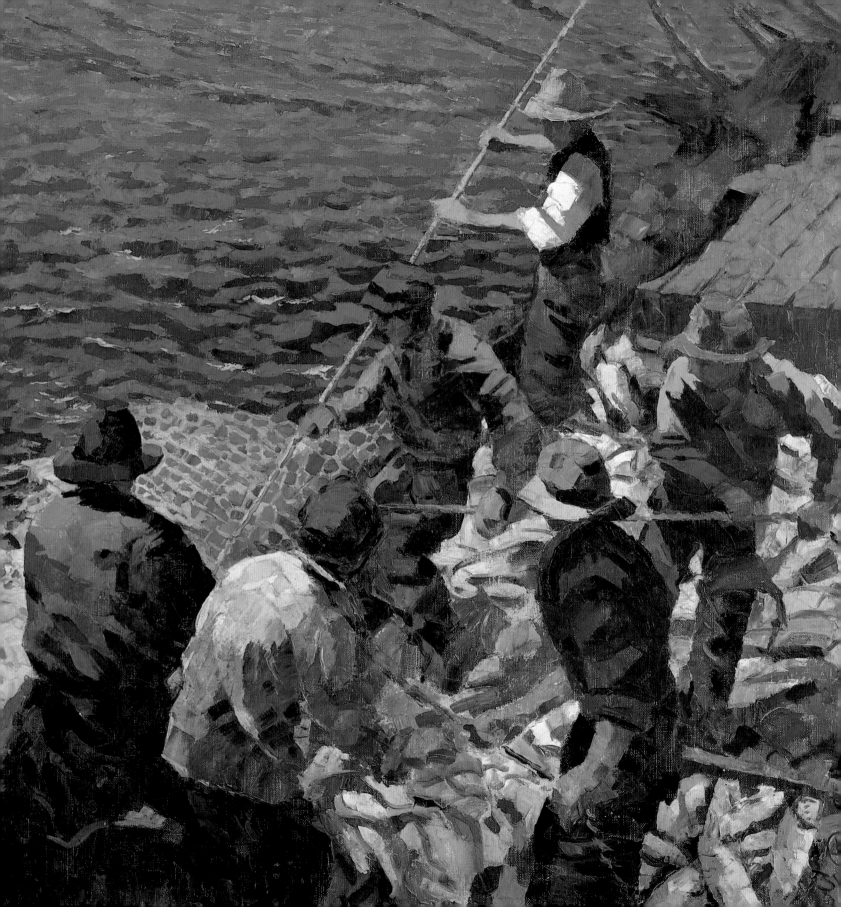

CHAPTER 3

RESIDENT PAINTERS: ALASKA'S BELOVED ARTISTS

The early years of the twentieth century saw the arrival of the first resident Alaskan painters—professional artists who went to Alaska not just to visit but to make their homes there for long periods. As we consider the work of the early resident painters, among the important questions we need to ask is, "Do artists who make such a dazzling landscape their home see it differently from those who are only visitors in the land?" We will explore this question as we look at the work of the four painters best known to most Alaskans—Sydney Laurence, Eustace Ziegler, Theodore Lambert, and Jules Dahlager. These artists should be examined both individually and collectively, as they have taken on an almost mythic status in the minds of long-time Alaskans and have influenced in varying degrees the way Alaskans see their own land.

Sydney Mortimer Laurence

It is appropriate to start with the man who is unquestionably Alaska's most beloved historical painter, Sydney Mortimer Laurence (1865–1940). Alaskans encounter Laurence's paintings not only in the state's museums but in its banks, hospitals, and offices, and in countless reproductions on merchandise from postcards to place mats. His paintings are found in private and public collections throughout the Pacific Northwest and West, and extend to the eastern United States and abroad, but until the retrospective of his work in 1990 at the Anchorage Museum, an exhibition that traveled throughout Alaska and to museums in California, Oregon, and Washington, the artist and his work were not well known outside the North. Until the retrospective, even in Alaska the painter's life

remained shrouded in mystery, and his place in the context of American art of the time lay largely unexamined. Although much of the mystery remains, we now have a relatively clear outline of his life and can begin to assess his contribution to art in Alaska.[1]

Sydney Laurence was born in 1865 in Brooklyn. Little is known of his childhood other than the fact that he attended Peekskill Military Academy in New York sometime before 1885. Laurence said that he studied painting in New York with the marine painter Edward Moran; in his entry in the catalogue of the 1890 Paris Salon Laurence listed Moran as his former teacher. Many sources speak of the young man's running away to sea sometime in his midteens for one to four years, and though none of those accounts has been corroborated, colorful stories of his adventures abound, including tales of shipwreck and narrow escape from drowning.[2]

Laurence painted and exhibited in New York between 1887 and 1889, and he was probably involved in the founding of the American Fine Arts Society there. He showed at the National Academy of Design in 1888 and 1889. During this period, he studied at the Art Students League of New York and was very much in the mainstream of a large group of young artists searching for a new way to paint landscape. Reacting specifically against the theatrical, obsessively detailed paintings of Albert Bierstadt, Thomas Hill, and others, Laurence and his young colleagues were instead more attracted to the plein-air naturalism of Jean-Baptiste-Camille Corot and his fellow Barbizon School painters. They were also influenced by the more "radical" work of the French Impressionists. The new

approach that these young American landscape painters forged came to be called Tonalism, a movement that would flourish from about 1880 to 1915.

Tonalist painting was very much in vogue in its day but was then largely forgotten until its rediscovery through several important exhibitions in the 1970s (Corn 1972; Gerdts, Sweet, and Preato 1982; Siegfried 1970). Tonalism was not the product of a consciously unified group of painters but a recognizable attitude toward and treatment of the landscape. Tonalist paintings featured a single predominating color and an all-enveloping atmosphere; intimate to modest scale, subject matter, and canvas size; and lively brushwork coupled with subdued color. Rejecting the smooth surfaces of the Hudson River School and Luminist painters as too cool, detailed, and dispassionate, and the impastoed surfaces of the Impressionists as too slapdash and uncraftsmanlike, the Tonalists sought a middle ground that would provide a more modern, lively effect and at the same time show respect for the landscape itself—a controlled vitality. Much of the middle to late work of William Keith was called Tonalist at the time, and the Alaskan Keith that we have examined (no. 40) is an outstanding example of the style.

Sydney Laurence's early work places him squarely with such prominent American painters as Henry Ward Ranger, Dwight Tryon, John Francis Murphy, George Inness, and others. But he would subsequently modify his style in response to the diverse landscapes he encountered in England, Europe, and Alaska.

In May 1889, Laurence and his bride, the New York artist Alexandrina Dupre, sailed for Europe. After touring the continent, they settled for most of the final decade of the nineteenth century in the artists' colony at Saint Ives, on the coast of Cornwall in England. Laurence began exhibiting with the Royal Society of British Artists almost immediately and was included in the Paris Salon in 1890, 1894, and 1895. In 1894, one of his seascapes won an honorable mention.[3]

Although the painter, then in his mid-thirties, seemed to be prolific, ambitious, and reasonably successful as a member of the sizable group of expatriate painters in Europe, he had already begun to show evidence of the wanderlust that would eventually take him to Alaska. From the mid-1890s, Laurence took jobs as an artist-correspondent in various regions of the globe. As early as 1895, he worked as an illustrator for the London-based *Black and White* magazine. By 1898, he was covering the Spanish-American War, probably for the *New York Herald*. In 1900, again for *Black and White*, he was in South Africa for the Boer War, and then in China covering the Boxer Rebellion. He continued to exhibit regularly with the Royal Society of British Artists through the late 1890s, and his work routinely appeared in *Black and White* through 1903.

We may never know why Sydney Laurence suddenly went to Alaska in 1904, leaving his wife and two small children in England. In a 1925 interview he explained: "I was attracted by the same thing that attracted all the other suckers, gold. I didn't find any appreciable quantity of the yellow metal and then, like a lot of other fellows, I was broke and couldn't get away. So I resumed my painting. I found enough material to keep me busy the rest of my life and I have stayed in Alaska ever since."[4]

What a prosaic contrast to the high-minded rhetoric of Rockwell Kent! Perhaps the comment was intentionally sardonic, downplaying romantic notions urged by his interviewer. Whatever the reason for Laurence's move, he made a clean break from his former life and appears never to have looked back. Christmas postcards from his wife and their two children, addressed to "S. M. Laurence Esq., Tyonook, Alaska" in 1904 are the last known contact between the artist and his family.

Laurence seems to have done little painting in his first years in the territory. Moving about the camps, boomtowns, and mineral fields of south-central Alaska, he endured the same kind of hard prospecting life led by many other Alaskan gold seekers of the era. Only a few small paintings of Cook Inlet known to be from those early years have survived, along with at least one giant canvas of Cordova Bay from 1909. When the painter and mountain climber Belmore Browne encountered Laurence in the village of Beluga on his way to Mount McKinley in 1910 (see chapter 2), Browne found the forty-four-year-old Laurence recounting his earlier glories and referring to his painting career in the past tense. Perhaps the encounter with the younger, energetic Browne or perhaps some other encounters helped turn around his attitude and fortunes.[5]

Whatever the reasons, between 1911 and 1914 Laurence began to refocus on his art, and during this period he made some of the finest paintings of his career. *Beached in Cook's Inlet* clearly demonstrates the excitement of a well-trained artist still probing the painterly possibilities of a new landscape

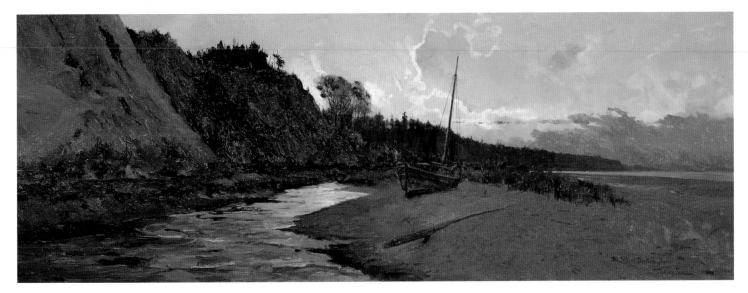

52. Sydney Mortimer Laurence, *Beached in Cook's Inlet*, 1911
Oil on canvas, 32 × 88 cm; Gift of the National Bank of Alaska, 91.62.15

(no. 52). The strongly horizontal proportions of the canvas, the bold diagonal composition, and the aggressive treatment of panoramic depth in a thin, horizontal slice are approaches that the artist soon largely abandoned for more traditional, symmetrical compositions, but are here used to novel and striking effect.

Another early canvas, the 1913 *Mount McKinley*, is among the earliest known Laurence paintings of the mountain with which he has been so closely identified (no. 53). Although the peak is set close to the center of the canvas, it shares center stage with baroque clouds of comparable size and interest. The approach to the summit begins from a loose, brushy foreground establishing the painter's location, and proceeds via a series of contrasting diagonal lights and darks and strikingly intense accents of various hues throughout the otherwise subdued overall tone of the image. Laurence here applies the lessons learned in New York, Europe, and England to a new landscape in a novel and personal way.

Laurence moved to the budding town of Anchorage in 1915 and opened a photography shop, although he continued to paint in earnest. By the early 1920s, he was clearly Alaska's most prominent painter, and his work was popular enough to enable him to close his photography studio, cease his ongoing dabbling in mining and oil leases, and pursue his painting full-time.

In 1923 the artist established a studio in Los Angeles, where he remarried in 1928. Throughout the remainder of his life Laurence spent most winters in Los Angeles or Seattle. He would return to Alaska to paint nearly every summer, however, and though accomplished Laurence landscapes of southern California and the Pacific Northwest survive, the vast majority of the paintings done in both his Los Angeles and Anchorage studios were of the Alaskan landscape. He died in 1940 in Anchorage.

Laurence made the image of Mount McKinley his trademark, but he also painted stirring depictions of sailing ships and steamships in Alaskan waters, totem poles in southeast Alaska, the dramatic headlands and quiet coves and lakes of south-central Alaska, cabins and caches under the northern lights, and Alaska's Natives, miners, and trappers engaged in their solitary lives in the Alaskan wilderness.

Laurence's paintings from the second and third decades of the century are his most accomplished work. By the end of this period, many of his scenes had settled into an almost formulaic repertoire. The depictions of Mount McKinley had become symmetrical, consciously aggrandizing, and the peak had taken on an almost metaphorical presence. The pressure to provide more and more paintings to a ready, largely uncritical audience in Alaska and elsewhere led him to produce hundreds of hastily executed, indifferent pictures, especially after 1930.

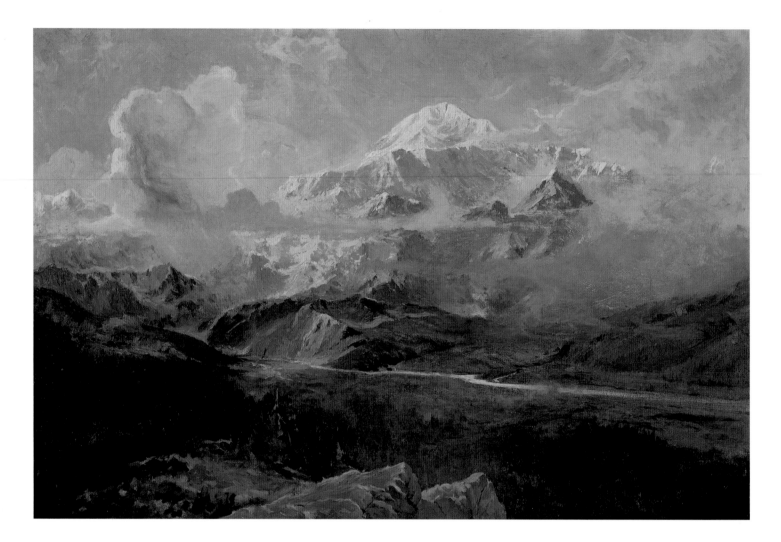

53. Sydney Mortimer Laurence, *Mount McKinley,* 1913
Oil on canvas, 50 × 76.5 cm; Gift of the Anchorage Museum Association
and friends of the Anchorage Museum, 88.39.1

But at intervals throughout his long career he was able to draw upon his early inspiration and produce meaningful, moving visions of the northern wilderness. Although many of his compositions have been appropriated and overused to the point of cliché by generations of later, derivative artists, it is important to remember that for Laurence, the image of the lonely trapper's cabin under the northern lights was fresh and original.

What, then, makes Laurence's paintings so popular and powerful? More prominent and accomplished artists than Laurence painted Alaska both before and after him. Thomas Hill had found sublimity in the tidewater glaciers of southeast Alaska. William Keith had found an atmosphere and light sympathetic to his own Tonalist experiments and reached for more in his Dreams of Alaska, but didn't stay long enough to bring those ideas to fruition. Rockwell Kent, painting on an island near Seward just as Laurence was finding success in Anchorage, found a metaphor for the triumphant human spirit in the wonder of the northern wilderness, but then took that discovery and applied it elsewhere.

It is Sydney Laurence's image of the "lonely landscape" that prevails. Not only has his vision influenced virtually all later depictions of Alaska but it has conditioned the way many Alaskans see their own land. Rather than eliminating the human presence in his canvases, Laurence almost invariably made the figures in his work small and unspecific. They are dwarfed by the scale of the land itself, a land that is not so much hostile as indifferent. For Laurence, the Alaskan landscape was immeasurably greater than the deeds of the men and women who visited or lived in it. If his Alaskan work reflects in some ways the landscape paintings of an earlier era, it is perhaps because the northern landscape in Laurence's time was still the seemingly limitless horizon that the American West had appeared to be for painters a half century before. The predominance of land over man had ended in the American West by Laurence's time and was soon to be threatened in Alaska. But if this region is for many Americans the "Last Frontier," then it is Sydney Laurence's image of the still-subordinate relationship of human to environment that depicts what we still look to Alaska to provide.

Eustace Paul Ziegler

If Sydney Laurence is Alaska's most beloved artist, Eustace Ziegler (1881–1969) is not far behind.[6] Indeed, many Alaskans prefer Ziegler's work because it focuses less on the mag-

nificent, distant Alaskan landscape than on the lives of early Alaskans. The paintings of Eustace Ziegler are a distinct counterpoint to those of Laurence, as his landscape is anything but lonely.

Depicted in Ziegler's canvases are men at work—crossing rivers, towing barges, surveying from hilltops, prospecting and mining, fishing and hauling nets (no. 54). Their work is hard, but rather than heroic the figures seem solid and admirable. Also portrayed are men at play—telling tales, playing cards, drinking and eating. Although Ziegler's figures appear tired and often bedraggled, they seem happy with life and fully engaged by it. Ziegler also painted innumerable portraits of the people on the frontier: Indians and Eskimos, priests, miners, and fishermen. In contrast to the largely symbolic, undifferentiated figures of Laurence's canvases, Ziegler's people are individuals, whether they are miners or young Native women, engaged in work or posed for portraits. Living and working in Alaska at the same time, Ziegler and Laurence reacted to quite different aspects of the frontier landscape.

Ziegler was born in Detroit, the son of an Episcopal minister. Interested in art from an early age, he studied at the Detroit Museum of Art (now the Detroit Institute of Arts) and later at the Yale University School of Art. But it was not as a painter that Ziegler came to Alaska. He arrived in the port of Cordova in January 1909 at the age of twenty-seven to manage the community's Episcopal mission. The Red Dragon, as the mission was called because of its color and its dedication to Saint George, provided a place for worship services on Sunday and an alcohol-free social hall the remainder of the week.

Cordova was a busy port at the time of Ziegler's arrival, providing access to the Copper River and the Northwestern Railway (then under construction) and to the railroad's destination, the thriving copper mines at Kennicott. Although there were more than two dozen bars in Cordova, the Red Dragon was the only institution of its kind. In addition to Cordova, Ziegler's missionary territory included the route north to the mines in interior Alaska, and he traveled regularly to construction camps and later to the mines in Chitina, Strelna, McCarthy, and Kennicott.

While attending to the duties of his ministry, Ziegler immediately began to paint religious scenes on the walls of the Red Dragon. He also painted the Native people, miners, and activity along his missionary routes. Selling his paintings from the window of a Cordova drugstore, he made perhaps his most

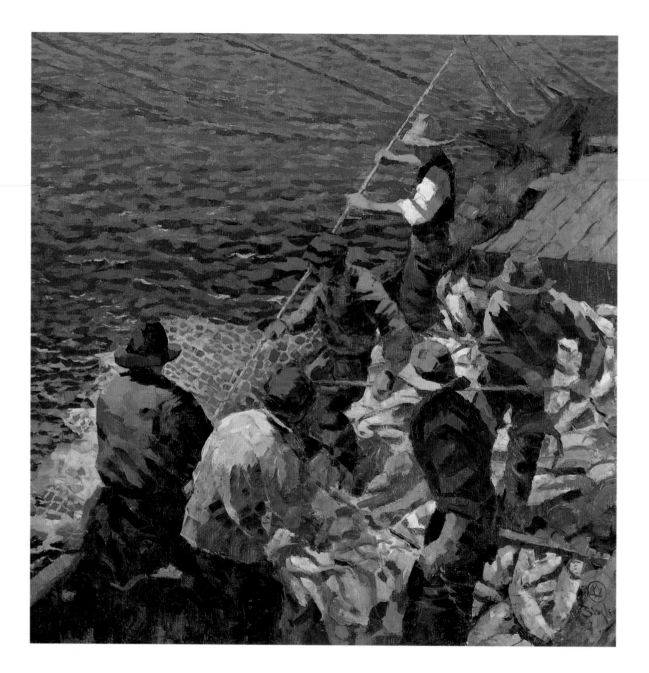

54. Eustace Paul Ziegler, *Alaska Fishermen,* ca. 1930
Oil on canvas, 87 × 87 cm; Joint purchase, Anchorage Museum Association
and Municipal Acquisition Fund, 78.43.1

important early sale to E. T. Stannard, the president of the Alaska Steamship Company, who later lured him to Seattle to do commissioned work for the company. Ziegler was married in 1911 and in 1914 took his family with him to Connecticut so that he might complete divinity school. Ordained by Bishop Peter Trimble Rowe on his return, he painted a large religious scene for the newly completed Saint George Episcopal Church in Cordova, of which he was put in charge. The artist went on to paint many other religious scenes in these and later years, including a Nativity and a Crucifixion for Saint Stephen's Mission in Fort Yukon. He also painted smaller canvases of the Madonna and Child using Native mothers and children as models, and biblical scenes set in the Alaskan landscape.

In the fall of 1920 the artist, perhaps feeling the need for further training, or perhaps simply wanting a break from frontier life, returned with his family to Connecticut and spent a year at the Yale University School of Art. He apparently painted at Provincetown, Massachusetts, during this time (Shalkop 1977, p. 4).

Not long after returning to Alaska, Ziegler was invited by Stannard to paint a series of murals for the Alaska Steamship Company offices in Seattle. Shortly after completing those murals, Ziegler and his family moved permanently to Seattle in 1924, but he continued to make regular summer trips to Alaska and for the rest of his long career produced paintings of the North, often working in the vicinity of Mount McKinley. He and his student Theodore Lambert took an ambitious trip down the Yukon River in 1936, and in 1939 the pair painted out of Talkeetna (*Alaska Life* 1939, p. 9).

In Seattle, Ziegler became a well-known figure in the art community. He was a founder and first president of the Puget Sound Group of Northwest Painters, and he won numerous awards in Northwest art exhibitions. He also did commissioned murals and oil paintings in Seattle and elsewhere. Major Seattle installations and canvases include those in the Arctic Club building, the Post-Intelligencer building, and the old Washington State Press Club (now in the University of Washington School of Communications). He painted a number of large canvases for the Baranof Hotel in Juneau and a commissioned piece for the Miami Clinic in Dayton, Ohio.

Ziegler was a prodigious worker, and he claimed late in life that he had executed one hundred paintings a year for some sixty years. In later years he resorted increasingly to mimicking his own early images, producing many of what he himself referred to as his "Alaskan potboilers" (Miletich 1960). But his best work is well-represented in museums in Alaska, Seattle, and beyond. The Anchorage Museum has a substantial collection of his work in a variety of media, including at least eight watercolors, eleven drawings, seven etchings and drypoints, and twenty-eight oils. Ziegler's etchings and drypoints, as well as his drawings like *The Tear Up,* demonstrate a fine command of lively, descriptive line (no. 55). At once spare and richly pictorial, his is some of the finest graphic work to come out of Alaska. He was working in drypoint and etching as early as the 1920s, and continued to explore the medium at least into the 1950s.

The paintings also show an active surface. More factured, or broken in stroke, than that of Laurence, Ziegler's technique was obviously influenced not just by the Impressionist painters that Laurence and his fellow Tonalists found too radical, but by Post-Impressionist and Expressionist work of the day as well. Whether accomplished with a palette knife or brush, his strokes remain always subordinate to their descriptive qualities, and he never flirted seriously with abstraction. But there is in much of Ziegler's work an evident interest in the character of the paint for its own sake. More than any Alaskan painter before him, Ziegler makes us as aware of the way the paint is applied as of the image it depicts.

Ziegler's influence is evident in the paintings of his best-known Alaskan pupil, Theodore Lambert, but his style is much more clearly recognized in the work of another of his students, Louise Lewis Gilbert (1900–87). Her large, accomplished oil painting *Alaska Fisher Women* was done in 1935 while Gilbert's husband was managing a fish cannery in Prince William Sound (no. 56).

Eustace Ziegler continued to paint until the last months before his death in 1969, and he died in Seattle just as a major exhibition of his work opened at the city's Frye Art Museum. His first museum exhibition had taken place at the Seattle Art Museum in 1947, and another retrospective of his work was mounted by the Anchorage Museum in 1977. Despite these exhibitions, much research remains to be done on the life and artistic contribution of this prolific painter of the North and Northwest. Even if we agree with his own modest assessment that, "I've never painted a masterpiece" (DeArmond 1978, p. 169), we can still acknowledge that the record he left us of

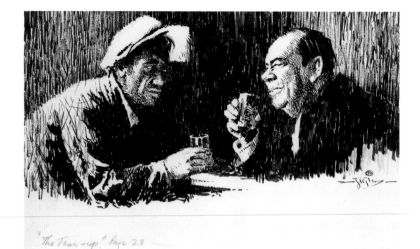

"The Tear-up." Page 28

55. Eustace Paul Ziegler, *The Tear Up,* ca. 1958
Ink and pencil on poster board, 19.7 × 31.1 cm;
Gift of the Anchorage Museum Association, 81.39.11

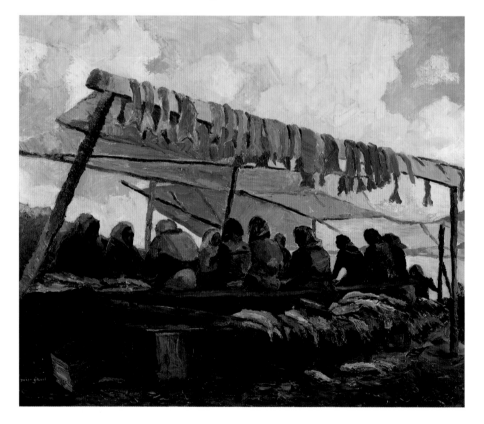

56. Louise Lewis Gilbert, *Alaska Fisher Women,* 1935
Oil on canvas, 87.3 × 102 cm; Gift of the Anchorage Museum Association, 87.54.1

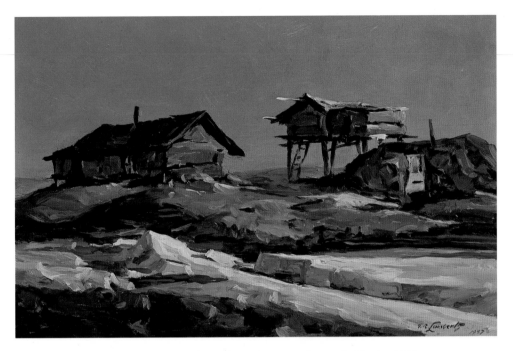

57. Theodore Roosevelt Lambert, *Spring Breakup on the Tundra,* 1937
Oil on board, 25.5 × 39.4 cm; Gift of Mr. and Mrs. Robert O. Kinsey, 78.79.1

early twentieth-century Alaska is striking and important. He captured not only the daily occupations of that pioneering era but the character of that activity. He provides a personal insight into the Alaska that Sydney Laurence portrayed as so sublime, serene, and beyond human touch.

Theodore Roosevelt Lambert

> If there is any road to art that can be counted on with any certainty, it is to live utterly what one wants to express, and then to be willing to sacrifice the society of others and the comforts of gregarious existence to give all one's energy and emotional strength to its expression. (McCollom 1976, p. 184)

This statement by Theodore Roosevelt Lambert (1905–60) could serve as his credo and epitaph. Probably the best-known Alaskan artist after Laurence and Ziegler, Ted Lambert was a restless, willful, ultimately unhappy man who finally disappeared in the Levelock area of southwest Alaska in 1960, after years of increasing paranoia and desiring to be left alone to paint without interference.[7] But however unhappy were his restless life and premature end, he is well remembered and much revered in the state for his paintings of the land and people of early Alaska.

Once a pupil of Eustace Ziegler, and later a friend and fellow traveler of the older artist, Lambert usually is thought of by Alaskans as a Fairbanks painter. Although he did live in Fairbanks for nearly twenty years, he traveled more widely in the territory than any artist we have yet considered. Arriving in Cordova in 1926, he worked and painted for lengthy periods in McCarthy, Kennicott, Dawson, Gakona, Eagle, Fairbanks, the North Slope, Bethel, Lake Clark, and Levelock. His style owed something to Ziegler's but would never be mistaken for it. His brushwork was like his life—restless, searching, abrupt, and strong.

Lambert was born in Zion, Illinois. Rebellious and high-spirited, he showed an early interest in drawing. He won a drawing contest at fifteen and was awarded a correspondence course in illustration. He worked part-time during the same years as a sign painter. While still in high school, he ran away from home with a friend. He returned after six weeks but then was off again on his own to Los Angeles. From there he

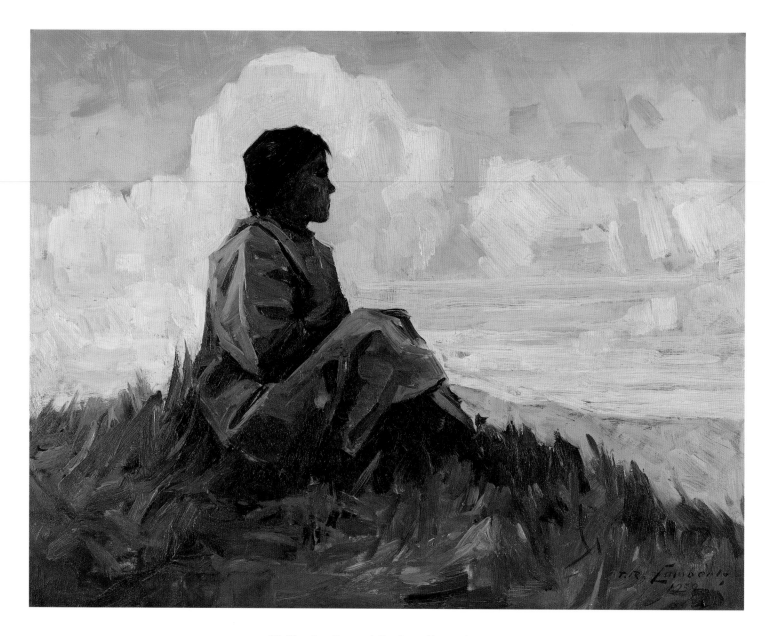

58. Theodore Roosevelt Lambert, *Tranquility,* 1939
Oil on board, 36.2 × 46 cm; Gift of the Anchorage Museum Association, 72.101.1

went on to Yellowstone Park and Montana, and finally found passage to Alaska as far as Cordova in the spring of 1926.

Lambert worked in the mines near McCarthy and Kennicott. In the spring of 1927 he and a friend drove a dog team toward Dawson, Yukon Territory, and arrived by home-built scow in May. He carried mail and freight by dogsled from Dawson to Kirkman Creek in the winter of 1927–28, and then went alone to trap, explore, and sketch in the tundra of Alaska's North Slope. After prospecting and trapping in the Eagle and Fortymile districts for some time, he returned to Kennicott. About 1930 he snowshoed the Richardson Highway to Fairbanks.

By 1932 Lambert had saved enough money, or been grubstaked by someone, to travel to Chicago for several months of formal art training. His transition from the graphic to the painterly arts seems to have resulted from that experience, as the etchings and drawings he had done before the trip increasingly gave way to paintings and watercolors (McCollom 1976, p. 186). He admired the work of both Laurence and Ziegler, and he was able to save enough money from a summer's work with the Fairbanks Exploration Company to travel to Seattle for a season of study with Ziegler the following winter.

After one last summer with the Fairbanks Exploration Company, he was again off making paintings in the Copper River country and exhibited those efforts in Anchorage, Cordova, and Juneau, where he painted in addition to showing. He traveled down the Chena, Tanana, and Yukon rivers and then across the portage to the Kuskokwim River with Ziegler in 1936, staying in Bethel when Ziegler returned to Seattle for the winter. There Lambert met the government schoolteacher he would marry the following year, Lovetta Gusky. The couple settled in Fairbanks in 1937.

Lambert maintained at least occasional contact with both Laurence and Ziegler. He visited Ziegler in Seattle and worked with him on illustrations for A. E. Lathrop's promotional book on Alaska, which commemorated the opening of radio station KFAR in Fairbanks. Anchorage reporter Kay Kennedy first met Lambert at Sydney and Jeanne Laurence's home in Anchorage in 1937. She later recalled Laurence's first comment to her about Lambert: "I have someone I want you to meet. He's a great artist and someday may be recognized as Alaska's greatest—maybe North America's—if nothing happens to him" (McCollom 1976, p. 189).

Laurence's caveat proved to be prescient. Although Lambert's career seemed very much on an upward track in the late 1930s and early 1940s, by 1945 the artist's marriage had turned sour and he was becoming increasingly withdrawn. In December of that year, he was successfully sued for divorce, and in February 1946 he was served with a restraining order preventing him from seeing his former wife or his daughter. They moved to California, and he never saw either of them again.

Lambert's embitterment over the courtroom battle and the loss of his child undoubtedly hastened the descent into withdrawal and paranoia which would only deepen in the following years. He moved again from place to place, painting in Gakona for a while before returning to Fairbanks in 1948, but he railed bitterly about what he saw and the people he met, and he began to threaten with physical violence anyone who disturbed him at his work. His final move was to the region of Levelock and Lake Clark, on the Alaska Peninsula near Bristol Bay. There he lived the next decade as a recluse, refusing the visits of all but a few close friends and ordering art supplies through his brother in Chicago. Even his remaining friends were frequently turned away in the later years. He was last seen at Levelock on July 27, 1960. His exact fate is unknown, and his body has never been found; it is presumed that he either committed suicide or had a fatal accident.

Lambert's possessions were removed from his Levelock cabin in 1965. Among them were a large volume of finished and unfinished paintings and sketches, all the official paperwork and news clippings he had saved, and a long manuscript recounting his life and career. Some thirty oil paintings as well as a number of etchings, watercolors, and pencil sketches were purchased for the University of Alaska, in Fairbanks, by Guilbert Thompson, a longtime Alaska teacher and a graduate of the university. The 250,000-word manuscript was turned over to the university by the artist's daughter, Pats.

The Anchorage Museum owns numerous oil paintings, watercolors, and etchings by Lambert. Both *Spring Breakup on the Tundra* (no. 57) and *Tranquility* (no. 58) date from the late 1930s and are typical of the painter's strongest work. At his best, Lambert was able to marry his bold, aggressive painterly stroke to a deft representation of the particular quality of light in a scene, strongly evoking the essence of a locale and subject. Lambert never abandoned the rough-and-ready life

of the sourdough. His deep familiarity with the paraphernalia of Alaskan dog mushing, boating, and bush life enabled him to paint his various subjects—the land and sky, rudely built bush dwellings, and the gear of the river and trail—without resorting to either niggling detail or romantic generalization. He has been consistently praised by longtime Alaskans for his attention to correct observation. Never settling into the life of a gentrified city dweller reflecting with nostalgia on the halcyon days of the frontier, he gave us perhaps our most direct and revealing look at both the lure and potential price of that hard life.

Jules Dahlager

The final member of our quartet of beloved Alaskan painters is Jules Dahlager (1884–1952), who lived in the territory from 1921 until his death.[8] He spent most of his life working as a printer and journalist and apparently had no formal training in art but painted in his spare time. He nevertheless produced a voluminous body of work, which is well known and much sought after (nos. 59, 60).

Jules Dahlager was born at Brookings, in the Dakota Territory. His family moved to Seattle four years later, and after his father died in 1890, the six-year-old Jules sought his first job. Hired as a newsboy by the *Seattle Post-Intelligencer*, he embarked on a career in newspapers that he would follow until retirement. Dahlager soon became a journeyman printer, but his ambition was to be a cartoonist. He was hired as the official cartoonist for the *Social Democrat*, a socialist newspaper in Seattle, and also worked briefly as a cartoonist in Vancouver, British Columbia, but soon returned to work as a printer.

After nine years in Vancouver and two as head of a weekly newspaper on Vashon Island, Washington, Dahlager and his wife moved in 1921 to Cordova, where he was employed by the *Cordova Daily Times*. In Alaska he began to paint and developed the style that would become his trademark. Evidently making his first painting attempts without the benefit of brushes, he resorted to using a palette knife. He found the method so congenial that he never adopted another, eventually handling even fine detail with his array of palette knives. The use of the tool gives all his work an instantly recognizable look, even without his characteristic signature, "Jules."

Dahlager met Eustace Ziegler soon after arriving in Cordova and later said that he was personally encouraged and helped by both Ziegler and Sydney Laurence (Roppel 1977, p. 191). He was also encouraged by early sales of his work in Cordova, including the purchase of a number of his paintings by President Herbert Hoover and his entourage on a visit to Cordova.

The Dahlagers in 1929 moved to Ketchikan, where Jules worked for the *Ketchikan Chronicle*. He remained in the city for the rest of his life. In Ketchikan he produced and sold to visitors countless landscape paintings and portraits of Native people and other Alaskans, and his work was exhibited throughout Alaska as well as in Seattle, Los Angeles, Chicago, and Vancouver. Like both Laurence and Ziegler, he resorted in later years to endless repetitions of his popular images to meet a steady demand. Perhaps his best known portraits are those of Chief Johnson, a distinguished elderly Tlingit in Ketchikan, often portrayed in ceremonial gear, and Horse Creek Mary, who was also painted by Eustace Ziegler. Horse Creek Mary was a well-known Copper River Native whom Dahlager had met in Cordova. Dahlager continued to paint variants of her craggy image for the rest of his life.

Dahlager enjoyed tremendous popularity but never achieved the recognition or professional success accorded Laurence, Ziegler, or even Lambert. Many of his paintings were quite small. He kept his prices low and painted what people liked, often giving his miniatures to friends. The range of his work is limited, and as with so many other artists who continue to rework their early images to meet commercial demand, the once-keen insightfulness of his portraiture and landscapes turns too often in the late work to caricature. But his best work has a refreshing directness and shows an undeniable joy at the good fortune of living and working in such a beautiful land. His charmingly direct statement of his guiding principles aptly summarizes the strengths and limitations of his work:

> An artist has to learn to paint almost entirely from memory. . . . A nature scene changes from moment to moment as the sunlight shifts. Constant practice gives a special training to the inner eye, and an appreciation of beauty means more to an artist than mere skill. . . . I want people who enjoy pictures to have them, and to have the pictures they enjoy. (Roppel 1977)

59. Jules Dahlager, *Power Creek, Cordova, Alaska,* 1928
Oil on board, 17.8 × 12.7 cm; Gift of the
Rasmuson Foundation, 71.171.4

60. Jules Dahlager, *Deer Mountain, Cordova,* date unknown
Oil on board, 20.3 × 15.2 cm; Gift of Mike
and Becky Dahlager, 91.51.8

61. Magnus Colcord (Rusty) Heurlin, *After Fishing,* ca. 1960
Oil on board, 65.5 × 105.7 cm; Gift of the Rasmuson Foundation, 85.27.1

62. Joseph William Kehoe, *Untitled* (harbor and houses, light snow), 1953
Watercolor on paper, 33.8 × 44.3 cm; Gift of Mr. and Mrs. Robert O. Kinsey, 84.76.1

Other Early Resident Painters

A number of other talented painters made Alaska their home prior to World War II. One of the earliest and best known was the Fairbanks painter Magnus Colcord Heurlin (1895–1986). Heurlin, known as "Rusty," came to Alaska in 1916, before either Ted Lambert or Jules Dahlager. Heurlin was born in Christianstad, Sweden, of American parents. Raised in Wakefield, Massachusetts, he took art classes in Boston at the Fenway School of Illustration. He worked on a ranch in Texas and on the docks in Seattle before taking the SS *Northwestern* to Valdez in 1916. World War I took him away briefly to serve in Europe. He spent the years immediately after the war in Westport, Connecticut, working as an artist-illustrator and turning out cover paintings for New York–based magazines. He returned to Alaska in 1924 and eventually made his home in Ester, just outside Fairbanks, where he lived until his death.

Heurlin is perhaps best known for several series of large canvases chronicling Alaska's history. He was commissioned by the 1967 Alaska Centennial Commission to paint fifteen murals depicting the history of the Klondike and Alaska Gold Rush. This Great Stampede series is still on view at the Alaskaland Centennial Park in Fairbanks. The similar-size Great Land historical series soon followed. In 1972 individuals connected with the University of Alaska commissioned the series Our Heritage, focusing on the life of Alaskan Eskimos from earliest times through the 1971 Alaska Native Claims Settlement Act.

Heurlin was a keen observer of the lives of Native and non-Native people throughout northern Alaska in his almost seventy years of residence there. In addition to his many years in Fairbanks, he spent four whaling seasons at Barrow in the early days of Eskimo whaling in umiaks under sail, a subject he

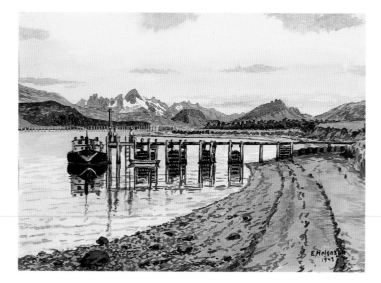

63. E. Helgason, *Chignik Lagoon, Alaska,* 1943
Watercolor on paper, 24.2 × 33.2 cm; Gift of the Anchorage Museum
Association, 85.19.2

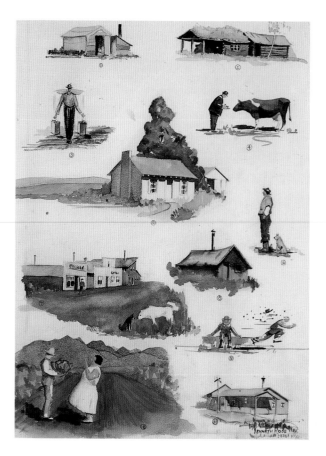

64. Kenneth Ross, *Matanuska Valley,* 1936
Watercolor on paper, 49.3 × 38.4 cm; Gift of the artist, 74.45.1

frequently painted. He was a captain in the Alaska Territorial Guard in World War II and helped Major M. R. "Muktuk" Marston recruit Eskimos in northwest Alaska for the guard. He received an honorary degree from the University of Alaska in May 1971 that recognized him as a "celebrated master of the brush and easel, faithful recorder of life in the Arctic" (*Nanook News* 1971). *After Fishing,* a major painting by Heurlin, is one of five works by the artist in the museum's collection (no. 61).[9]

Another early twentieth-century resident was Joseph William Kehoe (1890–1959), who came to Alaska with the army in World War I and stayed to practice law. Usually referred to as Judge Kehoe, he was not a professional painter but was an accomplished watercolorist. Kehoe remained in Alaska until 1954 and died in Oregon in 1959. The museum's holdings include ten of his watercolors (no. 62). Kehoe's watercolor landscapes combine a considerable amount of detailed obser-

vation with a fluid style. Most of Judge Kehoe's work focuses on the landscape, but he also did fine watercolor portraits as well as images of Alaskan animals.

E. Helgason is an artist about whom we know almost nothing, except that he or she might have been a resident of the Chignik area on the Alaska Peninsula in the 1930s and early 1940s (Deroux 1990, p. 17). Helgason's known works are all watercolors of views in the Chignik area. Less fluid than those of Kehoe, Helgason's watercolors are tightly rendered but quite competent pictures of specific locations and qualities of light. Both of the Anchorage Museum examples date from 1943 (no. 63).

Watercolor vignettes of life in the Matanuska Valley, the agricultural area north of Anchorage, were painted by Kenneth Ross in 1936 (no. 64). Little is known about Ross, who made similar vignettes of Savage Creek Camp, McKinley Park headquarters, the same year.

Indigenous Residents: Native Alaskan Painters

Those with the most obvious claim to resident status before World War II are Alaska's indigenous people. The traditional Native Alaskan arts and crafts—ivory carving, basketry, and skin sewing—continued to be practiced between the wars, but several Native Alaskans also were among the best-known producers of paintings and drawings in the territory. If we consider them here as a group, apart from the early transplanted Alaskan residents, it is because the media they employed, their means of depiction, and their subjects differ markedly from those of their non-Native colleagues.

Probably the best known of the group is the artist George Aden Ahgupuk (b. 1911). Ahgupuk was born in northwest Alaska in the village of Shishmaref on the Seward Peninsula. Like other young men of his generation, he learned the skills of the subsistence hunter. But in 1930, on his way back from a dogsled trip to Nome, he hurt his leg in a fall. Although the injury continued to trouble him, he put off seeking treatment until 1934, when he submitted to an operation and an eight-month convalescence at the Alaska Native Health Service in Kotzebue.

Ahgupuk had always been interested in drawing, but it was during this period of enforced physical inactivity that he began to make art the focus of his life. Without access to paper or pencil, he tried passing the time by using the charcoal of a burned wooden match to draw on tissue paper (Mozee 1975, p. 141). A nurse brought him paper and drawing materials, and he spent much of his convalescent time avidly practicing drawing.

Ahgupuk never recovered full mobility after the knee operation, although he was able to hunt.[10] He continued to draw after his return home from the hospital. When he ran out of paper, he improvised by drawing on bleached sealskin. The material has since become his trademark, along with the skins of reindeer, caribou, moose, and even fish. A typical drawing is begun with pencil and then drawn over in ink; some are tinted with paint or colored inks or both.

Ahgupuk works range from small, single vignettes of hunting or reindeer herding to large, elaborate compositions with many activities and scores of people and animals depicted. The whimsical *Radio Babies* (no. 65), perhaps his best-known drawing, is executed in ink and watercolor on skin but is a far cry from his traditional Eskimo scenes. In a distant house is an Eskimo mother about to give birth. In the foreground is Dr. J. H. Romig, an early-day Alaskan physician, talking to the Bethel patient by radio. On its way between the two settlements, along the path of the radio communication, flies the baby about to be born. Above the scene in the sky is written:

Dr. J. H. Romig Radio Babies

Price List		You Pay
Boy or Girl		$200
Twins	My Sympathy	$50–$150
Trips	"	$75–$125
Quads	"	$100–$100
Quints	"	$150–$50
Sext.	"	$200
Get Your Orders in Early		

As early as 1937, Ahgupuk's skills were recognized by no less an authority than Rockwell Kent. In a magazine article Kent was quoted:

> If there is another Eskimo that can draw half as well, I don't know of his existence. I know for a fact that nothing produced in Greenland is even comparable. Ranking with all comers he certainly is one of the foremost of artists who have drawn in the North. On more specific grounds I would cite for their special excellence his perspective, his action, his strong sense of both the pictorial and dramatic impact, and above all, the values in his comprehensive epic of Eskimo life. (*Time* 1937)

On the strength of Kent's recommendation and the drawings shown to them by the well-known artist, the prestigious American Artists Group in New York elected Ahgupuk a full member and shipped him pens, ink, and other drawing supplies. The American Artists Group later published Christmas cards featuring Ahgupuk's work.

The artist moved to Nome in 1948 and to Anchorage in 1951, where he still resides. He has shown his drawings in exhibitions throughout Alaska and the western United States as well as in New York, and his work is represented in museums within and outside the state. He has also illustrated several books and smaller publications.[11]

George Ahgupuk's work derives its allure from the combination of his perceptive observation, utter truthfulness, and

65. George Aden Ahgupuk, *Radio Babies,* date unknown
Ink and watercolor on skin, 25 × 38 cm; Gift of the National Bank of Alaska, 70.169.1

untrained but substantial drawing skills. He also has a broad, persistent streak of humor that comes through in interviews and in his work and clearly informs the way he looks at the world.[12] It is this rare alliance of qualities that makes his drawings direct without being simple, charming without being cute, and informative without being pedantic. The best of them afford the viewer privileged glimpses at a distinct way of life.

Ahgupuk's sister Bessie married another important Eskimo artist from the Seward Peninsula, James Kivetoruk Moses (1900–82). Moses was born in Cape Espenberg, fifty miles from Shishmaref, and he moved back and forth among Cape Espenberg, Deering, Kotzebue, and Shishmaref before finally settling in Nome. As a young man Moses hunted and trapped, traded, hauled mail by dogsled, and worked as a reindeer herder. He had begun drawing in Deering when he was fourteen, producing drawings that were good enough to interest buyers even then. He maintained an avid interest in drawing

until he was twenty-one, when he put the occupation aside in favor of trapping and reindeer herding. But in 1953 Moses's knee was severely injured in an airplane accident, and he could no longer hunt, trap, or work as a herder. Chafing at his sedentary life, he took up drawing as a way to make a living (Mozee 1978, pp. 105, 107).

Moses's work is very different from that of his brother-in-law, George Ahgupuk. Almost all the works are done on paper or board, in a variety of media ranging from ink to oil paint, watercolor, colored pencil, and Stabilo oil pencil. Moses's pictures are much more richly colored than those of Ahgupuk, and their surfaces are more heavily worked. They are closer to painting than drawing, despite being done primarily with drawing materials on paper surfaces.

The artist's subjects also deviate from the traditional hunting and herding scenes of Ahgupuk. Moses concentrated instead on narrative; his pictures almost invariably tell a story.

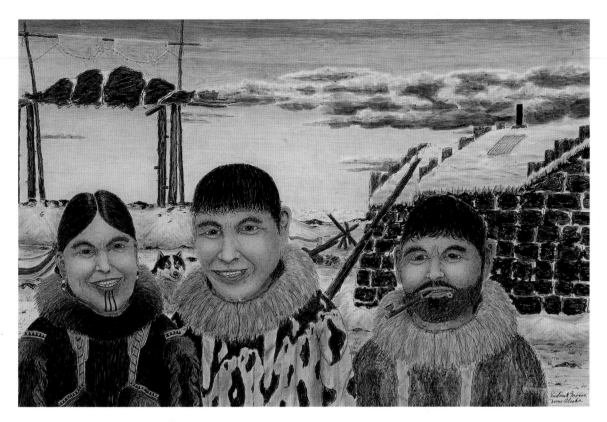

66. James Kivetoruk Moses, *Untitled* (Eskimo men and woman), ca. 1950
Watercolor, pen, and ink on poster board, 30.7 × 45.6 cm; Gift of the Anchorage Museum Association, 87.29.2

Sometimes the story can be as simple as an encounter between a walrus and a polar bear, but his favorite themes involve strange events or legends—a "mermaid" sitting on the edge of an ice floe, with Eskimo hunters regarding her curiously from a distance; a hunter shooting an eagle who has snatched the hunter's brother; a devil-like spirit being conjured by a shaman for consultation; or a legendary Eskimo giant swimming among floes in the icy waters of the Bering Sea. He also executed portraits in his characteristic style, usually group portraits with active background settings (no. 66).

By the time of his death in 1982, Moses was a much-celebrated artist. Painfully shy and still speaking little English, even toward the end of his life, he seldom traveled, but many admirers of his work stopped to see him in Nome. All three major museums in Alaska have substantial collections of his work, and private collectors from around the world cherish their examples.

Robert Mayokok (1903–83), another well-known Eskimo artist of the same generation, was as gregarious and well-traveled as Moses was shy and stay-at-home. Mayokok was born in the village of Wales, at the western tip of the Seward Peninsula on the Bering Strait. One writer's introduction of him makes it immediately apparent what a different life he led from that of Moses:

> For a fellow whose lifelong companions have been loneliness and fear, Robert Mayokok has an unsubdued twinkle, a sturdy faith, a productive pen—and 73 years of experiences like you wouldn't believe. . . . He has been a reindeer herder and lecturer, a deck hand and walrus hunter, a news broadcaster and a messboy, a fox trapper and church translator, a drifter and a multi-published author. He has traveled down the Yukon River, lectured to the Explorers Club in New York City, visited Siberia,

met explorers Roald Amundsen and Knud Rasmussen, been interviewed by Lowell Thomas, Sr., and served as baby-sitter to eight wild reindeer on a long journey to Boston. (Mozee 1976, p. 242)

Mayokok's mother died when he was quite small, and the stepaunt and two successive stepmothers who cared for him before he reached thirteen all died in turn. He began school at six without understanding any English but eventually completed the fifth grade. It was there that he came in contact with reproductions of famous art works and began to wish he could create art, but his early efforts were not encouraged. His lifelong commitment to the Christian faith, a central element in his life, was developed through contact and fascination with missionaries about the same time he was learning English. He soon served as an interpreter for some of them with his own people.

In the fall of 1918 Mayokok's home village was decimated by influenza. His father, grandfather, and sister died in the epidemic along with many others of his family and friends. Although he, too, became sick, Mayokok survived the horrific epidemic. In the next years he drifted aimlessly, taking jobs as an interpreter, a walrus hunter, and a crewman aboard the schooner *Teddy Bear*, which carried Knud Rasmussen. He served as an interpreter for a mission on Little Diomede Island in 1922–23, and then crewed on the *Nanuk* on its trip to Herschel Island.

After acting as caretaker for the *Teddy Bear* for a winter in Cordova and spending some time in Seward, Anchorage, Nenana, and Saint Michael on the way home, Mayokok and several other Eskimos were hired by the Lomen brothers, ranchers in Nome, to take seventy reindeer south, dropping off groups of them from Seattle to Boston. Mayokok continued all the way to Boston, trained the reindeer for exhibition there, and lived in the city for some time, visiting New York and Philadelphia as well.

Mayokok was married in Wales after brief stints in Barrow and Nome, and he supported his family by carving, hunting and trapping, and working for wages. In 1939, he participated in the Lomen brothers' exhibition at the New York World's Fair and followed that experience by traveling to sportsmen's shows and lecturing on Eskimo life. He and his wife returned to Nome, where they remained for the next seven years, and Robert carved ivory.

In 1947 misfortune struck again when Mayokok discovered that he had tuberculosis. He spent the next three years recuperating in a sanitarium in Seward. Like Ahgupuk and Moses, who also had some interest in art before their infirmities, Mayokok, too, dates his commitment to an artistic career directly from a period of convalescence. In a 1976 interview, he related the beginning of his dedication to drawing and writing:

> I didn't have any experience in writing, but there at the hospital at Seward, in the sanitarium where my ribs were removed to collapse my lung, I had to do something while recovering from surgery in order to kill time and amuse myself or to keep from worry. I started telling the nurses about where I came from and what we do for living, and the psychologist who was employed there told me to write about an experience I had in hunting. So I complied, and wrote an experience I had when I first started going out. At the same time I started sketching pictures. (Mozee 1976, p. 247)

Mayokok ran an informal outlet for Native arts and crafts in Fairbanks at the end of his recuperative period, in 1950, and also worked for the Fairbanks radio station KFAR, broadcasting news in Inupiaq, the Eskimo language of northwest Alaska. But by this time he was working hard to develop his own pen and ink drawing and experimenting with oil paints. He learned to work quickly and sold, for very modest prices, everything he made. He was able to quit both broadcasting and selling others' crafts to pursue his own art.

Soon stockpiling his work, the artist traveled to various parts of Alaska to sell it; he finally settled in Anchorage. During this time Mayokok also began to pursue his writing more actively and prepared one or two articles annually for some five years for the *Alaska Sportsman*. He later illustrated books that he and others wrote on Alaskan Eskimos (no. 67).[13]

Mayokok, however, was better known for his art, and he preferred it to writing. He worked in a variety of media, including ink, acrylic, watercolor, and oil, on paper, canvas, and various kinds of animal skin. From the mid-1970s Mayokok sketched and visited with tourists in the Treasure Shop in Anchorage and spent winters in Hawaii. By the time he died in Anchorage in 1983, his work was included in the collections of many Alaska museums, the California Academy of Sciences, the Indian Arts and Crafts Board, and hundreds of private collectors.

67. Robert Mayokok, *Untitled* (Eskimo hunter), 1970
From *In the Beginning* (Anchorage, 1970)
Pen and ink on paper, 12.6 × 20 cm; Gift of Helen A. White, 80.53.3

68. Florence Nupok Malewotkuk, *Walrus on Ice Floe,* ca. 1965
Ink on sealskin, 134.5 × 104.1 cm; Gift of the Anchorage Museum Association, 75.56.1

Mayokok's own assessment of his skills and fortunes is characteristically modest and true to the faith that sustained him through the tragedies of his life: "I don't think my pictures are as good as some other artists' work, but they seem to sell better. It's God-given talent that I didn't care for myself, but other people like that work because God put something in them so they take to liking my pictures" (Mozee 1976, p. 249).

One other Eskimo artist of this generation is Florence Nupok Malewotkuk (1906–71), from the village of Gambell on Saint Lawrence Island.[14] Her art work did not develop in a time of physical hardship but did seem to grow out of a sense of isolation in her remote community and a desire to share her vision of her people and their way of life with a wider world. Malewotkuk developed an early interest in drawing, and when she started mission school at the age of seven, she was already known as a "picture maker" (Hargraves 1982). From the age of nine she sold her pictures to non-Native visitors aboard ships visiting Gambell.

Malewotkuk's greatest encouragement came from the collector and archaeologist Otto Geist of the University of Alaska, who first met the artist on a visit to Saint Lawrence Island in 1926. Recognizing Malewotkuk's artistic skills as well as the documentary value of her portrayals of traditional Eskimo ways, Geist commissioned her to do thirteen pictures for the University of Alaska Museum, in Fairbanks. In the months after completing the commission, she produced more than ninety drawings colored with crayon or watercolor on 7-by-11-inch tablet paper. Geist acquired them for the university, paying her in both money and trade items such as jewelry.[15] Other important early encouragement came from Margaret Murie, the wife of the eminent biologist Olaus J. Murie, during a visit in the 1930s (Matthews 1973, p. 21). Twenty years later, the artist Kay Roberts of Anchorage bought a series of drawings from Malewotkuk which were then reproduced by a Seattle department store on place mats, glasses, and note paper under the copyrighted name Bering Sea Originals (Matthews 1973, p. 21; *Anchorage Daily Times* 1973).

In 1964 Malewotkuk was the only woman to participate in the federally funded Manpower Development and Training Act Designer-Craftsman program in Nome (Ray 1977, pp. 51–52, 271). In the 1960s, for Darroll Hargraves, then a Bureau of Indian Affairs teacher in Gambell, she completed a series of more than twenty drawings on poster board chronicling the traditional life of Saint Lawrence Eskimos. Although Malewotkuk became ill in 1967 and never fully recovered her vitality, she worked actively throughout the 1960s, producing and selling her drawings on paper and large compositions in ink on sealskin. She died in Anchorage in early 1971.

Malewotkuk's drawings maintained throughout her life the goal of her early efforts, to tell the story of her people and the animals on whom the Eskimos of Saint Lawrence Island depended for their subsistence. Her early work is schematic and simply rendered, while much of the later work, especially some of the large compositions on sealskin, employ rich, three-dimensional shading to give the animals mass and volume. The Anchorage Museum collection of nine works by the artist includes the large composition *Walrus on Ice Floe* (no. 68).

Artist Visitors between the Wars

Along with the early resident painters, indigenous and transplanted, visiting artists continued to travel to Alaska between the two world wars. A frequent visitor was the painter Edmond James FitzGerald (1912–89), who first went to Alaska in 1928, spent a number of summers there in the 1930s, and returned to work and paint again late in life. Although not an immediately recognizable name among Alaskan artists, FitzGerald was the finest watercolorist to work in the region in this century.

FitzGerald was born in Seattle. His older brothers Gerald, Jean Maurice, and Michael all showed considerable talent in art. Gerald served as a topographic engineer for the United States Geological Survey, and his stories from mapping assignments probably influenced his brother James to go north. Maurice was a direct artistic influence: FitzGerald called him "my first and perhaps most important teacher" (Bonnell 1986, p. 55).

A more celebrated teacher was the artist Eustace Ziegler, with whom FitzGerald studied after Ziegler moved to Seattle in 1924, and who must also have encouraged FitzGerald to visit the North. He did so for the first time in the summer of 1928, serving as a crewman on a cable ship that serviced underwater telegraph cables in southeast Alaska. He returned to Alaska seven times in the 1930s with the United States Geological Survey.

FitzGerald's work for the government survey as boatman, field assistant, cook, and packer gave him an outstanding

69. Edmond James FitzGerald, *Squirrel Creek,* ca. 1970
Watercolor on paper, 35.5 × 53.3 cm; Gift of the Anchorage Museum Association, 89.9.1

opportunity to travel throughout the territory, and he took both oils and watercolors along with him wherever he went. The watercolors proved much more practical for his spare-time artistic endeavors while on the move, and they are his most frequent and most accomplished works. In the 1930s he visited and made watercolor views of southeast Alaska; the Tikchik Lakes and Goodnews Bay areas of southwest Alaska; the Susitna Valley south of Mount McKinley; and the Mentasta Pass area. Some thirty years later, in 1970, he traveled to the Brooks Range, North Slope, and interior regions of the state while making illustrations for a Humble Oil Company article on the proposed trans-Alaska pipeline (no. 69).

FitzGerald's watercolors are marvelous examples of the expressive potential of the medium. Documentary and often tightly rendered, they at the same time are executed with a rare

sensitivity to the formal qualities of the paint itself. The watercolors are delightful as much for the handling of the medium as for the crisp, clear views they give of locales, activities, and the character of weather and light.

The well-known watercolorist Eliot O'Hara (1890–1969) also made a trip north prior to World War II, painting in southeast and south-central Alaska in the spring of 1940. The museum's five O'Hara watercolors include images of Columbia Glacier, Ketchikan, and Cape Saint Elias (no. 70).

The early resident artists proved to be as varied in their vision of Alaska as the territory's earlier visitors, if not more so. Long-term residence seems to have led not to the discovery of the same "real" Alaska, but to exploration of variations. From the cool, sublime image of an untouchable landscape in Sydney Laurence's paintings to the lively world of a rowdy

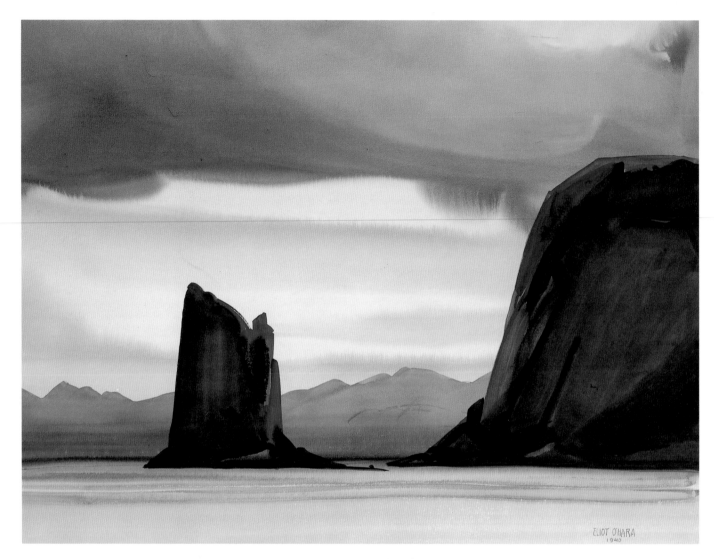

70. Eliot O'Hara, *Cape Saint Elias, Alaska,* 1940–41
Watercolor on paper, 40 × 53.4 cm; Gift of the Anchorage Museum Association, 74.62.2

frontier in Eustace Ziegler's work, artists in the same environ-ment focused on different aspects. Unfortunately, long-term residence coupled with commercial success in nearly every instance led to stale repetition toward the end of these artists' careers. But we also see in this era some of the first conscious efforts at painterly experimentation and a growing awareness of the potential of the medium itself.

The development of an artistic community in more recent years has helped mitigate the repetitive, commercially driven aspects of working in a remote area and encouraged the kind of experimentation we begin to see in these early years. But before that community formed, two more groups of visiting artists contributed to the body of Alaskan art works. Sent by the United States government to make official images of Alaska for the Works Progress Administration in the 1930s and to chronicle World War II in the 1940s, these professional artists produced still another image of America's northern frontier.

1. For a much more thorough account of Sydney Laurence's life, career, and relation to the art of his time, see my catalogue for the 1990 retrospective, *Sydney Laurence: Painter of the North* (Woodward 1990a).

2. For these and other delightful but uncorroborated tales of Laurence's early adventures, see Jeanne Laurence, *My Life with Sydney Laurence* (1974), and H. Wendy Jones, *The Man and the Mountain: The Life of Sydney Laurence plus an Anthology of Alaskan Prose and Poetry* (1962). The latter was written by both Jones and Jeanne Laurence and contains much of the same material as the former. Jeanne, Laurence's second wife, met Sydney when he was more than sixty years old, and her stories of those early adventures are undoubtedly based largely on his own accounts, some of which had clearly been embellished in the intervening years. Several of these and other interesting stories were perhaps first recounted by Cyrus Peter Francisco. Francisco met Laurence in Los Angeles in 1931 and was both his student and secretary, handling the sale and promotion of the artist's work. In 1932 Francisco wrote a brief account of some of the highlights in Laurence's life and career as told to him by the sixty-six-year-old artist. The manuscript circulated in typescript form until it was published in 1990 under the title *The Man and the Mountain: Sydney Laurence's Mt. McKinley.*

3. These real successes were substantially embellished in Laurence's own statements and those of others. His claims of awards at the Paris Salons of 1896 and 1897 are without foundation, as are accounts of a purchase of a large Laurence painting by the French government (variously reported as for the Musée du Louvre or the Luxembourg Gallery) and his knighting by Queen Victoria. It is unfortunate that these obvious embroideries have so clouded the artist's real accomplishments, and it was the chief task of the 1990 retrospective exhibition and catalogue of his work to divide the real from the fantastic in this legendary figure's career. For the success of that undertaking, we have largely to thank the indefatigable efforts of Anchorage journalist Sue Burrus, whose years of careful research provided the basis for the annotated chronology of the artist's life which appears in the exhibition catalogue. Former Anchorage Museum Director Robert L. Shalkop should also be given credit for doing the first serious research on the artist some years before (Shalkop 1975, 1982b).

4. Sydney Laurence, interview with the *Los Angeles Times*, reported in the *Anchorage Times*, December 3, 1925.

5. For more on the Browne-Laurence encounter and other possible contacts between the two artists, see my article for *Southwest Art* (Woodward 1990b). Browne's 1910 journal may be found in the Belmore Browne Papers (Browne n.d.), Box 2, Folder 4. The brief text pertaining to the encounter with Laurence reads, "Lawrence at Beluga is a sad relic of the frontier, or a noble one if you want. Starting as a successful correspondent for *Black and White*, he saw the Boer War, was stationed on battleships, and saw the world from a fine viewpoint, was talented, a gentleman, and met everyone. He came to America, joined the Salmagundi Club, took prizes, but being unable by his health to continue his work, he eventually drifted to Alaska, and after six years of tent dwelling, he is at Beluga."

6. The best single source of biographical information on Ziegler and reproductions of his work is Shalkop 1977. For other interesting items on Ziegler, see Barker 1940; Campbell 1974; DeArmond 1978; Hoffman 1969; Paxton 1986; Queener-Shaw 1987; and Wilson 1923.

7. There is no single comprehensive work on Lambert. An article for *Alaska Journal* (McCollom 1976) is the most helpful account. McCollom was designated by the family to edit and publish the manuscript found in Lambert's cabin after his death (the manuscript was never published). Among the other, relatively spare, sources on Lambert are *Alaska Life* 1942; First National Bank of Fairbanks 1986; Kennedy 1939; Queener-Shaw 1987; and Wold 1965, 1973.

8. For more on Dahlager, see Queener-Shaw 1987 and Roppel 1977.

9. For more on Heurlin, see Bedford 1986; *Nanook News* 1971; *Tundra Times* 1972; and Wold 1973.

10. It has often been erroneously assumed and reported that Ahgupuk turned to art as a career because his bad leg left him unable to hunt successfully. In fact, he continued to hunt actively for years, supplying many of his own skins for his drawings.

11. Among the publications illustrated by Ahgupuk are Adams 1961; Ahgupuk 1953; Green 1959; and Keithahn 1944.

12. Mozee 1975 and Woods 1957 provide a good deal of information about Ahgupuk's life and a fine sense of his wit.

13. Among them are Mayokok 1951, 1959, and 1960; Brown 1981; Caswell 1968; and Silook 1970.

14. Although Malewotkuk's Eskimo name has usually been rendered "Nupok," the earliest drawings that she signed with the name, from 1927, read "Florence Napuk," and in 1929 she signed her drawings "Florence Nupuk."

15. For a more detailed account of Geist's compensation of Malewotkuk's work and his interest in and encouragement of the artist, see Hargraves 1982.

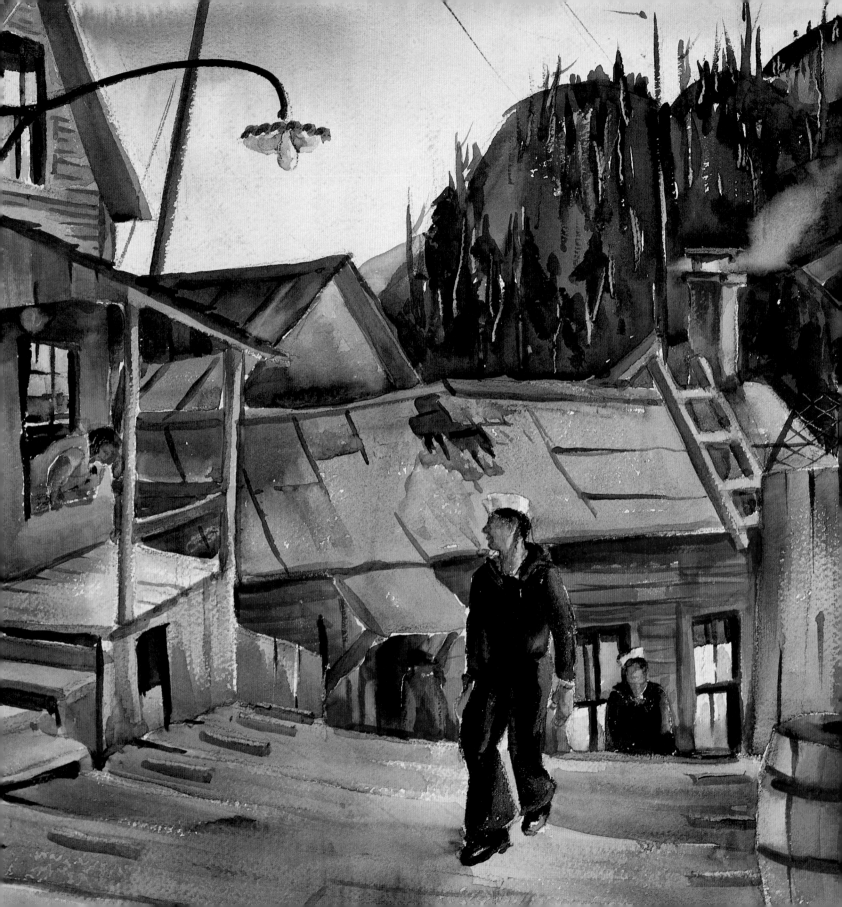

CHAPTER 4

OFFICIAL IMAGES: ARTISTS OF THE WPA AND WORLD WAR II

The WPA Alaska Art Project

Between 1937 and 1945, two new groups of artists came from outside Alaska to make images of the territory. The first group of twelve artists arrived in the spring of 1937 under the auspices of the United States government's Works Progress Administration (WPA). At first glance their mission, to produce paintings that would help publicize the territory of Alaska, harks back to the earlier era of official artists on exploring expeditions. But unlike those earlier expeditions, for which artistic representations were merely a small though important adjunct, the Alaska Art Project of 1937 had art as its primary focus.

There is another difference as well. While the range of work that was acceptable to the WPA was necessarily limited to a fairly realistic middle ground, the constraints and instructions placed on the artists of 1937 were much looser than those on the documentary painters of the late eighteenth- and early nineteenth-century exploring expeditions. Paintings commissioned by the WPA look conservative to our eyes a half century later, but it is clear from early correspondence between the project's organizers that individual expression was not only welcomed but sought. Outlining the personal histories of the twelve artists, Federal Art Project Director Holger Cahill noted in a letter to Ernest Gruening, director of territories and island possessions: "John Walley, Merlin Pollock, and Edwin Boyd Johnson, of Illinois, all were trained at the Chicago Art Institute. In other respects their background and experience reflect the sharp differences which have contributed to the individual-

ity and expressiveness of art in the Middlewest today" (Cahill 1937). This recognition of individuality and expressiveness as virtues is a far cry from the directive of early expeditions' organizers that the artists strive only for accuracy, shunning embellishment and individual expression.

The Alaska Art Project had originally been conceived as a proposal to publicize through art works the territories and island possessions of the United States—Alaska, the Virgin Islands, Puerto Rico, and Hawaii. Begun in April 1937 at the request of Secretary of the Interior Harold Ickes, with the assistance of Ernest Gruening, the proposal was referred by the WPA to Holger Cahill. Cahill agreed to a six-month experiment that would send artists to Alaska only.

The twelve artists were chosen by state directors of the Federal Art Project. They were all competent, experienced painters who had worked with the project before. As was typical, they were paid a wage and given travel expenses; their paintings would become the property of the WPA. In what now seems an extraordinarily brief time for such a bureaucratic endeavor to be conceived and enacted, the artists were chosen and sent their travel notifications in May. The artists met and were briefed in Seattle, and were in Alaska by June 4.

Tony Mattei of New York was chosen as artist supervisor of the group. Mattei was responsible for arranging the artists' travel schedules and for compiling a list of the paintings completed by the project's end. In Ketchikan, he divided the artists into four groups of three. All four groups spent the first month in the Ketchikan area, exploring islands, industries,

and settlements nearby. They had unusually good weather for the first weeks, but rainy weather began later in the month and continued throughout most of the summer. In such weather, the artists often began by sketching outdoors and then worked up the studies in hotel rooms shortly after.

The groups took off in various directions, per Mattei's plans, in mid-July. They traveled by boat, car, and train, and whenever possible used transportation provided by the federally owned Alaska Railroad and such agencies as the United States Forest Service. At the request of Gruening, all of the artists spent time in Mount McKinley National Park. There they stayed in Forest Service cabins, each group working in the vicinity approximately ten days.

Originally planned to continue through November, the project was cut a month short by bad weather, and the artists were instructed to complete their work at home before turning it in to the WPA. Mattei's lists of completed works were inconclusive. The count ranged from seventy finished and seventy unfinished works by Vernon Smith, to no finished works by Carl Saxild, who preferred to develop his paintings from sketchbooks on returning to his home in Massachusetts (Binek 1987, p. 6).

The project artists expected that a major exhibition of their works would be held, but the show was never mounted. The Treasury Relief Arts Program of the United States Treasury Department, which was given responsibility for making use of the work, was concerned about adverse publicity for the program as a whole because the costs of the Alaska Art Project were so high compared to other fine arts projects of the WPA. Most of the project's records were discarded even before the disbanding of the WPA near the outset of World War II, and it is not known what became of many of the paintings. Some of the work was sent to Timberline Lodge in Oregon, itself a WPA project, and eventually found its way to the governor's mansion in Juneau. Many paintings were sent to the hotel at Mount McKinley National Park, and forty-one of them were destroyed in a fire that burned the hotel to the ground in September 1972.[1]

At the time of the Anchorage Museum retrospective exhibition on the Alaska Art Project in 1987, some sixty paintings and many drawings had been located, representing eleven of the twelve artists.[2] Others have been traced since that time, and efforts to reconstruct the details of the project and the whereabouts of the lost paintings continue.

The Alaska Art Project Artists

Tony Mattei (b. 1900), the artist supervisor of the group, was born in New York and trained at Cooper Union, the National Academy of Design, and the Art Students League. He had an active professional career before and after the Alaska Art Project. Prior to 1937 he had shown regularly in New York at the Eighth Street Gallery as well as in Boston, and had been included in exhibitions at such major institutions as the National Academy, the Metropolitan Museum of Art, and the Brooklyn Museum.

In Alaska Mattei traveled with Arthur Kerrick and Carl Saxild. Eight Alaskan works by Mattei are known, although five were destroyed in the Mount McKinley Park fire. The Anchorage Museum owns *Alaska Railroad, Seward*. Mattei's work is also represented in the collections of the National Museum of American Art, Washington, D.C., the Albright-Knox Art Gallery, Buffalo, the Museum of Modern Art, New York, and the Detroit Institute of Arts.

Arthur T. Kerrick (1901–60) was born in Minnesota and trained at the Minneapolis School of Art and the Art Students League in New York. Kerrick was an instructor at the Walker Art Center in Minneapolis and a founder of the Minnetonka Art Center in Minnesota. His exhibition record includes the Pennsylvania Academy of the Fine Arts, Philadelphia, the Kansas City Art Institute, and the Art Institute of Chicago, and his work is in the Anchorage Museum as well as the Smithsonian Institution and the Minnesota Historical Society, Saint Paul. He returned to Alaska in 1942 when he was commissioned to paint a mural in the courtroom of the Federal Building in Anchorage, a work that is still displayed there.

Carl Saxild's early work was described by Cahill as "semiabstract" (Cahill 1937). According to Cahill, a Saxild abstraction entitled *Power* was circulating in a Federal Art Project exhibition in New England at the time of his selection for the Alaska Art Project. Although quite representational, Saxild's untitled Alaskan coastal landscape is much more stylized than those of the other project artists (no. 71). Dramatically simplified clouds and a distant mountain range are separated by a broad band of water from the energetic, brightly colored town at the extreme bottom of the canvas. There is a nice tension between the flat overall handling, with loose, perfunctory modeling, and the reading of deep space created by the inclusion of tiny ships in the otherwise blank band of water. This and three other large Saxild canvases in the Anchor-

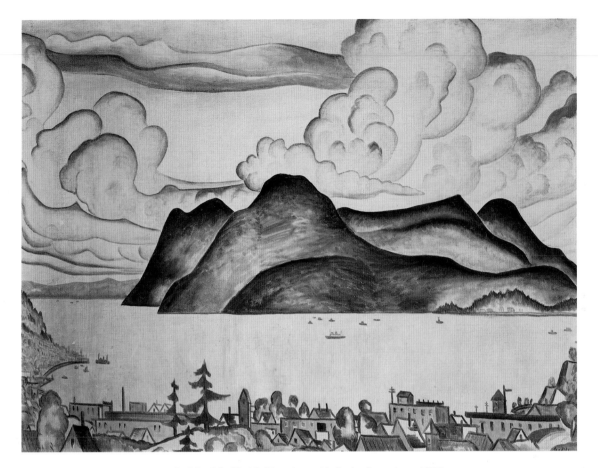

71. Carl Saxild, *Untitled* (southeast Alaska landscape), ca. 1937
Oil on canvas, 102 × 132 cm; Gift of the Alaska Railroad Corporation, 86.77.3

age Museum, like all of his Alaskan paintings, were completed in the artist's home studio after the trip.

The travels of the trio consisting of Edwin Boyd Johnson, Prescott Jones, and Vernon Smith are well documented.[3] Although theirs is the only complete itinerary currently known, it must have been typical of those of the other groups, who covered much the same ground at slightly different times and occasionally overlapped in various locales.

Johnson, Jones, and Smith spent five weeks in the vicinity of Ketchikan, left on July 17 for Wrangell, Petersburg, and Juneau, and then went on to Cordova and Valdez. After a two-week stay in Valdez, they traveled north to Fairbanks on the Richardson Highway by bus, stopping for a week in Paxson. Two weeks later, they hitched rides farther north, into the mining region north of Fairbanks as far as Circle. On September 16

the trio went by train to Mount McKinley National Park and after ten days there departed for Anchorage and the Kenai Peninsula. The month of October was spent in exploring the peninsula, after which the group went by ship back to southeast Alaska, arriving November 2. Another ten days were spent in the Ketchikan area and Metlakatla before Smith and Jones left for Seattle with the other project members; Johnson followed a week later.

Edwin Boyd Johnson was born in 1904 in Tennessee. He was schooled at the Art Institute of Chicago and the National Academy of Design, and in Vienna, Paris, and Alexandria, Egypt. A veteran participant of WPA art projects as a designer and muralist, his *Pioneers of Medicine* frescoes for the University of Illinois College of Medicine in Chicago are among his best-known works. They were documented in *New Horizons*

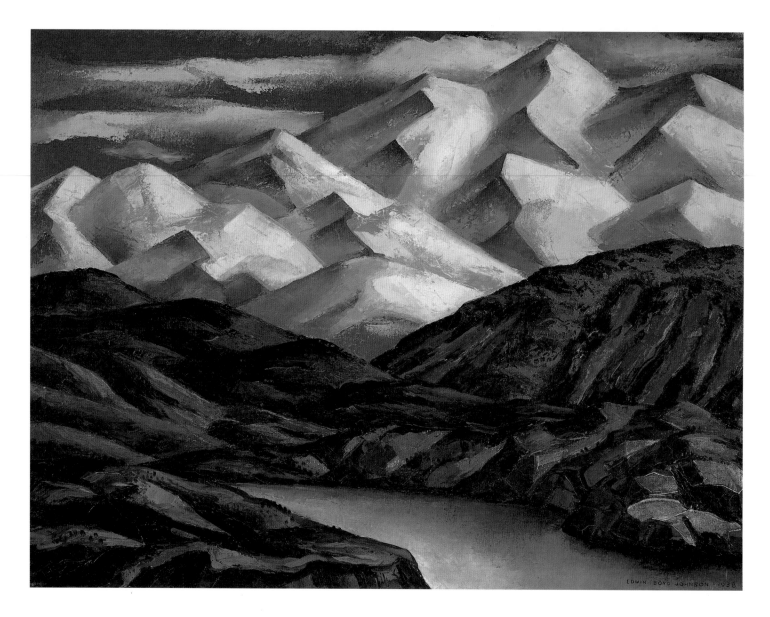

72. Edwin Boyd Johnson, *Mount Kimball, Alaska,* 1938
Oil on canvas, 76.7 × 102 cm; Joint purchase, Anchorage Museum Association
and Municipal Acquisition Fund, 92.78.1

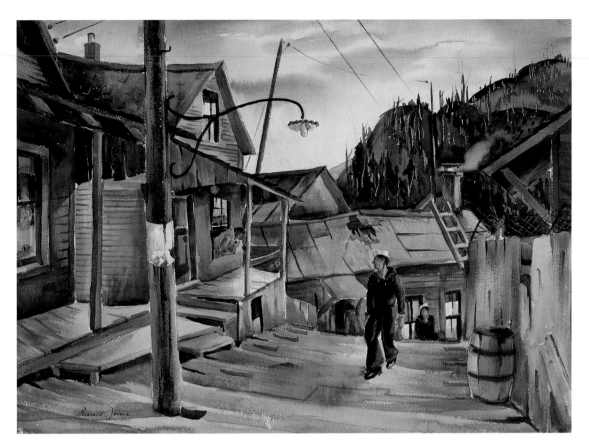

73. Prescott M. M. Jones, *Street in Ketchikan,* 1937
Watercolor on paper, 57 × 78.7 cm; Municipal Acquisition Fund purchase, 79.80.2

in American Art, an exhibition of WPA art at the Museum of Modern Art in 1936. His Alaskan paintings are heavy, dark, still, and solid in comparison with those of the other WPA Alaska painters; his mountains are built of solid masses of simplified shapes rather than the flickering light and line employed by most of his colleagues (no. 72).

Prescott M. M. Jones (d. 1981) was also born in 1904, in Haverhill, Massachusetts. Educated in Boston at Tufts College and the Vesper George School of Art, he had a long list of exhibitions to his credit before going to Alaska with the WPA project at the age of thirty-three. In addition to his active participation in exhibitions in Boston and throughout New England, he had been included in national showings at the Pennsylvania Academy of the Fine Arts, the Art Institute of Chicago, the Carnegie Institute, Pittsburgh, and the New York Watercolor Society.

Jones's Alaskan work is well-documented in the Anchorage Museum collection by more than a dozen drawings and a like number of watercolors. *Street in Ketchikan* is typical of his Alaskan work (no. 73). The fairly loose, fluid watercolor captures the dilapidation of the buildings and character of the surrounding landscape in a relaxed, confident manner, picking out just enough details to produce a strong sense of place.

Ten years older than Jones and Johnson, Vernon B. Smith (1894–1959) had served in World War I after studying at the New York School of Fine and Applied Arts. He stayed on in Paris for a year after the war to study art, and then moved to the Cape Cod area of Massachusetts where he worked as an art instructor and began to exhibit his paintings widely. Like other members of the Alaska Art Project, he had been a participant in earlier WPA programs. In addition to his showings with exhibitions of WPA work, he had already exhibited at the

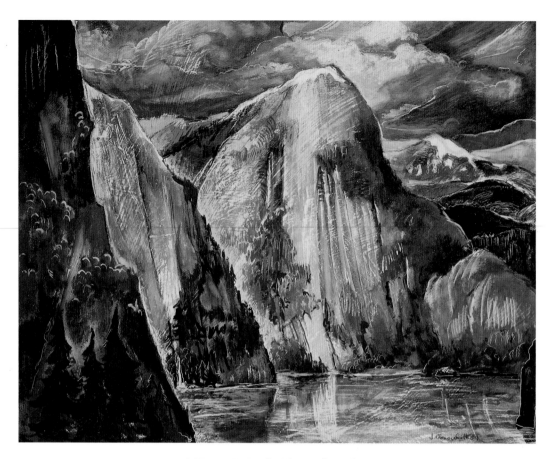

74. Vernon B. Smith, *The Punch Bowl,* 1937
Gouache on paper, 44.1 × 54.3 cm; Municipal Acquisition Fund purchase, 80.28.1

Museum of Modern Art and at the Goodman-Walker Gallery in Boston prior to going to Alaska.

Smith produced some seventy works during his stay in Alaska. His gouache on paper, *The Punch Bowl* (no. 74), is a bold evocation of the Alaskan landscape, quite removed in character from the easygoing imagery of Prescott Jones. Smith's drier, more aggressive handling of the medium and suppression of topographic detail in favor of expressive color and line enabled him to explore more fully the landscape's dramatic potential. Three Alaska watercolors by Smith are in the Anchorage Museum.

Because Austin Mecklem, Merlin Pollock, and John Edwin Walley traveled with their wives, they were known as the project's "married" group. Mecklem's wife, Marianne Appel Mecklem, was also a painter, and though she was not

an official member of the project, she did produce some paintings on the trip.

Austin Mecklem (1894–1951), who was born in Colfax, Washington, had been to Alaska before the WPA project when he worked in Juneau's Treadwell gold mines for two years prior to World War I. He had also seen the North while serving in Siberia in the navy during the war. He studied at the Art Students League in New York as well as at the San Francisco School of Fine Arts. Upon completion of his studies, he taught at the Oregon Museum School in Portland from 1927 to 1929, and then returned to the Art Students League as an instructor in 1929–30.

In the years preceding the Alaska Art Project, Mecklem had exhibited widely, and his work had been acquired by the Whitney Museum of American Art in New York. He and his

wife, Marianne Appel, also collaborated on a painting now in the collection of the United States Post Office in Wrangell, Alaska. The known Alaska paintings are in the Newark Museum and private collections.

Merlin Pollock (b. 1905) traveled with his wife, Barbara. Born in Manitowoc, Wisconsin, Pollock was known as a Chicago artist by the time of the WPA project. A specialist in mural painting, he studied fresco techniques in France and Italy while on a fellowship from the Art Institute of Chicago. Before joining the Alaska Art Project, he taught fresco painting at the Chicago Art Institute and was supervisor of mural painting for the WPA Illinois Art Project in 1936–37. Later he taught at the School of Art at Syracuse University and was chairman of the graduate school there until his retirement.

In an essay prepared for the retrospective of the Alaska project, Pollock recalled the trip and its impact on him:

> After we returned home to our original projects, our completed work was sent to the Washington office for its distribution. To my knowledge no public exhibition of the work was held and, at least for those of us from Chicago, that was the end of the Alaskan Project. But who could cut off so abruptly the wonderful experience of Alaska? The sweep and breadth of its landscape and wild beauty left a permanent imprint on my mind, and I continued over time to develop some paintings from sketches or ideas conceived while in Alaska. Even in my later years, long after World War II and my University work, the influence of the Alaskan experience emerges again in some of my work. (Binek 1987, p. 14)

Another member of the married group was John Edwin Walley (b. 1910), who was also educated at the Art Institute of Chicago. Born in Sheridan, Wyoming, Walley drew cartoons for a newspaper while in his teens and was a member of the Wyoming Artists' Association before working with several advertising agencies in Chicago. He was named director of the mural division of the Fine Arts Project Design Workshop and was appointed assistant state director of the Fine Arts Project for Illinois. One of his Alaska drawings, *Indian Town, Alaska,* is in the collection of the Southern Illinois University Museum, Carbondale.

The final group of Alaska Art Project painters, who styled themselves the "New York group," consisted of Karl Fortess and Roland Mousseau, from Woodstock, New York, and Ferdinand Lo Pinto, from New York City.

Roland Mousseau (1899–1980) was born in Minnesota and educated at the Minneapolis School of Art and the Art Students League of New York. He later served as an instructor at the Minnesota School of Art. At the time of the Alaska Art Project, Mousseau was a member of a thriving colony of artists living in Woodstock. Before 1937, examples of his work from other federal art projects were shown in group exhibitions at the Phillips Memorial Gallery in Washington, D.C., and at the Museum of Modern Art. No examples of Mousseau's Alaskan work were found for the 1987 Alaska Art Project exhibition at the Anchorage Museum, and he is as yet unrepresented in the museum's collection. One of his WPA oil paintings was destroyed by the Mount McKinley National Park fire.

Ferdinand Lo Pinto (b. 1906) was trained at the National Academy of Design and the Art Students League and exhibited widely before and after the trip to Alaska. Lo Pinto produced pen and ink illustrations for the federally sponsored guidebook to Alaska, *A Guide to Alaska: Last American Frontier* (Colby 1939), and two of his Alaska Art Project paintings were reproduced in the guide as well.

Karl Eugene Fortess (b. 1907) was born in Antwerp, Belgium, but came with his family to America in 1912 and became a United States citizen in 1923. He, too, studied art at the Chicago Art Institute and the Art Students League of New York. Before the WPA project his work had won recognition and inclusion in shows at the Corcoran Gallery, Washington, D.C., and the Cincinnati Museum of Art. Along with several other Alaska project painters, he was included in *New Horizons in American Art,* the exhibition of WPA painting at the Museum of Modern Art. An untitled view of a coastal village, one of a number of paintings, prints, and drawings by Fortess in the Anchorage Museum, is typical of the artist's Alaskan work (no. 75).

In an essay on the Alaska Art Project, Fortess reflected on the difficulty and unfamiliarity of the task assigned to the painters:

> Our goals were not very clear. The people from the Department of the Interior . . . were as unfamiliar with the Territory of Alaska as we were. We were simply told it was a new territory, go explore it, and bring back your

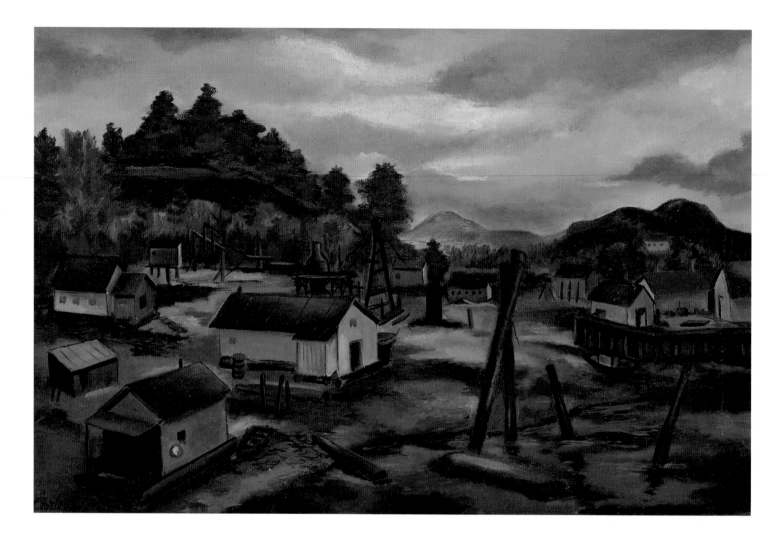

75. Karl Eugene Fortess, *Untitled* (village shore), ca. 1937
Oil on linen, 38 × 58.5 cm; Gift of Lillian Fortess, 84.69.2

impressions in pencil or in oil or in whatever medium you feel most competent to do it in. . . .

Whether we were the right people to send up to document a territory, I think, is questionable. A group of photographers would have given you a documentary, or a film maker would have covered everything from the animal life to the scenic to the working conditions of the industries—everything that existed up there at the time. We were all what we called "studio painters"; people who worked in their own homes and did things out of their heads. Being asked to do a documentary was an experience that was quite strange to many of us. But it was not for me to say; they sent artists. (Binek 1987, p. 9)

From our current perspective, the artist's comments aptly summarize the major conceptual difficulty faced by the painters, and they explain much about the appearance of the Alaska Project work. In all the work by these artists there is to varying degrees a self-conscious attempt to provide documentation. With few exceptions, their natural inclinations to experiment with new modes of expression and representation are held tightly in check. It is, then, a tribute to the creativity and skill of the individuals in the group that the art they produced often transcended the goal of recording. Constantly on the move, only adequately provisioned at best, they took their documentary charge seriously and tried to adjust again and again to the changing landscapes and conditions they encountered.

As we continue to discover new examples of their paintings, watercolors, and drawings, the WPA artists' contribution to the developing artistic image of Alaska will become clearer. For now, their "official" images of Alaska serve as a prelude to the work of another group of artists sent by the United States government to document life in the territory.

Drawing the Lines of Battle: Military Art of World War II

World War II provided a crucial turning point in Alaskan history.[4] The war brought disruption to the Native Aleut people in the form of internment, temporary relocation, and the destruction of their homes as battles raged on Alaska's Aleutian Islands. The conflict also brought development (seen either as progress or merely as further disruption) in the form of many new military bases and airports and the Alaska High-

way, built as a military supply route. And the war introduced Alaska to thousands of Americans and others who arrived in the territory to work as soldiers, interpreters, and construction workers.

The Japanese bombed Dutch Harbor in the Aleutians on June 3 and 4, 1942, and seized Attu and Kiska islands, but the war effort in Alaska had already been under way for some three years. When Germany invaded Poland in 1939, there was only one active military post in Alaska and four seasonally active airfields of consequence. Money for construction of new bases began to pour into the territory in 1940 in a belated attempt to shore up this huge, largely undefended northwestern approach to the United States. With the invasion in 1942, the project shifted to high gear. Troops and materiel were sent not only to retake the captured islands but to construct the Alaska Highway and strengthen other defenses. By the war's end, more than 300,000 military personnel had served active duty in Alaska, and many more had come north in support of the buildup (Binek 1989, p. 8).

Official and unofficial artists followed closely on the heels of the first wave of soldiers. The United States Navy, Army War Art Unit, Army Air Corps, and Canadian armed forces sent official artists to document the war. Other outstanding artists who happened to serve in the military at the time came with them.

Unlike the neat, well-organized structure of the WPA project, the source of the artistic depiction of Alaska during World War II was a complex mix of official and unofficial projects by various governmental agencies, support and collaboration of such major magazines as *Life* and *Collier's*,[5] and incalculable personal initiatives. With each passing year we discover additional artists who worked in Alaska during World War II and more of their art work. Here, we will look at the effort as a whole and focus on some of the more prominent artists who took part in it.

Henry Varnum Poor (1888–1970) was one of the best-known and perhaps the most active artist involved in chronicling Alaska during the war. Sent to Alaska with the Army War Art Unit in 1942, he was given a tour of the Alaska Territorial Guard coastline defenses and traveled as far north as Barrow. He also had the opportunity to see some of interior Alaska when he spent time with Joseph John Jones, who was documenting the construction of the Alaska Highway. Poor wrote two books about his experiences, *An Artist Sees Alaska*

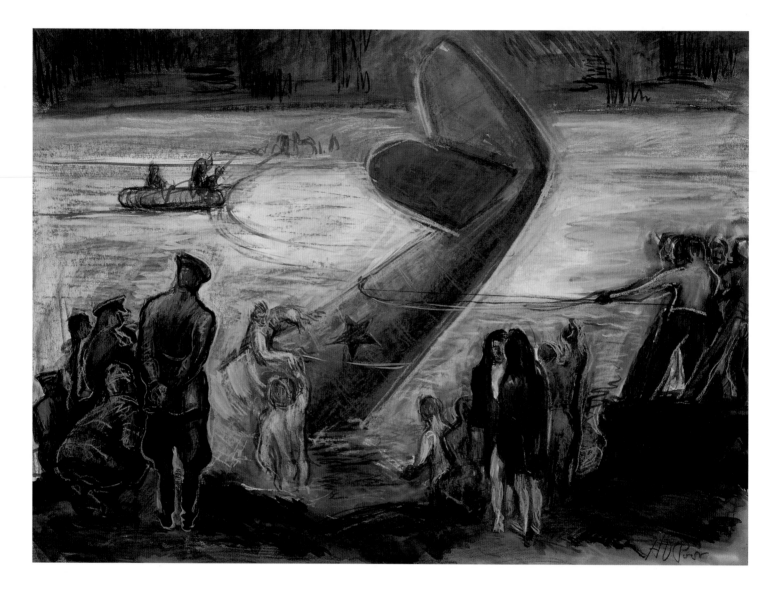

76. Henry Varnum Poor, *Rescue on the River,* 1942–43
Gouache on paper, 35.6 × 48.2 cm; Municipal Acquisition Fund purchase, 78.3.6

(1945a) and *The Cruise of the Ada* (1945b), and much of what we know about the American attempt to document the war visually comes from his pen and brush.

Born in 1888 in New York, Poor was trained at Stanford University, California, the Slade School in London, and the Académie Julian in Paris. He later became a longtime instructor at the Skowhegan School of Art in Maine, and a well-known and prolific artist. His work is included in most major art museums in the country. He went to Alaska along with the other three members of the Army War Art Unit, Lieutenants Willard Cummings, Joe Jones, and Edward Laning, on May 3, 1943. Unlike Cummings, who was actually in the army, Poor, Jones, and Laning were civilian members of the unit. They were chosen by the War Department Art Advisory Committee and given the rank of lieutenant and officers' uniforms but served as "correspondents," with quasi-military status and authority that were at times unclear.

It is noteworthy that in the initial briefing of the group, Poor took it upon himself to explain to the group that their duty was to gather "a wide range of pictorial material of a nature other than that which the camera could catch" (Poor 1945a, p. 45). Each of the artists was sent in a different direction, with a slightly different mission. Poor went to Ladd Field in Fairbanks, where Russian pilots were involved in the extraordinary Lend-Lease airlift, then to Nome, Saint Lawrence Island, and the northwest coast of Alaska to see the outposts of the Alaska Territorial Guard.

In Fairbanks Poor sketched many fine portraits of Russian pilots and scenes of the airlift, and recorded the flights and at least one crash of the airplanes themselves. From Fairbanks Poor, Joe Jones, and Private Ben Dangers (known only as an aide with some art training who produced some drawings) proceeded to Galena and then to Nome. There they met Major Marvin "Muktuk" Marston, who secured the use of a 40-foot boat, the *Ada*, to deliver guns and ammunition to coastal villages as far north as Barrow. Poor, Jones, and Dangers accompanied the crew of the *Ada* on the trip and sketched villages and Native people along the coast.

Poor's *Rescue on the River* is typical of the work he produced in Alaska during the war (no. 76). With shading and a strong, economical line he captured the essence of an incident swiftly and surely. However foreign to his larger artistic goals such a subject might have been, Poor's skills as an incisive observer of fleeting events made him one of the best documenters of activity directly and indirectly related to the war effort. The Anchorage Museum has some dozen examples of his Alaskan work.

The artist Joseph John Jones (1909–63) captured Poor at work in northwest Alaska in the tempera *Henry Poor Drawing Eskimo Children on the Beach* (no. 77). Although he was a fellow member of the Army War Art Unit, Joe Jones had a background quite unlike Poor's. Born in 1909 in Saint Louis, Jones was largely self-taught. His lack of formal training, however, did not deter him from becoming a prolific and accomplished artist, and his exhibition record and the list of collections in which he is represented include many of the major institutions in the United States. His Alaskan drawings are remarkably similar to those of Poor, and since they often traveled together and drew the same scenes, it is difficult to tell their work apart without checking the signatures.

Most of Jones's time in Alaska was spent documenting highway construction. According to Poor, "Jones, with his social-conscious point of view, was much intrigued by reports of the Negro troops who had largely built the Alcan Highway and were now at Livengood" (Poor 1945a, p. 51). The museum has several sketches by Jones of African-American soldiers at work. When funding for the Army War Art Unit was pulled by Congress in July 1943, and the support of the war artists was taken up by *Life* and *Collier's* magazines, Jones traveled to other theaters of the war.

Ogden Pleissner (1905–83) was another well-known artist who worked on the Alaskan front in World War II. Born in Brooklyn, Pleissner studied at the Art Students League in New York before becoming recognized for his western landscape watercolors. He accepted a captain's commission as a war artist with the Army Air Corps even as he was being approached by *Life* magazine to cover the construction of the Alaska Highway. After completing officer's training, he was assigned to the Aleutians.

Pleissner arrived in Alaska in the spring of 1943 and made hundreds of watercolors and drawings in the following three months. Unlike Jones and Poor, Pleissner was near the front, making images of the airfields and planes directly engaged in the fighting. *Headquarters Camouflage, Umnak* is representative of his Alaskan work (no. 78). Much more thoroughly finished than the works of Poor and Jones, Pleissner's watercolors are in no way sketches but are fully realized paintings. Carefully and dramatically composed, they rely for their impact on

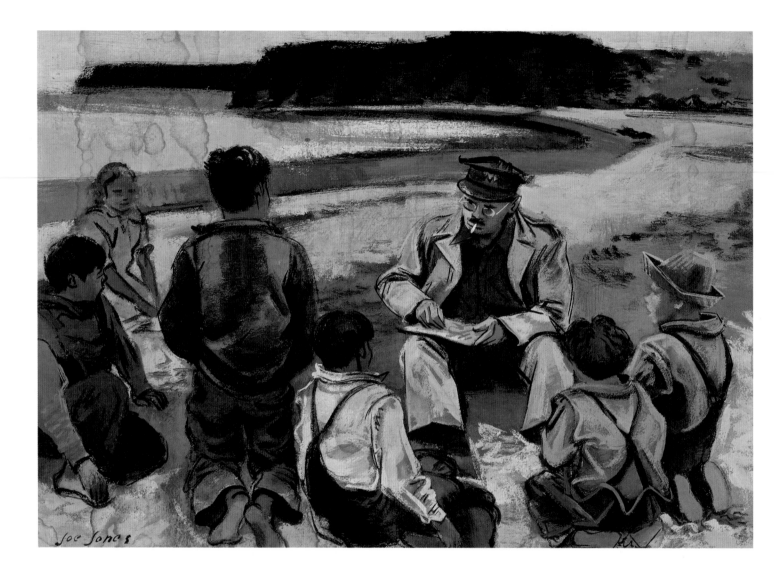

77. Joseph John Jones, *Henry Poor Drawing Eskimo Children on the Beach*, 1943
Tempera on paper, 34.3 × 49.3 cm; Gift of the Anchorage Museum Association, 75.6.2

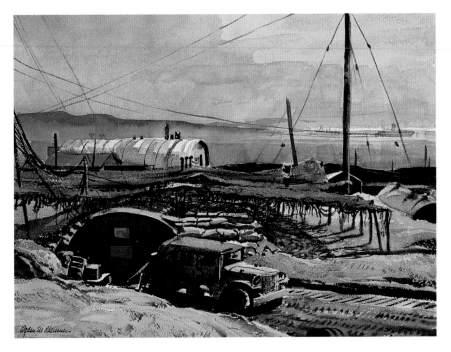

78. Ogden Pleissner, *Headquarters Camouflage, Umnak*, 1942–43
Watercolor on paper, 29.2 × 39 cm; Gift of the artist, 80.57.2

a combination of deft washes of watercolor for local color and shading, dramatic contrasts of light and dark, and just enough detail to make the people, equipment, and movement particular and real.

If Pleissner's are the strongest watercolors done in Alaska during the war, it is little wonder. Although conservative in his technique and approach, the artist was extremely accomplished, and the airfields and maneuvers on the Aleutian front provided excellent material for his brush. He continued working as a war correspondent with *Life* magazine after Congress discontinued war art funding. His Aleutian works were shown at the Corcoran Gallery, Washington, D.C., and he later completed more than forty large paintings depicting the war in the Aleutians.

Pleissner's list of accomplishments before and after World War II is extensive. He won major awards from the National Academy of Design, including the Altman Prize in 1961, and from most of the major watercolor organizations in America. He was a vice president of the National Academy of Design, an instructor at the Pratt Institute, New York, and president and director of the Louis Comfort Tiffany Foundation, Long Island. Pleissner's work is included in the Metropolitan Museum of Art, the Brooklyn Museum, the Philadelphia Museum of Art, the Los Angeles County Museum of Art, and many other major art museums. After the war he painted extensively in New England and in Europe, becoming best known for his hunting and fishing scenes. An entire building is devoted to his work at the Shelburne Museum in Vermont, where his studio has been recreated in one wing.[6]

If paintings of military activity and village life in Alaska during World War II fit well within the normal range of work done by Poor, Jones, and Pleissner, they could not be farther from the regular oeuvre of another artist who painted in Alaska during the war—the renowned abstract painter Ilya Bolotowsky (1907–81). A well-known American abstract painter even before the war, Bolotowsky served as a sergeant in the army in Nome, where he worked as an interpreter for Soviet pilots involved in the Lend-Lease program. Painting was far from his official duties, but he found time to sketch and paint life in Nome and the surrounding area and made a number of strong, stylized small paintings of the local people, among them the Anchorage Museum oil on canvas *An Old Couple* (no. 79).

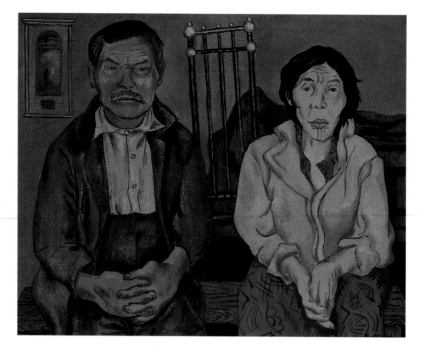

79. Ilya Bolotowsky, *An Old Couple,* 1943
Oil on canvas, 40.6 × 50.8 cm; Municipal Acquisition Fund purchase, 75.14

A number of other noteworthy artists worked officially or unofficially in Alaska during the war. Lieutenant William F. Draper was one of five navy artists assigned to cover the events of World War II. He worked in Kodiak and the Aleutians from October 1942 until the spring of 1943.[7] Don Miller joined the staff of the *Adakian,* an army newsletter, as a cartoonist in 1944, and he also made watercolors and oil paintings of military life in Alaska, one of which is in the Anchorage Museum. Lieutenants Willard Cummings and Edward Laning were members of the Army War Art Unit with Poor and Jones. Cummings specialized in portraiture, and, with Poor, founded the Skowhegan School of Art in Maine. Laning had been trained as a muralist and worked in that field for the Works Progress Administration. He continued his association with *Life* magazine after August 1943 and had a long career as an active, successful artist.

The Canadian artist Henry George Glyde joined his better-known colleague A. Y. Jackson, one of Canada's greatest painters, on a tour of the Alaska Highway in 1943 for the express purpose of making studies of the project.[8] Another Canadian, Edward John Hughes, painted at Kiska in the Aleutians in 1943. Hughes was an official Canadian war artist and

an officer in the Royal Canadian Army. His highly stylized oil paintings of troops and gun emplacements in the dramatic scenery and weather of the Aleutians are among the most striking images of World War II in Alaska.[9]

These and other World War II artists labored under the same kind of restrictive goals laid on the WPA artists in the preceding decade. And as noted earlier, both groups had something in common with the official artist-explorers of more than a century before. But for all of these artists, the immensity and drama of the Alaskan landscape and the unusual character of Alaskan life proved too powerful to ignore. The spirit and skills of accomplished artists responded vigorously to the land and the people. Their work often seems to be straining against the traces of documentary requirement, but it occasionally bursts forth with fresh vision.

The development and attention brought on by World War II proved to be a turning point for Alaska's artistic development. "Discovered" by the wider world, more accessible by road and air, and documented and publicized by artists of skill and reputation, postwar Alaska would be transformed, and the pace of growth in its art community would quicken almost immediately.

1. More than one hundred works of art were lost in the tragic fire, including fifteen oils, fifty-four watercolors, ten original prints, six drawings, and more than twenty photographs. Nine of the thirty-four artists whose works were in the hotel were members of the Alaska Art Project (Binek 1987, p. 3).

2. The Anchorage Museum and guest curator Lynn Binek undertook a major retrospective exhibition of work from the WPA Alaska Art Project in 1987, the fiftieth anniversary of the project. The exhibition brought together more than fifty paintings and drawings produced by project members. The catalogue (Binek 1987) is the single comprehensive work on the Alaska Art Project. It includes a brief introductory essay; descriptions of the itinerary of each group of artists; biographical data on the artists; and reminiscences by two of them, Karl Fortess and Merlin Pollock.

3. Jones's diary of his stay in Alaska, now a part of his papers at the Archives of American Art, Smithsonian Institution, are an important source of information on the WPA Alaska Art Project. The papers of Vernon B. Smith, also at the Archives of American Art, are similarly valuable. Smith maintained the most complete records of any artist involved in the project (Binek 1987, p. 24).

4. *Drawing the Lines of Battle: Military Art of World War II* was the title of a major exhibition of war images of Alaska presented at the Anchorage Museum in 1989. Organized by guest curator Lynn Binek and Curator of Collections Walter Van Horn, the exhibition included ninety-five paintings by American and Canadian artists sent to record events on the Alaskan front for the people back home. Works were borrowed from the collections of the United States Army Center of Military History, the United States Navy Art Center, the Canadian War Art Museum, and other sources. Many of the artists included were shown in Alaska for the first time in this exhibition. Much detailed information and references to primary source materials may be found in the exhibition catalogue (Binek 1989).

5. When in 1943 Congress withdrew support for the Army War Art Unit as a cost-saving measure, *Life* and *Collier's* stepped in to hire the artists in the program. Art Unit artists continued to be billeted and transported by the army but were actually working for the two magazines. The magazines had use of their images and in return agreed to give the finished works to the military after the war (Binek 1989, p. 9).

6. For more on Pleissner, see Peter Bergh, *The Art of Ogden M. Pleissner* (1984).

7. For more on Draper, see Binek 1989, pp. 24–29, and Morgan 1980.

8. The literature on Jackson, one of the two or three best-known Canadian painters, is voluminous. Perhaps most important is *A Painter's Country: The Autobiography of A.Y. Jackson.* Toronto: Clarke and Irwin, 1967. For more on Glyde, see Ainslie 1987.

9. For more on Hughes, see Surrey Art Gallery 1983.

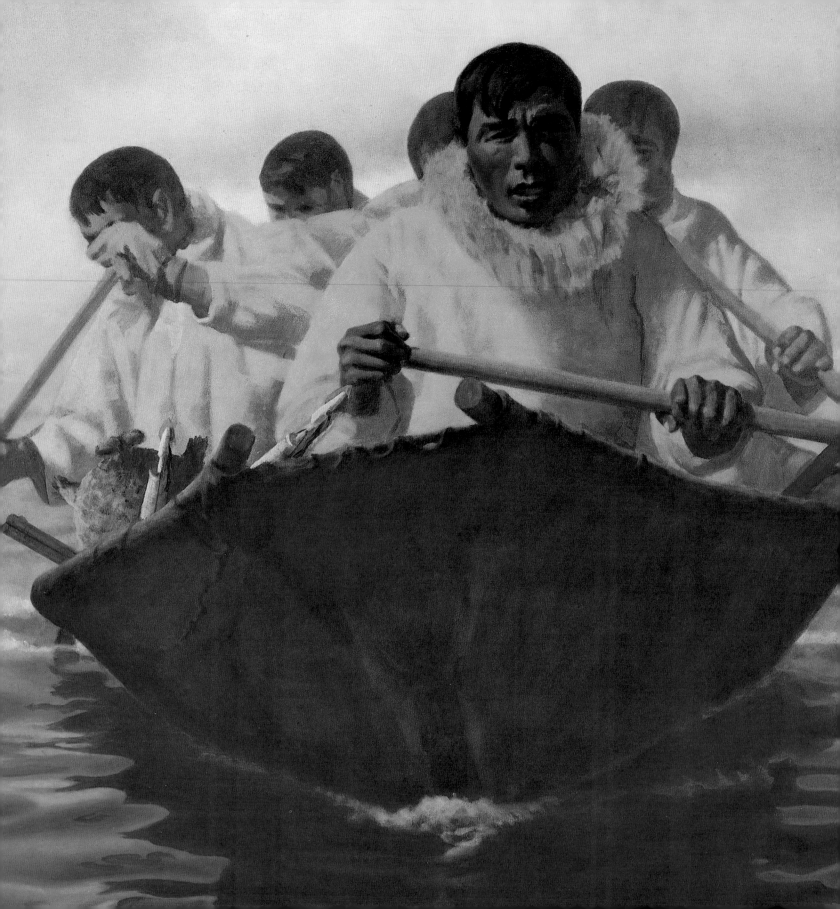

CHAPTER 5

A GROWING COMMUNITY: POSTWAR ART IN ALASKA

World War II is a crucial turning point in Alaska history. While events here may have had minor impact on the war as a whole, the war changed the face of Alaska. For the first time since the War of 1812, continental territory of the United States was invaded and held by an enemy. The strategic importance of Alaska in the North Pacific was emphasized. Aleut villagers were captured and shipped to prison camps in Japan; other Aleuts were transported out of the war zone to camps in Southeast Alaska. After the war they returned to find their homes devastated. The war brought progress as well as destruction. The first road linking Alaska to the lower forty-eight states, the Alcan Highway, was built as a military supply route. Thousands of United States and Canadian troops jammed posts throughout the Territory, and, impressed by what they saw, many of them returned after the war to make their homes here. (Patricia Wolf, in Binek 1989, p. 5)

Anchorage Museum director Patricia Wolf aptly summarized the impact of the war on the territory. The changes in Alaska during and after the war were pervasive. Monumental construction projects—not just the Alaska Highway, but military bases, airfields, and the supporting infrastructure—brought thousands of workers and soldiers to the North. Some of them stayed or returned later, smitten by the attractions of this new "frontier" and finding their hometowns too tame by comparison. The tales they told of the North, as well as the extensive news coverage of Alaska during the war, brought fresh adventure seekers, fortune seekers, and settlers to the territory.

Population growth in Alaska had quickened even before the war, rising from about 59,000 in 1929 to 72,000 in 1939, but the real growth came in the postwar years. The territory's population skyrocketed to 128,000 by 1950 and to 182,000 just three years later. With rising population came a natural desire for more self-government. When Alaska achieved statehood in 1959, the population stood at almost 250,000, an unthinkable number just two decades before.[1]

Just as Alaska was a different place after World War II, so was its arts community. Serious, professional artists had been working in the territory before World War II, and shortly after the war longtime Alaskan Herbert Hilscher recognized the interest of the territory's residents in art:

> Residents of the Northland are not unmindful of cultural needs. Alaskan homes have more good original paintings by recognized artists than I have ever seen in similar class homes in the States. Alaskans have an intense loyalty to art that interprets Alaska. Northland paintings by Eustace P. Ziegler, Ted Lambert, Federal Judge J. W. Kehoe, the Crumrines (mother and daughter), Jules Dahlager, Rusty Heurlin, the Eskimo artist George Ahgupuk, Fred Machetanz and the late Sidney Laurence are much in demand. (Hilscher 1948, pp. 84–85)

But artists were still few in number; although they knew of one another and had some contact, the critical mass necessary for a sense of community had not yet been reached. With the growth of the territory's population and development of its infrastructure, more artists would make Alaska their home.

Already the center of the state's population, Anchorage would see the biggest boom. When Hilscher observed in 1948, "Today Anchorage has 14,000 residents. But within the next couple of decades, according to its leading citizens, this town will be a booming community of 50,000 persons" (p. 67), little could he know how conservative those estimates would prove. By 1975, Alaska's largest metropolis had topped 170,000, more than three times his most optimistic prediction, and by 1982 it increased to 200,000. In that same time, the number of serious artists in and near the city grew from a handful of isolated talents to a community with many factions competing for attention and support.

Fairbanks prospered as well, and Juneau recovered from the loss of mining income when territorial and, later, state government proliferated. Artists in smaller communities, too, found it easier to maintain contact with those in the larger towns and cities. But it was unclear at the war's close just what form the new artistic community would take.

A Search for Artistic Leadership in Postwar Alaska

In the years immediately following World War II, the mantle of artistic leadership in Alaska was up for grabs. Sydney Laurence had died in 1940, and although Eustace Ziegler occasionally still visited Alaska to paint in the summer, he had moved to Seattle years before. Theodore Lambert spent some time in Anchorage and briefly made his home in Fairbanks, but eventually abandoned his fellow artists and everyone else. As noted, the outstanding Eskimo artists working in painting and drawing were part of an entirely different group and tradition from the non-Native artists of the era. That gap would narrow in the 1980s, but in the immediate postwar years, Native and non-Native artists lived in different worlds. So who were the artists who would come to prominence in this era of burgeoning growth and flowering cultural interest? Eventually not one mantle of leadership was assumed but at least two, by very different groups of artists.

On the one hand were the artistic heirs of Sydney Laurence and Eustace Ziegler, painters who looked back to a pioneer Alaska, a land filled not just with natural beauty but with sourdoughs and sled dogs and "exotic" Native people and customs. Those elements indeed could still be found in post–World War II Alaska (as they can in some measure even today). For many accomplished artists in the Alaska of the 1950s and 1960s, this was still a fruitful vision, and if it seems increasingly quaint to many in the arts community as time goes on, it has clearly retained a hold on those Alaskans and others who still look north for a simpler, purer vision of an idealized frontier.

On the other hand were the more widely ambitious, artistically innovative artists who went to postwar Alaska, not looking back, but anxious to explore new visions of the North. The artistic backgrounds of the two groups were remarkably similar: the vast majority trained in art schools and universities or with prominent artists of the day. But the latter group, many of whom themselves became college and university teachers, brought modern art to Alaska, whether the territory was ready for it or not. They eventually came to predominate, in the view of critics, curators, and the artistic community if not in the view of the general public. But their ascendance does not obscure the real contribution of those well-trained, accomplished artists who chose to follow or further develop the course charted by the early resident artists.

Looking Back at Old Alaska: The Heirs of Laurence and Ziegler

Perhaps the most popularly acclaimed artist to embrace and elaborate the traditional image of Alaska in the postwar era is Fred Machetanz (b. 1908). Machetanz settled not in Anchorage but near the town of Palmer in the Matanuska Valley some thirty miles north. The painter still lives and works in his home, High Ridge, which he and his wife, Sara, began building in 1950.

Fred Machetanz's first visit to Alaska came well before World War II, in 1935, when he accepted an invitation to spend six weeks in Unalakleet at the trading post of his uncle, Charles Traeger. *Miowak*, painted by Machetanz in 1937, is from that first visit (no. 80). Miowak, or Marian Gonongan, was the daughter of a leading Native elder in Unalakleet. She was among those who went to greet the bush plane carrying Machetanz when it landed at the Unalakleet airstrip. As the twenty-seven-year-old Machetanz stepped down, the Eskimo woman was convinced that he was the son she had recently lost, returned to life in a different form. Miowak befriended Machetanz and continued to treat him as a son during the "six-week stay" that extended to two years.

The portrait is remarkably powerful, capturing not only a likeness, presumably, but an extraordinary beauty and dignity in the serene face of the Eskimo woman. The icy landscape, almost crowded out of the composition by the figure,

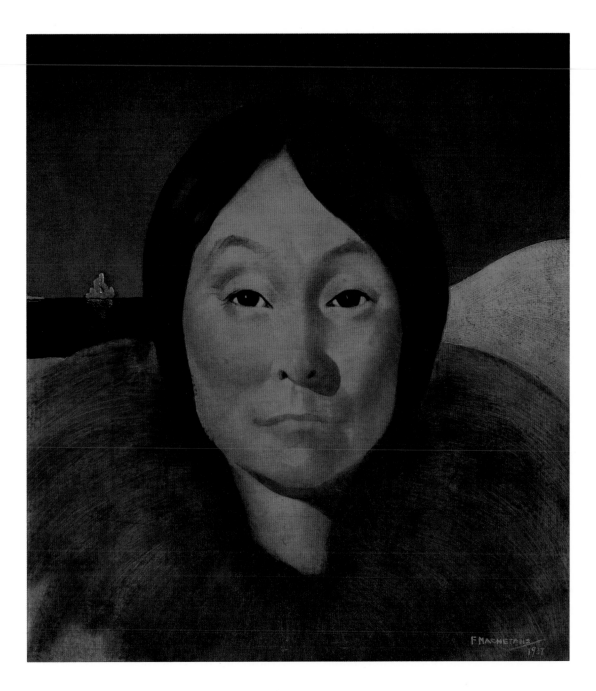

80. Fred Machetanz, *Miowak,* 1937
Oil on board, 35.7 × 40.7 cm; Gift of Mrs. Levi Browning and friends
in memory of Dr. Levi Browning, 72.106.1

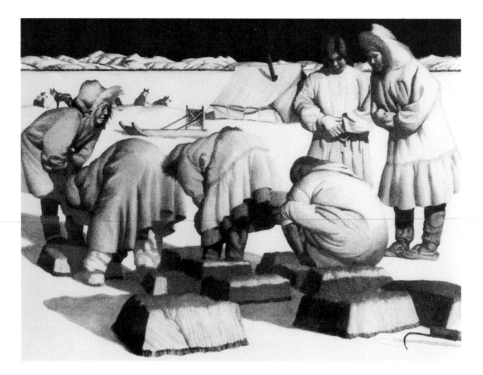

81. Fred Machetanz, *Dividing the Muktuk,* 1969
Lithograph, 37 × 47 cm; Gift of Fred and Sara Machetanz, 69.98.1

is radically simplified, a distant iceberg evoking spatial depth over a glassy sea. The painting is direct and full of light, life, and a talented young artist's wonder at a magic place and people at the edge of the world.

John Diffily of the Amon Carter Museum of Art, Fort Worth, has compared *Miowak* to the work of the fifteenth-century Flemish master Rogier Van der Weyden (Diffily 1980, p. 7). A closer comparison might be to the work of one of the best-known painters of the era in which *Miowak* was painted—Maxfield Parrish. Machetanz was a friend of Parrish and owns at least one of his paintings (Lawton 1965, p. 61). *Arctic Night* (1936), another small Machetanz painting, which hangs next to *Miowak* in the Anchorage Museum permanent exhibition galleries, is as close as one could imagine to something Parrish might have painted had he gone to the coast of the Bering Sea. The northern light in Machetanz's painting is even truer to the qualities of light made famous by Parrish than the New England skies that inspired the older artist's work.

Machetanz arrived in Unalakleet fresh out of graduate school, with a master's degree in art from Ohio State Univer-

sity. He painted and filled sketchbooks with drawings during his initial two-year stay in the village and then took his portfolio to New York, hoping to get a job illustrating a book on Alaska. After completing illustrations for a juvenile book on skyscrapers for Charles Scribner's Sons instead, he wrote and illustrated his own first book, *Panuck, Eskimo Sled Dog* (1939). On the strength of this work, the great explorer Vilhjalmur Stefansson nominated Machetanz for membership in the Explorer's Club. The artist's second book, *On Arctic Ice* (1940), garnered the attention of Admiral Fred Zeusler of the United States Coast Guard, who invited Machetanz to sail with a Coast Guard patrol along Alaska's coast from Ketchikan to Barrow. The voyage provided the artist with impressions and imagery that fueled his work for many years.

Machetanz saw more of Alaska when he volunteered for service with the navy in World War II and requested posting to the Aleutians. He spent much of the war there, finishing his tour of duty as a lieutenant commander in charge of the intelligence center for the North Pacific Command (Diffily 1980, p. 10). Heading back to Unalakleet after his discharge,

82. Fred Machetanz, *Quest for Avuk,* 1973
Oil on board, 81.3 × 130.8 cm; Gift of Mr. and Mrs. Elmer E. Rasmuson, 74.47.1

Machetanz met and fell in love with Sara Dunn, a writer on leave from the public relations department of RCA Victor. The two were married in 1947 in Unalakleet.

Between 1947 and 1962, the couple worked together on a variety of projects. Despite the success of his early books, Machetanz always claimed that he was not much of a writer and only wrote as a vehicle for making illustrations. With Sara doing the writing and Fred the illustrating, the Machetanzes published eight books together. They also collaborated on a number of films for *Encyclopedia Britannica*, Walt Disney, and the Territory of Alaska. Between 1948 and 1960 they traveled throughout the United States in the winter months, lecturing on Alaska and promoting their books and films.

After the birth of their son, Traeger, in 1959, the lecture circuit became too grueling. With the encouragement of long-time Anchorage friends who promised to arrange an exhibition for him, Machetanz borrowed money from his family and painted for a full year. The forty-four paintings he produced were shown at the Anchorage Westward Hotel on April 21, 1962, and twenty-four of them sold the first day. With that exhibition, Machetanz became a successful, full-time painter. Since then, he has become a legend among Alaskans almost on par with Sydney Laurence and Eustace Ziegler.

Trained in lithography by Will Barnet at the Art Students League in New York in 1946, the artist produced fifty original black and white lithographs that are as highly sought after as his paintings. The Anchorage Museum now has more than thirty of the series (no. 81). It is Machetanz's oils, however, with their deep, luminous surfaces that have most excited collectors and been reproduced photographically in large editions. Much has been made of the artist's glazing technique, which has changed little over his half century of painting in Alaska. Panels of untempered Masonite are coated with white shellac, zinc white, lead white, and titanium white pigments, sometimes on the smooth side of the panel and sometimes on the textured surface. The back is given one coat of paint to seal the surface and prevent warping. An underpainting is done with ultramarine and a large bristle brush, with which the composition is worked out and refined. After drying, traditional linseed oil–based glazes are used to build up the surface colors and refine the forms. The drying time for each stage is hastened by placing the panels in a room adjacent to the studio under banks of drying lights.[2]

Quest for Avuk, painted in 1973, is typical of the work for which he has become known (no. 82). The highly symmetrical composition chronicles a traditional activity of Alaskan Eskimos, the walrus hunt by skin boat, or umiak. This and other similar paintings are based on the artist's firsthand experience of whale, walrus, and seal hunts with Eskimos in Unalakleet and later in Point Hope.

It is clear that the paintings and prints are often based on photographs, which is not surprising given the artist's background in filmmaking and illustration. Machetanz has been quite candid about using photographs in place of preparatory sketches, saying, "It's sort of a tradition that you should sketch. I don't do a lot of it. I take many action photographs. It gives me more of a feeling for what I want than a sketch. I take a great deal of black and white because I like to visualize my own color" (Diffily 1980, p. 13).

Fred Machetanz has remained faithful to his romantic, serene vision of Alaska, which has proved immensely popular both within and outside the state. Reproductions of his work are marketed nationally, and his paintings of Eskimos, sourdoughs, polar bears, and mountain peaks have sold to individuals and museums throughout the United States and abroad. He has received honorary degrees from both the University of Alaska and Alaska Pacific University for his longtime contribution to the art of Alaska. In the first years after the founding of the Anchorage Museum, Machetanz played an active role in the life of the institution, serving on boards and committees, lecturing, and maintaining a lively interest. In more recent years, he has lived a quiet, fairly isolated life at High Ridge and has continued to paint well into his eighties.

If many contemporary artists and critics have characterized Machetanz's work as an invention of a relentlessly pleasant, idealized "past that never really was" (Ingram 1988), others have praised him for his determination to say in his life and art, "This is where I will live and work and say what I have to say to the world" (Blaine 1983). Like Sydney Laurence and Eustace Ziegler, Fred Machetanz has become a part of the legend of Alaska. Surely even as we recognize the limitations of his romantic view, we can honor his lifelong commitment to it and acknowledge that his vision has affected so many of his fellow Alaskans and others beyond.[3]

Two other well-known Alaskan painters moved to Anchorage in 1943. In the following decades, Ellen Henne

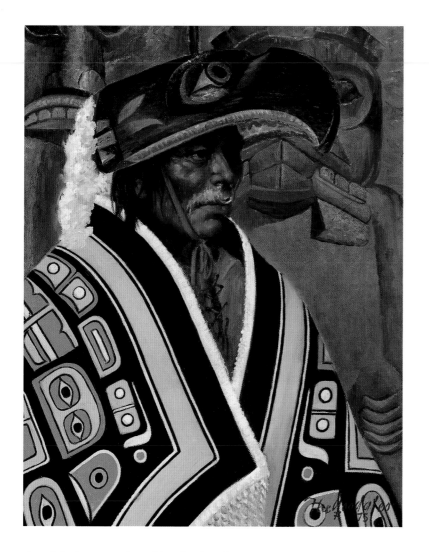

83. Harvey Goodale and Ellen Henne Goodale,
Indian Chief, 1975
Oil on canvas, 70 × 52.1 cm; Gift of Katherine Elmore
in memory of Maj. Gen. William S. Elmore, 81.134.1

Goodale (1915–91) and her husband, Harvey Goodale (1900–80), painted and widely sold thousands of portraits of Alaskan sourdoughs, pilots, and Native people, bush scenes with cabins and caches, and images of dog teams.[4]

Harvey Goodale was born in Danvers, Massachusetts, and studied art at the Boston Museum School and the Rhode Island School of Design. Ellen Henne grew up in Seattle, where she was trained in commercial art. The two met when Ellen was hired as a designer in a Seattle neon sign shop where Harvey was already employed. The couple decided to move north in 1943 during World War II, not knowing where they would settle. After five rainy months in Ketchikan and brief stays in Juneau and Haines, they made their way north to

Anchorage late in the year. By working and saving money for several months, they were able to open Ad Art Studios, an early-day art supply store and picture framing shop. They painted in their spare time. After running the business for three years, the Goodales moved to Valdez for eighteen months. Missing the action of the big city and demoralized by more than two dozen feet of snow in a single winter, the couple moved back to the Anchorage area to stay, eventually building a home and studio on Upper Fire Lake in Eagle River.

Harvey Goodale is perhaps best known for the series of portraits of old-time Alaska bush pilots which he produced for Bob Reeve, founder of Reeve Aleutian Airways. After several

paintings at the Anchorage International Airport were lost in the 1964 earthquake, the remainder of the forty-four canvases burned in a fire at the University of Alaska commons in Fairbanks a few years later. They are now known only through the large photographic reproductions made by Reeve, many of which hang in the Rasmuson Library at the university today.

Ellen Henne Goodale, who usually signed her work "Henne," is best known for her dog-team pictures, but she painted portraits as well. The two collaborated on *Indian Chief*, a portrait of a Northwest Coast Indian elder in ceremonial regalia (no. 83). The museum numbers another eleven canvases by Harvey Goodale and four by Ellen Henne in its collection.[5]

Another postwar Anchorage artist, Marvin Mangus (b. 1924), first came to Alaska in 1947 not as a painter but as a geologist. Trained in that discipline at Pennsylvania State University, Mangus spent many field seasons working for the United States Geological Survey and later for Atlantic Richfield Company in the Arctic regions of Alaska and Canada. While he mapped, explored, and surveyed for oil prospects, Mangus took advantage of his access to remote locations and dramatic scenery to study and paint the landscape. Aided by formal art training in the early 1950s with the well-known artists Eliot O'Hara, Roger Rittase, and William Walter, the artist realized his desire to see and paint the land accurately in canvases that are enriched by an equally intense desire to explore the nature of composition, light, color, and the physical properties of paint.

Mangus's own comments highlight his dual interests. Speaking to his interest in accuracy, he reflected in a 1989 interview, "I pride myself on an ability to be as detailed and realistic as I can" (Blucher 1990, G1). In a statement for his solo exhibition at the Anchorage Museum the same year, he said, "Being representational, I favor the bright light and clean air of the northern climes, where strong contrasts between lights and darks exist," but also affirmed, "I consider all paintings as abstracts, putting in the important masses and never trying to depict everything I see" (Padzuikas 1989). As most painters know, these seemingly disparate statements are not at all contradictory. The details and accuracy of which Mangus spoke are not the photographic details recorded by a camera, but the true rendition of the character of landforms, the particular light of a place and time of day—the sum of the myriad details that individually are extraneous to the overall impression.

Mangus's bright, bold *Rabbit Creek* is typical of his best work (no. 84). Although his brushwork is loose, aggressive, and expressionistic in comparison to that of the other postwar painters so far discussed, it is far from radical; nor is his subject matter daring. He admits, "My goal is to paint much of the Alaska scene as it was 35- to 40-odd years ago when I first went into the Brooks Range for the Geological Survey" (Padzuikas 1989). This nostalgic goal is kept firmly in check, however, by accomplished technical skills, a lively interest in experimentation with painterly means, and an awareness of new and challenging painting. Mangus has had an active exhibition record, including more than fifty solo exhibitions and several group shows in Washington, D.C., at the Corcoran Gallery of Art, the Smithsonian Institution, and the Arts Club.

An avid supporter of the Anchorage Museum since its opening, Mangus was one of the first artists invited to have a solo exhibition in 1969. By that time he had already established himself both as a serious painter and as part of the growing postwar community of artists pushing for more serious, vigorous, informed art in Alaska. If the traditional subjects and relatively conservative handling of Mangus's work place him in the context of those artists who look backward to an earlier Alaska, his energy and openness to new ideas in his own work and that of others are evidence of a spirit that has always looked forward.[6]

Since World War II, Anchorage's increasingly large size in relation to other communities in Alaska (almost half the population base of Alaska) and its consequently more extensive media coverage led to its artists becoming the state's most popular. But artists in other communities have occasionally weathered the odds to gain statewide recognition. Nina Crumrine (1889–1959) and her daughter Josephine Crumrine Liddell (b. 1917), both represented in the museum's collection, are most recognized for their work in pastels. Nina Crumrine is known for her portraits of mid-century Native Alaskans, twenty-four of which were purchased by the Alaska territorial legislature in 1941. Although Josephine is noted for her portraits of Alaskan sled dogs, she has turned increasingly to the region's landscape for subject matter since 1960. Eight of her pastel dog portraits were commissioned by the Alaska Steamship Company in 1941 for reproduction on its menu covers, which have become collector's items.

Nina Crumrine was born in Indiana and trained at the Art Institute of Chicago (Reed 1945, p. 53). Josephine was born

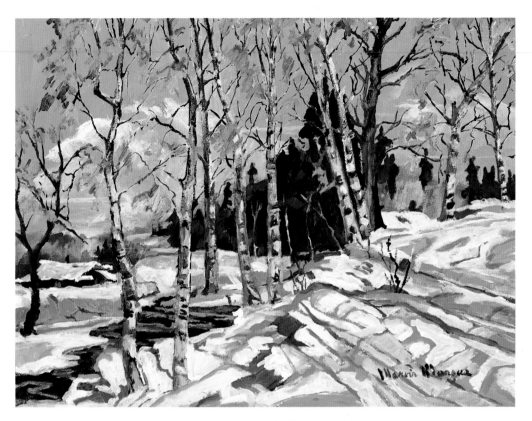

84. Marvin Mangus, *Rabbit Creek*, 1980
Acrylic on canvas, 44.3 × 59.6 cm; Municipal Acquisition Fund purchase, 80.39.1

in Seattle and as a young girl in 1923 went north with her mother to live with Nina's uncle, H. V. McGee, in Ketchikan. Trained in art first by her mother, Josephine was sent to San Francisco for further schooling and studied at the Art Center in Los Angeles and the Colorado Springs Fine Arts Center. Mother and daughter were great travelers in the following decades, visiting every region of Alaska as well as South America, Africa, Europe, and Asia. Nina eventually acquired land in Haines, and when Josephine married Robert Liddell in 1959, the couple built a house on her property. Josephine currently divides her time between Seattle and Homer, Alaska.[7]

A southeast Alaska artist who moved north well before World War II, but who acquired prominence only in later years, is the printmaker Dale DeArmond (b. 1914). Born in Bismarck, North Dakota, she grew up in Saint Paul, Minnesota, and Tacoma, Washington. While in high school in Tacoma, she met Robert DeArmond, who would become one of Alaska's most noted journalists and historians. She visited

him in his hometown of Sitka in 1935, and the couple were married there later that year. They moved to Juneau in 1952, returning to Sitka in 1990.

Dale DeArmond, who was director of the Juneau library for many years, was primarily a painter until taking a woodcut workshop in the early 1960s with printmaker Danny Pierce at the University of Alaska. The medium seems to have suited her perfectly. She has become widely known for works in this medium and, since 1982, for wood engraving. Her work has been reproduced in a number of books, and she has produced several of her own. A complete set of the twenty-eight prints used in *Raven: A Book of Woodcuts* (DeArmond 1975) was donated to the Anchorage Museum. They are among the more than sixty works by the artist in the museum's collection. *Raven Opened the Box of Daylight* is an earlier exploration of the same theme (no. 85).

DeArmond's woodcuts and wood engravings pack a remarkable amount of strong design, narrative content, and

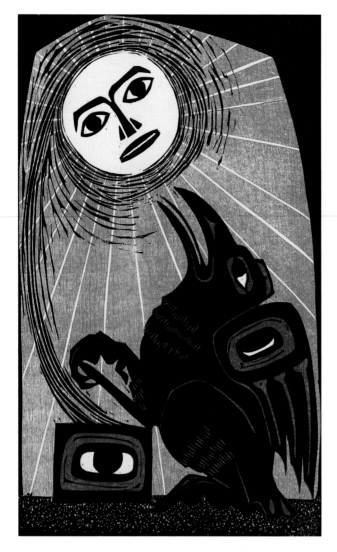

85. Dale DeArmond, *Raven Opened the Box of Daylight*, 1970
Woodblock print, 48 × 29 cm; Gift of La Bow, Haynes of Alaska,
70.144.1

wry, insightful humor into small packages. Impeccably crafted, her work as it has grown and developed over time has managed to remain charming without ever becoming slick or cute. The almost diffident scale and means of her prints have tended to disguise their sophistication, making them accessible to a wide audience.[8]

Another southeast Alaska artist to become successful in the postwar years is the Juneau artist Rie Muñoz. Muñoz visited Alaska while on vacation in 1950 and was so enamored with

Juneau that she found a job within twenty-four hours and has lived there ever since (Mozee 1974, p. 97). Born in California of Dutch parents, Muñoz studied theater at Washington and Lee University in Lexington, Virginia, and painting and printmaking in Fairbanks at the University of Alaska.

While remaining settled in Alaska's capital, Muñoz has traveled the state widely, from Ketchikan to Barrow, in search of new experiences and imagery. She taught school on remote King Island in 1951–52, was commissioned by the United States Bureau of Indian Affairs to record the reindeer roundup on Nunivak Island in 1968, and for the past forty years has sketched people and places on regular trips throughout Alaska. One of the state's most celebrated artists, she has produced watercolor and casein paintings, prints in various media, designs for tapestries woven to her specifications in Aubusson, France, and at least seven large-scale murals in various Alaskan communities. *Unloading,* typical of her work in all media, is characterized by bright colors and an obvious delight in the everyday aspects of Alaskan life (no. 86).[9]

A less well-known and very different kind of painter who arrived in southeast Alaska a decade earlier than Muñoz is the accomplished Haines artist Gil Smith (b. 1911). Smith, born in Jacksonville, Illinois, studied in the early 1930s at the Kansas City Art Institute in Missouri. He moved to Alaska in 1940 and by 1953 was noted for his paintings of the Chilkat Range (Hulley 1970, p. 368). Although he has remained settled in Haines, recent ill health has caused him to spend much of the last few years in the southwestern United States (DeRoux 1990, p. 21).

After spending World War II in the Aleutians, India, and Asia, Smith returned to Haines immediately after the war. He worked construction jobs on the Alaska Highway and in interior Alaska during the summers for much of his first three decades in the North before turning to painting full-time around 1970. Best known for his paintings of the Cathedral Peaks near Haines, he has painted mountain landscapes throughout Alaska in oil, acrylic, watercolor, and pastel. His work is highly naturalistic, with slight stylization of complex mountain forms for clarity and lighting effects, but without overt dramatization.

Smith's decision to remain in the small, relatively isolated community of Haines and his lack of self-promotion have kept him from achieving the widespread recognition that he deserves. Nevertheless, he is well represented in the three major

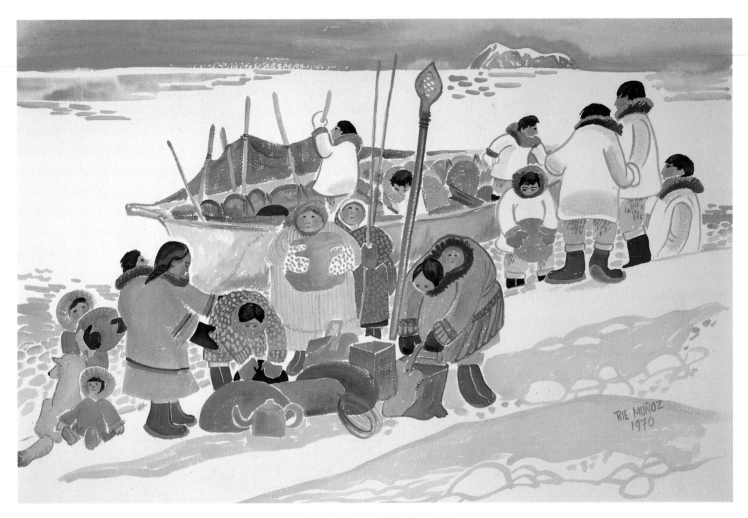

86. Rie Muñoz, *Unloading,* 1970
Casein on paper, 50.8 × 76.2 cm; Gift of the Rasmuson Foundation, 71.218.1

museums in Alaska: the Anchorage Museum of History and Art, the University of Alaska Museum in Fairbanks, and the Alaska State Museum in Juneau. Smith was also chosen for inclusion in the 1978 Smithsonian Institution exhibition *Contemporary Art from Alaska* (National Collection of Fine Arts 1978, p. 59).

Fairbanks, too, with a population of about three thousand at the close of the war, had its share of active postwar artists. Rusty Heurlin was already working there before the war (see chapter 3), and he settled back in after completing his service with the Alaska Territorial Guard. He was soon joined by the painter and sculptor Claire Fejes (b. 1920), who would become

one of Fairbanks's most popular artists (no. 87). In 1946 Fejes followed her husband to Alaska, where he had served as a Russian interpreter during World War II.

Born in New York, Fejes grew up in Greenwich Village and received her early art training at the Art Students League and the Newark Museum. Influenced by her sculpture instructors Jose de Creeft, Aaron Goodleman, and Saul Baizerman, Fejes early on produced carvings in wood and stone. In Fairbanks, however, she soon abandoned sculpture and began drawing and painting the Native people of the community. Out of this interest grew a strong desire to visit outlying Eskimo villages and observe their way of life.

Fejes first visited a remote village in 1958 when she traveled to the whaling camp of Sheshalik, in the Kotzebue area. The extended stay was a pivotal event in her career. Mary Goodwin noted in the catalogue for Fejes's 1991 retrospective at the University of Alaska Museum:

> Here, Fejes made an important transition, discovering a forceful simplicity, an economy of line and form. There is less of the interest in modeling and detail that characterized her earlier "Self-Portrait." With the Sheshalik paintings, the artist truly came into her own style, bringing to painting her sculptor's love of form. The space between figures is as substantial as the figures themselves. Fejes feels that she was forced into a new awareness of space, ". . . forced by the shock of being in a perfect place—no trees; just people, sky, water, and earth." (Goodwin 1991, p. 14)

Indeed, although Fejes has adapted, developed, and experimented with the style she forged in response to that first village experience, her work from the late 1950s is instantly recognizable to those who know her paintings of the 1990s. Fejes returned on many occasions to the camps and villages of northwest Alaska, sketching and painting the whale hunts and daily life of the Eskimos of Sheshalik and Point Hope.

Recognition followed the first Sheshalik paintings relatively quickly. By 1960 Fejes had mounted solo shows at the Frye Art Museum in Seattle and at the Roko Gallery in New York, and in 1966 Alfred A. Knopf published her first book, *People of the Noatak* (Fejes 1966).[10] Based on five extended visits to northwest Alaska villages, the volume details the daily life of the Eskimo people she came to know and admire. Like much of her later writing and painting, Fejes's words and illustrations in *People of the Noatak* recount and celebrate in particular the role of women in that society. Goodwin notes how rare and important that quality of Fejes's work is:

> She offers an alternate vision. From the perspective of the cramped quarters of a sod hut where three generations coexist, she marvels at the generosity of spirit that embraces her as a guest. Days are spent primarily with women—a cast of characters from infancy to oldest age, variously committed to the "old ways" or the new. Fejes offers detailed sketches of a society where Coca-cola and soured whale meat are both coveted treats, where family

diets depend on the success of seasonal hunting, and where mothers must cope when food is scarce or not at all. Fejes leads the reader along a path of awareness, describing behavior that is inexplicable to a cultural outsider. Hers is one of the rare female voices reflecting the woman's side of Arctic society. (Goodwin 1991, p. 18)

In her fifties, Fejes again undertook an extended voyage in search of Native Alaskan life in the villages. This time, she traveled up the Tanana and Yukon rivers, visiting Athabaskan Indian communities between Nenana and Eagle. Illustrated and written by the artist, *Villagers* (Fejes 1981) recounts that experience, as do many of her paintings and drawings from that period and after. Her paintings continued to enjoy acclaim during the 1970s in solo exhibitions at Alaskan museums, the Washington State Capital Museum in Olympia, Larcada Gallery in New York, and as far away as Tel Aviv. She was also one of only two living artists included in the 1975 Amherst College exhibition, *American Painters of the Arctic* (Shepard 1975).

Fejes has helped to foster the developing artistic community in Alaska; she has been a consistent supporter of other artists and of a lively artistic dialogue in Fairbanks. She and her husband, Joe, ran the art gallery and craft shop Alaska House from their home for ten years. They showed a wide range of work by Native and non-Native, established and promising artists and mounted what may have been the first exhibition of Canadian Eskimo prints in Alaska. Her friendship and correspondence with the artist Rockwell Kent (whose idea it was that she approach Knopf with her first book) led to the acquisition in the 1970s of the state's largest collection of Kent drawings, paintings, prints, and memorabilia by the Noel Wien Library in Fairbanks.

Spending part of each winter in New York and California and summers at work in her studio in downtown Fairbanks, Fejes has continued to be a productive and well-respected figure in the 1990s. Her long-standing support for the Native Alaskans' struggle to gain self-determination and maintain the positive aspects of their traditional lifestyle is a frequent theme in her work of the past decade.

Despite almost a half century of commitment to Alaska, an outstanding exhibition record, a long list of museums that have acquired her work, and recognition on both coasts of the

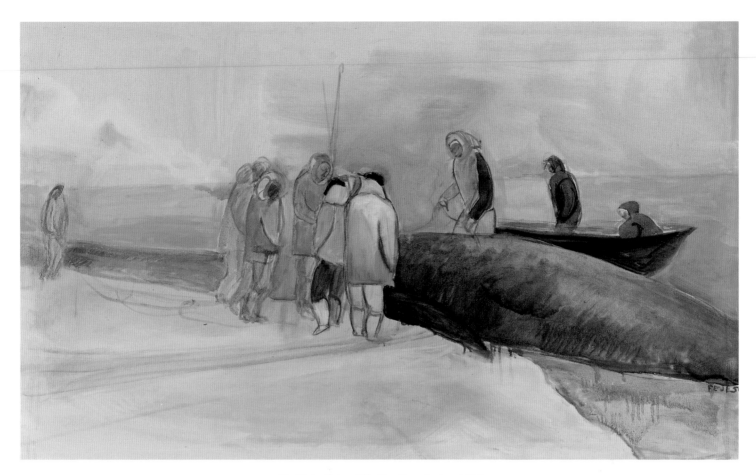

87. Claire Fejes, *Whaling Consultation,* 1976
Oil on canvas, 76.2 × 127 cm; Municipal Acquisition Fund purchase, 78.65.1

United States and abroad, Fejes is less well-known in Alaska than many of her colleagues. Gender and geography have certainly played roles in this undervaluation, but artistic fashion has contributed as well. Modernist but relatively conservative, idiosyncratic rather than stylish, and insistently representational, her work has remained a highly personal exploration of her individual vision.

Because Claire Fejes's work has yielded little to artistic fashion or public taste, it has been overlooked from both ends of the artistic spectrum. Those who long for glowing renditions of Alaska's landscape and wildlife or depictions of ennobled Native hunters frozen in time have found her brusque, expressionist canvases of everyday Native women at work and whales being butchered harsh and puzzling. Conversely, those

who look for the latest in formal innovation and abstract or conceptual experimentation have been disappointed as well. The 1991 retrospective of her work, which traveled to museums in Alaska and on the West Coast of the United States, has brought the public awareness that her unique contribution deserves.[11]

A New Artistic Generation: The Birth of Alaska's Modern Arts Community

An artist whose work and career differed radically from those of such painters as Machetanz, the Goodales, Muñoz, and even the more modernist Mangus and Fejes came to prominence in Anchorage at about the same time. William Yusaburo Kimura (1920–91) is far less well known to the average Alaskan than

Fred Machetanz, but through his art, his teaching, and his early efforts at the center of the growing community of innovative Alaskan artists, he had a much more dramatic impact on the development of contemporary Alaskan art. Although Kimura was no longer a dominant presence in the Anchorage art scene by the 1980s, and illness curtailed his activities in later years, when he died in April 1991 the arts community throughout Alaska mourned his loss and loudly praised his accomplishments.[12]

Bill Kimura's father went to Alaska from Seattle in 1916 before returning to marry his Japanese bride. William Yusaburo was born in Seattle on June 28, 1920. Kimura's parents moved back to Anchorage in 1922, but before they headed north, their desperate financial situation forced them to send their four children to live with family in Japan. Bill spent the next five years with an uncle near Nagasaki. In 1927 he rejoined his parents, who were running a restaurant in Anchorage. In the early 1930s an artist named Coleman Cohen, who was a regular customer of the restaurant, began giving painting lessons to young people, and Kimura received his first tutelage in oil painting.

The young man's interest in art continued to grow, and he met and was encouraged by Sydney Laurence while still in high school. After graduation, Kimura worked as a commercial fisherman to earn money for art school, against his family's wishes for a more conventional career. In 1940 he enrolled in the Hollywood Art Center in Los Angeles, where he benefited from visits to local museums.

When Kimura tried to return to Anchorage at the outbreak of the war with Japan in December 1941, he was denied a travel permit from Seattle because his parents were Japanese. He was rejected for military service for physical reasons as well, so he enrolled in Seattle's Cornish College of the Arts. In May 1942, however, Kimura and other Americans of Japanese descent in the Northwest were interned in a government camp near Twin Falls, Idaho. There he became better acquainted with a woman he had met while in school in Seattle, Minnie Mitamura, and the two were married in Twin Falls in 1943. She waited tables at the camp, and he worked various jobs in the surrounding area. The couple had two children by the time they were released in 1946.

Kimura prepared a portfolio, cashed his war bonds, and moved his family to New York, hoping to find work as an illustrator. When nothing materialized there, they tried Chicago and then went back to Idaho. Later in 1946, a telegram from his parents urged Kimura to return to burgeoning postwar Anchorage to help with the family's new restaurant.

In his spare hours after working at the restaurant, and later at the family's laundry, Kimura learned about the region and also found time to paint and seek out other young artists. These ambitious young artists founded the Alaska Artists' Guild and began to organize art shows at the city's annual winter celebration, Fur Rendezvous. During the late 1940s and early 1950s, Kimura studied with Adolph Kronengold, Miles Llewellyn, Mel Mateson, and Evan Phoutrides. Kronengold ran an art supply store, which he sold upon leaving the city. Llewellyn and Mateson, young painters from the Seattle area, purchased the business, and Phoutrides, another Seattle painter, soon joined them in the enterprise.

Former University of Alaska professor Frank Buske wrote about Kimura and this crucial period in the development of an innovative society of artists in Anchorage:

> In 1950, Anchorage was a place of cultural ferment. There was an enormous amount of energy, some of it well-directed. Although in regular contact with the rest of the United States with daily airplane flights, there was not the immediate exchange of ideas such as was possible in the States. People were always interested in the new and since Alaska was too far away to be supplied with its cultural needs, it had to supply its own art shows, concerts and theatrical performances.

Buske goes on to marvel at the cooperative efforts of Kimura and others who in 1952 organized an exhibition of work by prominent artists from the Pacific Northwest:

> For Anchorage, it was the Armory Show all over again. More people saw the exhibit than had voted in the previous municipal election and a whole new world of artistic possibilities opened up to Anchorage area painters.
>
> Bill still speaks of the enormous impact on his own work from this show. . . . In the show were the great names of Northwest painting—Morris Graves, Mark Tobey, Kenneth Callahan and many others. But there was also a whole new painting vocabulary, new methods of expression, new approaches to subject matter.
>
> For the viewing audience, too, the exhibit was a revelation. Long accustomed to the dog sled–northern

88. William Yusaburo Kimura, *Homage to the Yen,* 1973
Acrylic and plastic on canvas, 121.6 × 89.9 cm; Municipal Acquisition Fund purchase, 83.59.1

lights–log cabin school of sticky sentimentality, the vitality and freshness of the paintings helped create a climate in which Bill and his fellow painters could experiment, change, and grow. (Buske 1965, pp. 75–76)[13]

For Kimura and others, the impact of the exhibition was dramatic. Bill painted his first abstract canvas the same year, and in the following year one of his paintings was accepted in the Northwest Artists Annual at the Seattle Art Museum. In 1955 Kimura traveled for eight weeks in Japan and studied the art of that country, which he internalized and subtly incorporated in his work rather than overtly adopting elements of Japanese style.

Kimura's long-term commitment to the teaching of art began in 1959 when two local women asked him to give them painting lessons. The private lessons quickly grew into organized classes held at Studio One, the Garret, the Color Center Gallery of fellow artist Armond Kirschbaum, Elmendorf Air Force Base, Anchorage Community College, and Alaska Methodist University (now Alaska Pacific University). Kimura also served as printmaker-in-residence at the Visual Arts Center of Alaska in 1976. A good number of Anchorage artists came under his tutelage and influence between the late 1950s and the late 1970s.

Kimura's contribution, however, was not just as a teacher and a catalyst for a new art community. His own art was strong, innovative, and influential. It was also restless. Never settling into a signature style, he constantly searched for new materials, methods, and images to explore his unique vision of Alaska. Pushing the boundaries of Alaskan imagery, his abstracted Native figures and Alaskan animals from the early 1950s, while not avant-garde for their time, were far more radical than any work we have yet examined. In the 1960s, he became a very active printmaker, producing many monoprints, woodcuts, and lithographs. The first solo exhibition of his paintings came at Alaska Methodist University in 1963, and he exhibited woodcuts at Mel Kohler Interiors a year later.

By the 1970s, Kimura's painting was becoming larger, bolder in color, and more abstract. Deep geometric forms with surfaces of luminous color and experimentally achieved textures began to dominate. *Homage to the Yen,* one of a group of paintings, prints, mixed-media works, and sculptures by Kimura in the museum's collection, is representative of the period (no. 88).

89. William Yusaburo Kimura, *Homage to the Salmon,* 1979
Aluminum, 285 × 100 × 77 cm; Gift of the Anchorage Chamber of
Commerce, 80.117.1

Ever unpredictable, Kimura pulled back from this nonobjective mode to further explore recognizable imagery, although in bold, abstracted forms. He continued to experiment with new materials as well. His large-scale sculpture of abstracted fish forms, *Homage to the Salmon,* was commissioned by the Anchorage Chamber of Commerce in 1979 and now stands in an exterior courtyard of the museum (no. 89).

In the 1980s Kimura designed a series of nineteen elegant stained-glass windows for the All Saints Episcopal Church in Anchorage. *Anchorage Daily News* art critic Jan Ingram, reflecting on Kimura's career, wrote about the stained-glass windows shortly after his death:

> It is in this work that Kimura's love of simplicity and his impulse toward sensual richness come together in what now seems the most logical medium for him: stained glass. Kimura was one of a small group of artist-teachers who presented sophisticated alternatives to the romanticized scenery painting that dominated Alaska art of the time. The handful of publicly displayed works he left behind are a welcome reminder of his understated and enduring leadership. (Ingram 1991)

Artist-Teachers: The Role of the University in Postwar Alaskan Art

Bill Kimura was only one of a number of Alaskan artists represented in the Anchorage Museum who exerted influence through their teaching as well as their art work during the 1950s, 1960s, and 1970s. The University of Alaska (at major campuses in Fairbanks, Anchorage, and Juneau), Anchorage Community College, Alaska Methodist University (now Alaska Pacific University) in Anchorage, and Sheldon Jackson College in Sitka all provided haven and support for innovative, ambitious artists.

University art training in Alaska had begun in Fairbanks, at the University of Alaska. Rusty Heurlin was hired as Alaska's first college art teacher in the early 1950s by Minnie Wells, head of the Department of Arts and Letters at the university. He provided instruction for several years before resigning to paint full-time. Claire Fejes occasionally taught classes at the university in the late 1950s, and painter and printmaker Danny Pierce was appointed Visiting Carnegie Instructor of Art in 1960. Ronald Senungetuk joined Pierce in 1961 when he was hired as Visiting Carnegie Instructor and assistant professor of art and design. Glen Simpson, Terrence Choy, Arthur William Brody, and L. Stanley Zielinski are all active artists who taught at the University of Alaska by the early 1970s.

In Anchorage, college art instruction began in the early 1960s. Among the important artists who came to statewide prominence while teaching there in the 1960s and early 1970s were Alex Combs, Keith Appel, Saradell Ard, Joan Kimura, Wassily Sommer, Pat Austin, Jody Cooke, and Gerald Conaway. College art classes began in southeast Alaska in the 1960s as well. The painter Linda Larsen was teaching at Sitka's Sheldon Jackson College by 1969.

Ronald W. Senungetuk (b. 1933), an Inupiat Eskimo, was born in the village of Wales. His family later moved to Nome, where he completed high school. Senungetuk received his college art training at the School for American Craftsmen, Rochester Institute of Technology, completing the B.F.A. program in 1960. He continued his training in Oslo, Norway, the following year under a Fulbright Fellowship. There he met his wife, the Norwegian-born and -trained Turid Senungetuk, a talented metalsmith who has become well-known in Alaska and is represented in the museum's collection.

Ron Senungetuk has perhaps the most extensive national and international exhibition record of any Alaskan artist. His woodwork and metalwork were being exhibited nationally by 1954, even before he completed his schooling. Before 1960, his work had been included in exhibitions on the East Coast and in California and France. In 1962 alone he was included in several exhibitions: *Young Talent* at the Krannert Art Museum in Champaign, Illinois, *Northwest Craftsmen* at the Henry Art Gallery in Seattle, and *Young Americans '62* at the Museum of Contemporary Crafts in New York (now the American Craft Museum). Many museum competitions and invitationals followed, including the important exhibition *Objects, U.S.A.* at the Museum of Contemporary Crafts in 1970, and have continued to the present. Senungetuk has also exhibited regularly and widely in Alaska.

As a contemporary artist, Senungetuk has always seen his Eskimo heritage as only one of the many wells from which he could draw inspiration and imagery. Although still showing the influence of his early training, his immaculately crafted work in recent years has increasingly evoked imagery from his Native culture (no. 90).

90. Ronald W. Senungetuk, *Whaling, Whales,*
and Whaling Celebration, 1991
Maple, oil stain, aluminum, each 75.5 × 75.5 cm;
Gift of the Anchorage Museum Association, 91.34.1a–c

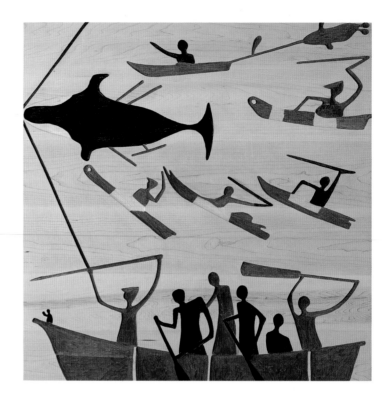

As well-known as Senungetuk has become as an artist, he has been equally influential as a teacher and as director of the Native Art Center at the University of Alaska in Fairbanks. In 1964, three years after Senungetuk joined the faculty of the university, he was chosen to serve as supervisor of the Designer-Craftsman program in Nome, federally funded by the Manpower Development and Training Act. Out of the project evolved extension classes under his direction the next year at the University of Alaska. Under Senungetuk's leadership, the Native Art Center, as it was later called, provided formal art training for the next two decades to Native Alaskan artists without regard to educational background.

Senungetuk retired from the university in 1988 but still actively exhibits in Alaska and throughout the United States and abroad. For the past thirty years he has regularly served as a consultant to major museums, as a panelist at national and international arts and crafts conferences, and as the leading interpreter of Native Alaskan art and arbiter of its place in the mainstream of international contemporary art.[14]

One of Senungetuk's first students, Glen C. Simpson (b. 1941) has become a well-known artist-craftsman in Alaska.

Upon completion of his undergraduate work at the University of Alaska, Simpson followed Senungetuk's example by completing his training at the Rochester Institute of Technology, receiving his M.F.A. in 1969. He returned to Fairbanks and joined the faculty of the university the same year.

Born in Atlin, British Columbia, Simpson has both pioneer Canadian ancestors and a Tahltan-Kaska Indian heritage. His active exhibition record includes solo exhibitions at the Anchorage Museum of History and Art, the Alaska State Museum, and the University of Alaska Museum. Among the many national exhibitions in which he has been invited to participate are *American Crafts: A Pacific Heritage,* in Sacramento in 1982; *Remains To Be Seen,* a major exhibition at the Kohler Arts Center in Sheboygan, Wisconsin, in 1982; and *Craft Today, Poetry of the Physical* at the American Craft Museum in New York in 1986.

In recent years, Simpson's work has become increasingly concerned with reinterpreting traditional Native Alaskan forms and imagery in nontraditional materials. A fine example of this convergence is the pair of potlatch spoons depicting Wolf and Raven, which were commissioned by the Anchorage

Museum (no. 91). Crafted from wood and silver, the striking sculptures are based on the traditional Northwest Coast Indian potlatch spoons fashioned of sheep horn.[15]

Another craftsman with East Coast training who joined the University of Alaska faculty in the 1960s is L. Stanley Zielinski (b. 1928). Born in New Jersey, Zielinski was trained in ceramics at Alfred University in New York. After twelve years teaching at the State University of New York College at Buffalo, Zielinski moved to Fairbanks in 1966. He has been a frequent participant and award winner in statewide craft exhibitions in Alaska, had a solo exhibition at the Anchorage Museum in 1981, and was included in the *Contemporary Art from Alaska* exhibition at the Smithsonian Institution in 1978.

Arthur William Brody (b. 1943) taught printmaking, drawing, and painting at the University of Alaska from 1967 to 1969 before leaving the state for nearly a decade. In 1977 he returned to the university and teaches printmaking, painting, and computer art. Best known for his figurative prints, for which he has an extensive national exhibition record, Brody in recent years has turned his attention to landscape painting and computer-generated works. His computer-assisted art works

often involve a complex manipulation of figurative and landscape images between one medium and another.

In the last several years, Brody has joined other Fairbanks artists in trips to the Arctic National Wildlife Refuge in northeastern Alaska, and has worked on-site in other dramatic locations such as Kluane Lake in Canadian Yukon Territory. Although the artist has intermittently produced plein-air landscapes for many years, the more realistic, more tightly structured, and more detailed landscape images he has created as a result of his most recent trips are quite different from his work of just a few years back.[16]

One of the earliest college art instructors in southeast Alaska was Linda Larsen (b. 1939), a painter and ceramic sculptor who began teaching art in 1969 at Sheldon Jackson College in Sitka. Her best-known work, diaphanous color-field paintings from the early 1980s, drew upon the mist-shrouded mountains of southeast Alaska for inspiration. Her work is well-represented in all three major museums in Alaska, and she had a solo exhibition at the Anchorage Museum in 1979. Larsen played an active role in the development of the Baranof Arts and Crafts Association in Sitka, the Southeast Alaska Regional Arts

91. Glen C. Simpson
Wolf Potlatch Spoon (top), ca. 1986
Sterling silver, cocobolo, 7.3 × 30.8 × 4.1 cm;
Gift of Cook Inlet Region, Inc., 86.68.1
Raven Potlatch Spoon (bottom), 1985
Sterling silver, ebony, 7.3 × 30.7 × 3.7 cm;
Gift of Cook Inlet Region, Inc., 85.67.1

Council, and the Sitka Fine Arts Camp. She was for several years a board member of the Alaska State Council on the Arts (Sunde 1983).

Alex Duff Combs (b. 1919; no. 92), who came to Alaska in 1955, was among the first college art instructors in Anchorage.[17] Born in Hazard, Kentucky, Combs began his art training at the age of twenty-five after serving in the navy. He received a B.F.A. from Temple University in Philadelphia and an M.F.A. from Temple's Tyler School of Art in 1952. He also studied at the Accademia de Belle Arti in Florence and with Victor D'Amico in New York.

After working at the Tyler School of Art for several years, Combs went to Anchorage, where he worked as an art instructor for the Anchorage school district, did some commercial fishing, and for a time owned a small gallery that showed his own work and that of others (McCollom 1974a, p. 159). In 1962 he joined the faculty of Anchorage Community College where he remained until 1979. He also taught privately during much of that time and conducted summer workshops and art tours to New York and abroad for Anchorage residents.

Most recognized as a sculptor and ceramist, Combs designed and produced one of the first public art works in Alaska, the sculptural frieze that surrounds the older sections of the

Anchorage Museum. Also an accomplished painter, Combs has won awards in more than a dozen All Alaska Juried Art Exhibitions and Earth, Fire, and Fibre exhibitions—the statewide juried competitions hosted by the Anchorage Museum. The museum mounted a retrospective exhibition of his work in 1980. He continues to work prolifically from his studio in Halibut Cove, across Kachemak Bay from Homer, where he moved after retiring from the university.[18]

Wassily Sommer (1912–1979) was another early, influential instructor at Anchorage Community College. Born in Saint Petersburg, Russia, Sommer studied music at the Petrograd Conservatory of Music before taking classes in painting at the Munich art museum and private lessons from Oskar Kokoschka in Vienna. After moving to the United States in 1949, Sommer continued his training in Philadelphia at the Fleisher Memorial Art School, the Philadelphia Museum of Art, and the Pennsylvania Academy of the Fine Arts. He won a watercolor prize and the Thomas Eakins Painting Prize at the Pennsylvania Academy during this period. While in Philadelphia, Sommer met Mary Jean Ritchie, an art student. The couple were married in 1954 and moved to Alaska in 1959.

Sommer taught at Tanana Valley Community College in Fairbanks before moving to Anchorage and joining the faculty

92. Alex Duff Combs, *Totem,* 1980
Acrylic on canvas, 122 × 76 cm; Municipal Acquisition Fund purchase, 81.8.2

93. Wassily Sommer, *Green Lake,* ca. 1970
Acrylic on board, 50.8 × 60.8 cm; Gift of Robert Hardy, 89.33.1

of Anchorage Community College in 1967. His work, although less familiar today than that of many of the artists considered here, was especially admired by his fellow painters. Based on the Alaskan landscape, his early impressionistic scenes soon gave way to more expressionistic, abstracted canvases. Rich in color and assured in the handling of line and form, *Green Lake* is one of eleven Sommer paintings in the museum's collection and is typical of the artist's best work (no. 93). The northern setting and expressionistic approach call to mind the work of the great Norwegian painter Edvard Munch. Sommer's work was featured in the first solo exhibition held at the Anchorage Museum in 1968.

Wassily and his wife, Mary Jean, had a two-person show at the Anchorage Museum in 1977. Mary Jean Sommer, who studied art in Philadelphia at Milliken University and the Pennsylvania Academy of the Fine Arts, continued an active painting career in Alaska. She exhibited frequently in statewide competitions in the 1970s and exhibited work at the Seattle Art Museum and the Cheney Cowles Museum in Spokane, Washington. Her series of flattened abstractions inspired by Russian Orthodox churches in Alaska are her most identifiable works, although in later years she has turned to portraiture (*Anchorage Historical and Fine Arts Museum Newsletter,* May 1977). Sommer organized a retrospective exhibition of her husband's work at the Anchorage Museum in January 1980, after his death in October 1979.[19]

Gerald Conaway, another successful painter and sculptor during this era, taught at Alaska Methodist University from

94. Keith K. Appel, *Lunar Solstice,* 1974
Enamel on acrylic plastic, 98.7 × 129.6 cm; Gift of the Anchorage Museum Association, 74.18.1

1966 to 1975. Conaway established his reputation with bio-morphic sculptures and paintings of abstracted natural forms, although in the late 1970s he began to move toward concep-tual work.

Keith K. Appel (b. 1934) arrived in Anchorage in 1960 and has been a constant presence on the arts scene since that time. Trained at Mankato State University in Minnesota, he taught art in the Anchorage school district from 1960 to 1967 and served as art director for the district from 1968 to 1970. He left that position to join the faculty of the University of Alaska in Anchorage, where he remained until 1981. Since that time, he has been a full-time artist, concentrating prima-rily on large-scale public art commissions throughout the state of which he has completed more than a dozen.

Appel's work has varied in terms of materials and imagery. Beginning as a painter, he turned in the 1970s to acrylic and enamel on Plexiglas (no. 94), and later to enamel on steel. In the mid-1980s his work made a transition from two-dimen-sional to sculptural. The artist's imagery has ranged from non-representational work derived from landscape and geological forms to designs incorporating playful silhouettes of Alaskan mountains and animals.[20]

Another progenitor of college art education in Anchor-age is Saradell Ard (b. 1920), who has been a leader on the Anchorage arts scene for thirty years. Ard, born in Macon, Georgia, was trained in art, speech, and art education at Asbury College in Kentucky (A.B.), the University of Michi-gan (M.A.), and Columbia University Teacher's College in

New York (D.Ed). She also studied silversmithing in New York at the Craft Students League and painting at the Art Students League and the University of California, Berkeley. She traveled to Whittier, Alaska, in 1952–53 as the army education supervisor, and returned to Alaska to stay in 1962 after serving as chief of the Army Arts and Crafts Program in Europe.

Ard's nonrepresentational color-field painting evolved from an abstract expressionist to hard-edged style between the early 1960s and early 1970s. She was a frequent exhibitor in All Alaska Juried Art Exhibitions for many years, was included in the 1978 exhibition *Contemporary Art from Alaska* at the Smithsonian Institution, and has had a number of solo exhibitions in Alaska.

Ard's influence on Anchorage art and artists is pervasive. She taught art and art history at Alaska Methodist University from 1962 to 1973, and helped develop the art department at the Anchorage campus of the University of Alaska from its inception in 1973 until her retirement in 1985. She has also served as a member of the Anchorage Museum Commission and on the board of directors of the Anchorage Museum Association for most of the museum's twenty-five-year history. She has written on contemporary and historical Native Alaskan art and continues to live and work in Anchorage.[21]

Pat Austin (b. 1935), who moved to Anchorage in 1965, has not only been an influential artist and teacher but has written forcefully and articulately about contemporary issues in Alaskan art. She wrote the major essay of the exhibition catalogue for *Contemporary Art from Alaska,* entitled "Observations from the Inside: A Look at Some Influences on the Making of Art in Alaska" (National Collection of Fine Arts 1978, pp. 9–17). The mixed concerns and opportunities she addressed fifteen years ago—isolation from major cultural centers, the open field, lack of serious critical discourse, widespread support for Alaskan imagery, the impediments to large-scale and avantgarde work—sound as fresh today as they did then.

Austin's background in English and creative writing in addition to art (she has a B.A. in English from the University of Michigan, a B.F.A. in art from the University of Washington, and an M.F.A. in creative writing from the University of Alaska Anchorage) has served her students and audience in good stead. The art appreciation, painting, and printmaking classes she taught for years at Anchorage Community College, and occasionally at the Anchorage Museum, have been widely praised for opening the eyes and honing the skills of a generation of Alaskans.

Austin's direct contributions as an artist have been substantial as well. Her paintings, prints, and mixed-media constructions have been an ever-changing kaleidoscope of carefully crafted and engaging images (no. 95). Ranging from nonobjective to illustrative and from playful to intense, her work was for many years a fixture in statewide competitions and frequent solo exhibitions. Purchase awards for her prints, paintings, and works on paper have come from throughout Alaska, Washington State, Michigan, and elsewhere. Austin retired several years ago and moved to Salem, Oregon. She currently resides in Port Townsend, Washington.[22]

The work of Joan Kimura (b. 1934), who arrived in Alaska in 1971, appropriately ends this historical account and foreshadows the future (no. 96). Although her Alaskan career parallels in most ways those of the earlier group of progressive postwar Anchorage artists, she provides a transition between the postwar Alaskan art world of the 1950s, 1960s, and 1970s and the post-pipeline art scene of the 1980s and 1990s.

The artist grew up in Los Angeles and completed a four-year program at the Art Center (now the Art Center College of Design). After a brief stint with the *Los Angeles Examiner,* she moved to New York in 1955 to pursue a career in commercial advertising design. There she met Sam Kimura (the youngest brother of Bill Kimura), and the two were married two years later. Sam Kimura, who had operated a portrait studio in Anchorage before owning a photography studio in New York, is now one of Alaska's best-known photographers.

Joan did freelance commercial illustration for the next six years. After the birth of two children and a move to New Jersey, she took up painting again and by 1967 was exhibiting in New York, New Jersey, and Connecticut. The couple moved to Anchorage in 1971. Joan immediately began to do freelance design work, and both started teaching at Anchorage Community College.

Since settling in Alaska, Joan Kimura has become recognized as one of the state's finest painters, and probably its most popular nonrepresentational artist. During the past two decades her work, always ambitious, has evolved more dramatically than that of most of her colleagues. Throughout the 1970s she elaborated and developed her hard-edged color-field paintings, working bands, rectangles, and triangles of color against looser, brushy grounds. By 1981, however, the hard-edged

95. Pat Austin, *Easter Tableau*, ca. 1988
Acrylic on canvas, 106.7 × 122 cm; Gift of the Anchorage Museum Association, 89.38.1

96. Joan Kimura, *H.S. Variations II, #22,* 1982
Oil on canvas, 121.5 × 172.5 cm; Gift of Saradell Ard, 83.70.1

geometry started to give way, and the looser fields of color began to dominate. Like many prominent artists in New York and Europe at the time, Kimura began to develop a more expressionist approach to both paint handling and color.

In the mid-1980s, figurative elements began to appear in her paintings. The reviews and discussion of Kimura's work during this period reveal the continuing isolation of Alaska from the world's major cultural centers: while Kimura's development was thoroughly in keeping with the movements in the larger art world, this stylistic transition was seen by most of her Alaskan followers as a radical break with her former concerns. For most of the arts community and the small critical audience in Anchorage, the idea of an Alaskan artist being involved in a serious and highly personal way with formal concerns shared by other artists in the world remains even today a foreign notion.

This evolution of Kimura's work marks an important milestone in the maturation of art in Alaska. Not for the first time, but particularly clearly and dramatically, we are confronted with an artist who lives in Alaska and is committed to it, but whose artistic reference remains outside the North. Not slavishly following the fashions of the larger world of painting, but sensitive to them, Kimura's artistic development paralleled changes then occurring in the work of artists throughout America and Europe. Her work grows ever stronger because of this broader perspective.

The sense of being part of the larger art world is more common among those artists who arrived in Alaska in the late 1970s and in the 1980s, many of whom stayed a brief time and left to rejoin that world. But as Joan Kimura has demonstrated, it is possible for Alaskan painters to stay in the North and still be part of the wider art scene. They can strive to bring to Alaskan art a current approach and even maintain their freshness and connection with the greater world while remaining committed to the place. This is the challenge that contemporary Alaskan artists still struggle to meet.[23]

1. Postwar Alaska obviously was not one happy, growing family. The influx of money, people, and jobs was not distributed equally throughout the state, and the impacts of postwar growth were not all positive. Changes in the way of life of the territory's Natives increased, and even many non-Native Alaskans who had come north to find a quieter, simpler life were dismayed by the irremediable loss of the old ways.

2. This glazing process has been described in various sources but is covered in the greatest detail in Diffily 1980, pp. 9, 13.

3. In addition to the catalogue of Machetanz's oil paintings compiled by his wife, Sara, and introduced by John A. Diffily (Diffily 1980), and an article on the artist and his wife by Joseph Lawton in *Alaska Review* (1965), a number of biographical and critical articles about Machetanz have appeared. Among the most interesting are *Alaska Life* 1941; Blaine 1983; Diffily 1981; Doherty 1981; Farneski 1988; Ingram 1988; Jones 1968; McCollom 1974b; Nelson 1982; Wood 1982; and Yost 1970.

4. According to Ann Chandonnet (1975, p. 218), the Goodales estimated in 1975 that they had painted more than six thousand Alaskan canvases, of which they had retained only three.

5. For more on the Goodales, see *Alaskana* 1980; Chandonnet 1975; and Vaughan 1990.

6. For more on Mangus, see Artique Ltd. Fine Art Gallery 1983; reviews by Haines (1980b) and Ingram (1989a); and the extensive article by the artist's wife on his work and travels, in *Alaska Journal* (Mangus 1975).

7. For biographical information and reproductions of work by the Crumrines, see such early references as Arnold 1942 and Reed 1945. For an update on Josephine Crumrine Liddell's later work, see Shuler 1977.

8. For more on DeArmond, see Artique Ltd. Fine Art Gallery 1983; National Collection of Fine Arts 1978, p. 40; DeArmond 1973, 1975, 1979, 1985, 1990a, 1990b; and Rich 1987; as well as numerous announcements of new print releases in the *Alaska Journal*.

9. For more on Muñoz, see Artique Ltd. Fine Art Gallery 1983; DeRoux 1990, pp. 19–20; Eppenbach 1983; Mozee 1974; Muñoz 1984, 1987; National Collection of Fine Arts 1978, pp. 52–53; and the many books she has illustrated.

10. This was Fejes's first major publication. In 1959 Fejes's husband, Joe, had printed an illustrated volume of his wife's poems under the title *Primeval Land and Other Poems* (Fejes 1959).

11. A good deal has been written about the life and lengthy career of Claire Fejes. Her own books include Fejes 1959, 1966, 1969, and 1981, and she provided illustrations for Hall 1975. The Goodwin catalogue for the 1991 retrospective at the University of Alaska Museum is the most incisive and comprehensive treatment of the work itself. See also Brunberg 1966; Capps 1991; Harder 1987; Ingram 1992; Mollett 1979; Noyes 1990; Oehring 1985; Ondash 1985; and Parish 1982.

12. Kimura died unexpectedly of a heart attack on April 28, 1991. Among the many moving articles on his life, art, and legacy that appeared in Anchorage newspapers following his death are Harrison 1991; Ingram 1991; McPherson 1991; Sopalski 1991; and Stock 1991.

13. Buske 1965 is still the best single source on Kimura's early career, and it provides a good deal more detail about the events described briefly here. It is also one of very few writings to reflect on the importance of those early postwar events in Anchorage's cultural history.

14. The sources on Senungetuk are extensive. His work was published in August 1954 in *House Beautiful*, and in such standard works on contemporary metalsmithing as Untracht 1982 (pp. 2, 109, 495). See also Blackman and Hall 1988; Fedoroff 1966; Frederick 1972; Nordness 1970; Ray 1967, 1969, 1977; and Simpson 1991.

15. For more examples of work by Simpson, see the portfolio of his work published in *American Craft*, August–September 1984.

16. For more on Brody's work see, for instance, Michaels 1990a, 1990b; Mollett 1982; and National Collection of Fine Arts 1978.

17. Probably the first college art teacher in Anchorage was the gallery owner and interior decorator Mel Kohler. Kohler, who had earned a master's degree from Columbia University Teacher's College, ran a gallery in Washington State and worked at the Henry Art Gallery of the University of Washington before coming to Anchorage and opening Mel Kohler Interiors. Not a practicing artist himself, but highly influential in his role of encouraging local artists and showing their work, he was hired in 1960 both to decorate the newly opened Alaska Methodist University and to teach art there (personal communication with Saradell Ard, August 1992).

18. For more on Combs, see Ingram 1987, 1990; McCollom 1974a; *Anchorage Historical and Fine Arts Museum Newsletter,* November 1970, November 1973, December 1980; and National Collection of Fine Arts 1978.

19. Although Sommer was one of the most celebrated artists in Alaska when he died, his work was not widely discussed in print. Brief articles on his exhibitions appear in the *Anchorage Historical and Fine Arts Museum Newsletter,* November 1971, May 1977, November 1979, and January 1980. His teaching style is briefly discussed in Ingram 1991.

20. For more on Appel, see Artique Ltd. Fine Art Gallery 1983; Brice 1986; Chandonnet 1979; Ingram 1982; Lew 1980; McCollom 1979; and National Collection of Fine Arts 1978.

21. Articles by Ard (under her married name of Frederick) include "Alaskan Eskimo Art Today" (Frederick 1972) and a piece on Canadian Inuit sculpture (Frederick 1980). Her essay "Roots in the Past" was included in Fitzhugh and Kaplan 1982. For more on her career and contributions to the arts in Alaska see *Anchorage Historical and Fine Arts Museum Newsletter,* March 1971, October 1976, November 1984; and National Collection of Fine Arts 1978.

22. For more on Austin, see Haines 1980a; Ingram 1986, 1989b; and McKinney 1982.

23. For more on Kimura, see Billington 1989; Bouilhet 1988; Haines 1980b; Ingram 1981, 1983, 1989c; and McCollom 1973.

LOOKING BACK AND AHEAD

It is hard for a visitor to believe that the Anchorage Museum of History and Art is only twenty-five years old, after exploring the magnificent 140,000-square-foot facility and spending time with the extensive collection. For the people of Anchorage, for art and history lovers from around the state, and for the quarter million visitors who come through its doors each year, the museum already seems venerable. Conveying substantiality, sophistication, and a sense of history, the soaring spaces of the vaulted galleries and light-filled atrium and the panoply of treasures on view could barely have been envisaged by Alaskans as late as the 1960s and would have been unimaginable to the territory's early twentieth-century residents.

Or maybe they could have imagined such an institution. This museum, like the city of Anchorage and the state of Alaska, was built and has been sustained by people who like to dream big.

Founding of the Museum

The Anchorage Historical and Fine Arts Museum (renamed the Anchorage Museum of History and Art in December 1984) on July 18, 1968, opened the doors to its 10,000-square-foot facility. On display were an exhibition of sixty borrowed Alaskan paintings and a collection of 2500 historical items inherited from the Cook Inlet Historical Society. The events leading to that opening show the desire and determination of Anchorage citizens to have a significant museum.

The year 1967 marked the one hundredth anniversary of the purchase of Alaska from Russia by the United States. To commemorate the upcoming anniversary, the federal government made available to communities throughout Alaska funds for civic building projects; some of the money was earmarked for an Anchorage museum. Museum supporters under the leadership of Mayor Elmer Rasmuson and his wife, Mary Louise, waged a successful campaign in the fall of 1966 to earn the support of Anchorage voters for a bond issue to build a museum. They then secured pledges and funds from individuals and businesses to retire the bonds. The Anchorage City Council donated two and one half acres of valuable downtown property as a museum site, and the official ground breaking ceremony took place September 12, 1967. The museum opened its doors less than a year after the ground breaking. Michael Kennedy, former director of the Montana Historical Society, was named the first director of the new museum, which had an operating budget of $20,000.

In July 1969, the Anchorage Fine Arts Museum Association (AFAMA) was formed, and its volunteer members handled many of the new institution's chores and programs. A sales desk, fund-raising activities, guided tours, and a training program for museum docents were soon initiated by AFAMA. The support organization, which was renamed the Anchorage Museum Association (AMA) in 1985, remains a key element in the success of the museum today. The group runs the museum store, museum cafe, and other operations. Profits from these and other fund-raising endeavors provide major support for the museum and are the primary source of funding for new acquisitions.

The Anchorage Museum under Robert L. Shalkop

The character, scope, and depth of the museum's collection today are the direct result of the connoisseurship of Robert L. Shalkop, who succeeded Michael Kennedy as museum director in January 1972. Between his appointment and his retirement in 1987, he led the development of the permanent collection from a few thousand items to more than 10,000 art, ethnological, and historical objects.

In September 1973, voters approved a $1.2 million bond issue for an addition to the museum building. Ground was broken for the new 15,000-square-foot construction in May 1974, and the new facility was opened to the public on February 27, 1975.

The museum continued to grow, not just in building size but in popularity and in the depth of its collection. Long-term exhibitions on Alaska's history and its Native peoples were developed and installed. Temporary exhibitions of wide diversity were brought from national and international sources. Solo exhibitions and annual statewide competitions provided the state's most prestigious forum for Alaskan contemporary artists. An already active education program was expanded.

Growing Facilities and Expanding Ambitions in the 1980s

By 1980, the expanded museum facility again seemed too cramped to accommodate the wealth of material to be shown and programs to be undertaken by a growing staff and aspiring leadership. A design study for further expansion was performed, and when the Alaska state legislature appropriated more than $200 million to Anchorage for capital projects in 1981, the museum moved to take advantage of the opportunity. Mayor George Sullivan and the Anchorage assembly gave the museum a high priority, and with the support of the new mayor, Tony Knowles, ground was broken in September 1982. July 13, 1986, marked the completion of the new building and renovation of the old one.

The new building brought the total museum space to 93,000 square feet of exhibition and work spaces and 47,000 square feet of underground parking. More than $1 million more had to be raised through a capital fund drive to finish the museum renovation and build a new Alaska Gallery. Spearheaded by volunteers Carol and Duane Davis Heyman, many individuals and corporations donated generously to the fund.

The naming of the Mary Louise Rasmuson Atrium recognized the major contribution of Elmer and Mary Louise Rasmuson to this drive as well as their unstinting support of the museum's goals throughout the history of the institution, and Mary Louise Rasmuson's long, distinguished tenure as chair of the museum commission.

The largest single space in the new building was the 15,000-square-foot Alaska Gallery. This impressive self-contained gallery, one and one half times the size of the original museum, tells the story of Alaska and its people from prehistoric to contemporary times. The lives and material culture of Alaska's Native people, their contact with Europeans and Americans, and changes in Alaska throughout the nineteenth and twentieth centuries are explored in long-term exhibits that make use of the museum's collections in an integrated, interpretive way.

A series of new galleries in the addition was designed to allow a chronological display of Alaskan painting, drawing, and sculpture from 1778 to the present, including contemporary works by Alaskan artists and the outstanding collection of contemporary Native art, commissioned with a grant from Cook Inlet Region, Inc. An additional 10,000 square feet of temporary exhibition space was gained in the new building, not only making possible larger and more comprehensive traveling exhibitions but also allowing greater flexibility in the use of the museum's older, smaller spaces.

Other major additions in the expansion included a large children's gallery and activity room for use by the Education Department, a much-expanded auditorium, and a new 3000-square-foot library and archival space. By the time of its completion in 1986, the museum's new facility was one of the finest on the West Coast and among the notable museum structures in the country. Moreover, it provided the physical structure for an institution that was growing in energy, ambition, and visitor interest as rapidly as the building itself.

Looking Ahead: A Museum of the North

The growth of the Anchorage Museum of History and Art in its first quarter century has been remarkable. That a city so young and so removed from the major urban cultural centers of North America should build in less than twenty-five years a major institution in the service of art and history is little short of miraculous. The Alaskan collection, which took definite and comprehensive form in the fifteen-year tenure of Robert

Shalkop, has continued to grow under the leadership of Director Patricia Wolf.

Under Wolf's direction since 1987, the ambition and scope of the museum have also increased rapidly, despite difficult economic times. By hosting major traveling exhibitions on northern themes in the late 1980s and early 1990s, and organizing its first major traveling exhibitions, the museum has risen to a new level of prominence. It has become an institution that is no longer content to accept and display what others have to say about Alaska and the North, but is eager to make its own substantial statements to the world through exhibitions of Alaskan art.

Far from forgetting its community roots, the museum has made similarly important forays in education, interpretation, and community service. It has also assumed a position of leadership in public art. In 1988, the museum was given responsibility for the city's public art program, currently one of the only city art programs in this country to be run by a municipal museum. The Anchorage Museum of History and Art is more than ever a center for community life in Anchorage, and its collection continues to develop through the generosity of donors and the identification of funds to acquire important works.

Paralleling the growth of Anchorage in size and self-confidence, the museum has assumed increasing authority. Beginning as a leader in the cultural life of Anchorage, it has become a leader in the cultural life of Alaska, and is on the brink of taking such a role among art and history museums in the circumpolar North. What, then, does this mean for the museum and its collection in the next twenty-five years? What kind of institution will the Anchorage Museum be at the end of its next quarter century?

Collecting Alaskan Art: Filling the Gaps and Broadening the Base

Whatever else it may do in the next quarter century, the Anchorage Museum will continue to build on the strengths of its collection. Its directors have understood that a major museum collects both broadly and deeply, and that it acquires major works. Works by artists already represented in the collection, especially principal figures, will undoubtedly continue to be sought in greater depth. A full range of styles, periods, and subject matter is the goal of the museum for those artists who are key to the development of Alaskan art. For well-known artists who traveled only once, or very few times, to Alaska, it is important to acquire the best examples possible. Although historical gaps remain, the Anchorage Museum has achieved a comprehensive collection of Alaskan art. While working toward strengthening existing holdings, the institution has already begun to move toward larger goals.

The museum's leaders are realistic. Although Anchorage is the largest city in Alaska, it is tiny in comparison with the world's major cultural centers. The resources on which the museum can draw, no matter how ambitiously, are limited, and the world art market has become expensive. Historical Native Alaskan art is an obvious goal for future acquisitions, but the heyday of large-scale artifact collecting is long past, and the cost of major works of historical Native art is almost invariably prohibitive for all but the largest institutions. The museum continues to increase its holdings in traditional Native art, but its leaders are aware that it is unlikely to become a major institution in that arena.

The same is even more true of building a collection of European or American masterworks. Skyrocketing prices for paintings and sculptures by major American and European artists have put all but minor examples beyond the museum's reach. The institution can stretch to acquire a major work and has done so for Alaskan pieces, but to try to build a representative collection of American art now would doom the museum to a future of, at best, minor works by major artists or major works by less important artists.

There is, however, an arena in which this institution can be more than a small player on the world stage. The museum has taken the first steps in a direction that is relevant to the citizens of Anchorage and Alaska. Recognizing that its future, like Alaska's, is intertwined with the future of the circumpolar North, the Anchorage Museum is extending its collection with work from other parts of that global region.

The attractions of acquiring the work of other northern regions are clear. What better way to enhance the understanding and development of Alaskan art than by collecting and exhibiting related northern art? The differences in the art of Alaska, Canada, Scandinavia, and northern Russia are as enlightening as the similarities. It is with those who have similar landscapes, wildlife, climate, Native cultures, and historical and contemporary problems that Alaskans share the greatest

affinity. This fact has been increasingly apparent in other areas of endeavor in recent years. Social and physical scientists, politicians, naturalists, writers, and other residents of the North have long recognized that national boundaries do not separate their interests and concerns. The Anchorage Museum has realized that the same is true of art.

In this arena the Anchorage Museum has begun to stake an almost unique claim. Already the museum has acquired fine examples of work from other parts of the Arctic and Sub-Arctic, some of which have been discussed in the text. Other outstanding examples are being sought. Such a move requires no major refocusing and no dilution of the institution's original aims. One need only examine the work of George Francis Lyon, Albert Operti, and others to see how such examples complement and shed light on the work of their Alaskan contemporaries.

The long-term possibilities of such a goal are exciting. It would be wonderful for visitors to see paintings by Canada's early twentieth-century Group of Seven and such contemporary Canadian artists as Joyce Wieland and Paterson Ewen beside Alaskan work of the same periods. Educational as well as artistic goals would be served if pieces by contemporary and historical artists from Yakutsk, Vladivostok, Stockholm, and Nuk were viewed next to the work of artists from Fairbanks, Anchorage, Juneau, and Barrow.

In the historical galleries, Thomas Hill's Muir Glacier would be all the more meaningful if next to it hung the eastern Arctic icebergs of William Bradford, Frederic Church, Thomas Moran, or Albert Bierstadt. In newer, more experimental modes, the important Alaskan work of artists like Ken Gray and David Felker would have greater impact if seen in the context of the environmental sculptures of Andy Goldsworthy or the environmental video works of Mary Lucier.

Such acquisitions are not easy to make, and important examples would still be a stretch for a museum in a city of less than a quarter million people, situated in a state that is facing hard economic times. But the leaders of the Anchorage Museum have taken the initiative in a mission that has the potential to capture the imagination of donors, supporters, and artists around the world. They have set a goal that transforms the parameters of the collection, the museum's location, and the interests of Anchorage citizens from possible disadvantages into advantages.

The individuals affiliated with the Anchorage Museum have long understood that to better serve this community, to help it grow not just in size but in character (and not just in boom times but in difficult economic times), it is necessary to broaden goals. The museum set high aims in its first quarter century, which resulted in remarkable growth and impact. The next quarter century may be greater still.

REFERENCES CITED

Adams, Ben
1961 *The Last Frontier, A Short History of Alaska.* Illustrations by George Ahgupuk. New York: Hill and Wang.

Adney, Edwin Tappan
1900 *The Klondike Stampede.* New York: Harper and Brothers.

Ahgupuk, George
1953 *Eighteen Reproductions of Paintings by . . . George Ahgupuk.* Seattle: Deers Press.

Ainslie, Patricia
1987 *A Lifelong Journey: The Art and Teaching of H. G. Glyde.* Calgary, Alberta: Glenbow Museum.

Alaska Life, The Territorial Magazine
1939 "News Note," Aug., p. 9
1941 "Northern Lights," 4, no. 12 (Dec.), p. 29, cover.
1942 "Ted Lambert, Alaskan," 5, no. 6 (June), p. 2, cover.

Alaska State Museum
1988 *Lockwood de Forest, Alaska Oil Sketches.* Juneau: Alaska State Museum.

Alaskana
1980 "Pioneer Painter: Harvey Goodale," 8, no. 2, p. 46.

Anchorage Daily Times
1973 "Nupok Depicts Alaskan Life," Oct. 19.

Andrews, C. L.
1938 *The Story of Alaska.* Caldwell, Idaho: Claxton Press.

Arkelian, Marjorie Dakin
1980 *Thomas Hill: The Grand View.* Oakland, Calif.: Oakland Museum.

Arnold, C. B.
1942 "The Painters Crumrine." *Alaska Life* 5, no. 7 (July), pp. 5, 24.

Artique Ltd. Fine Art Gallery
1983 *Alaska's Artists in Washington, D.C.* Anchorage.

Barker, Charles
1940 "Philosopher on Canvas." *Alaska Life* 3, no. 5 (May), pp. 6, 30.

Bates, Robert H.
1988 *Mountain Man: The Story of Belmore Browne, Hunter, Explorer, Artist, Naturalist and Preserver of Our Northern Wilderness.* Clinton, N.J.: Amwell Press.

Bedford, Jimmy
1986 "The Long Journey of Rusty Heurlin." *Fairbanks Daily News-Miner,* March 16, p. D1.

Bergh, Peter
1984 *The Art of Ogden M. Pleissner.* Boston: David R. Godine.

Billington, Linda
1989 "Drawing on Transition." *Anchorage Daily News,* Oct. 29, pp. F1–F2.

Binek, Lynn

1987 *Works Progress Administration's Alaska Art Project, 1937: A Retrospective Exhibition.* Anchorage: Anchorage Museum of History and Art.

1989 *Drawing the Lines of Battle: Military Art of World War II Alaska.* Anchorage: Anchorage Museum of History and Art.

Birket-Smith, Kaj

1959 "The Earliest Eskimo Portraits." *Folk* 1, pp. 5–14.

Blackman, Margaret, and Edwin S. Hall

1988 "Alaska Native Arts in the Twentieth Century." In *Crossroads of Continents: Cultures of Siberia and Alaska,* ed. William W. Fitzhugh and Aron Crowell, pp. 326–40. Washington, D.C.: Smithsonian Institution.

Blaine, John

1983 "Degree Honors Machetanz' Contribution to Alaska Culture." *Anchorage Daily News,* Sept. 18.

Blucher, Jay

1990 "Rising above the Everyday Landscape: Two Alaska Artists Shine in Showcase Competition." *Anchorage Daily News,* June 17, pp. G1–G2.

Bonnell, Raymond

1986 "An Artist on the Trail: Edmond James Fitzgerald and the U.S. Geological Survey." *Alaska Journal* 16, pp. 55–60.

Bouilhet, Carline

1988 *Joan Kimura.* Exh. cat. Anchorage: Anchorage Museum of History and Art.

Brice, Jennifer

1986 "Keeping the Lead Open." *Fairbanks Daily News-Miner,* June 19, p. 19.

Brown, Emily Ivanoff (Ticasuk)

1981 *The Longest Story Ever Told: Qayaq, the Magical Man.* Illustrations by Robert Mayokok. Anchorage: Alaska Pacific University Press.

Browne, Belmore

n.d. Belmore Browne Papers. Stefansson Manuscript no.190. Dartmouth College Library, Hanover, New Hampshire.

1913 *The Conquest of Mount McKinley: The Story of Three Expeditions through the Alaskan Wilderness.* New York: G. P. Putnam's Sons.

Brunberg, Janet

1966 "Claire Fejes, Artist." *Alaska Review* 2, no. 2 (Spring/Summer).

Buske, Frank

1965 "William Kimura." *Alaska Review* 2, no. 1 (Fall), pp. 67–78.

Cahill, Holger

1937 Letter to Ernest Gruening. June 21. Record Group 126, File no. 9-1-91. National Archives, Washington, D.C.

Campbell, Nola H.

1974 *Talkeetna Cronies.* Anchorage: Color Art Printing.

Capps, Kris

1991 "Claire Fejes: Capturing Northern Life on Canvas." *Fairbanks Daily News-Miner, Heartland* magazine, November, pp. H8–H13.

Caswell, Helen Rayburn

1968 *Shadows from the Singing House: Eskimo Folk Tales.* Illustrations by Robert Mayokok. Rutland, Vt.: C. E. Tuttle.

Champney, Benjamin

1900 *Sixty Years' Memories of Art and Artists.* Woburn, Mass.: The News Print, Wallace and Andrews.

Chandonnet, Ann

1975 "The Goodales: Painters of Alaska for 32 Years." *Alaska Journal* 5, no. 4 (Autumn), pp. 217–23.

1979 "Ten Alaskan Artists: An In-depth Look at Their Lives, Their Craft, and Their Works." *Anchorage Magazine* 1, no. 8 (Sept.), p. 9.

Colby, Merle Estes

1939 *A Guide to Alaska: Last American Frontier.* New York: Macmillan.

Cole, Douglas

1979 "John Webber, A Sketch of Captain James Cook's Artist." *British Columbia Historical News* 13, no. 1 (Fall).

1985 *Captured Heritage: The Scramble for Northwest Coast Artifacts.* Seattle: University of Washington Press.

Cook, Frederick Albert

1900 *Through the First Antarctic Night, 1898–1899.* New York: Doubleday and McClure.

Cook, James

1784 *A Voyage to the Pacific Ocean . . . by Captain James Cook. . . .* 3 vols. and atlas. London: G. Nicol and T. Cadell.

Corn, Wanda M.

1972 *The Color of Mood: American Tonalism, 1880–1910.* Exh. cat. San Francisco: M. H. De Young Memorial Museum and the California Palace of the Legion of Honor.

Cornelius, Fidelis

1942 *Keith, Old Master of California.* New York: G. P. Putnam's Sons.

Crane, Frank A.

1915 "Who Is Who in Minnesota Art Annals: The Story of a Pioneer." *The Minnesotan* 1, no. 5 (Dec.), pp. 19–21.

Current Opinion

1913 "A Great Artistic Interpreter of the Frozen North," Oct., pp. 274–75.

Davis, Mary Lee

1930 *Uncle Sam's Attic: An Intimate Story of Alaska.* Boston: W. A. Wilde.

Dawdy, Doris Ostrander

1985 *Artists of the American West.* Vol. 3. Athens, Ohio: Swallow Press.

DeArmond, Dale Burlison

1973 *Juneau: A Book of Woodcuts.* Anchorage: Alaska Northwest Publishing.

1975 *Raven: A Collection of Woodcuts.* Anchorage: Alaska Northwest Publishing.

1979 *Dale DeArmond: A First Book Collection of Her Prints.* Anchorage: Alaska Northwest Publishing.

1985 *Berry Woman's Children.* New York: Greenwillow Books.

1990a *The Boy Who Found the Light: Eskimo Folktales.* San Francisco: Sierra Club Books.

1990b *The First Man: A Cautionary Tale.* Sitka: Old Harbor Press.

DeArmond, Robert N.

1978 "Ziegler in Black and White." *Alaska Journal* 8, no. 2 (Spring), pp. 162–69.

1981 *Lady Franklin Visits Sitka, Alaska, 1870: The Journal of Sophia Cracroft, Sir John Franklin's Niece.* Anchorage: Alaska Historical Society.

1989 "Graphic Artists in Sitka, 1867–1897." Paper presented at annual meeting of the Alaska Historical Society, Sitka.

DeRoux, Kenneth

1990 *The Gentle Craft: Watercolor Views of Alaska 1778–1974 from the Collection of the Alaska State Museum, Juneau, Alaska.* Juneau: Alaska State Museum.

Diffily, John

1980 Introduction. Sara Machetanz. *The Oil Paintings of Fred Machetanz,* pp. 7–14. Leigh-on-Sea, England: F. Lewis Publishers.

1981 "Machetanz." *Alaskafest,* Nov., pp. 26–33, cover.

Doherty, M. Stephen

1981 "The American Artist Collection, 1981 Selection, Fred Machetanz." *American Artist,* Nov., pp. 50–55, cover.

Elliott, Henry Wood

1886 *Our Arctic Province: Alaska and the Seal Islands.* New York: Charles Scribner's Sons.

Eppenbach, Sarah

1983 "Rie Muñoz in Tapestry." *Alaskafest,* Nov.,
 pp. 16–20.

Farneski, Anna

1988 "Machetanz Has Many Fans in the Interior."
 Fairbanks Daily News-Miner, Feb. 19, p. 17.

Fedoroff, George W.

1966 Indian Arts and Crafts Board. "Alaska." *Smoke
 Signals,* nos. 50–51. pp. 10–17, 20, 21.

Fejes, Claire

1959 *Primeval Land and Other Poems.* Fairbanks: J. Fejes.

1966 *People of the Noatak.* New York: Alfred A. Knopf.

1969 *Enuk, My Son.* New York: Pantheon Books.

1981 *Villagers: Athabaskan Indian Life along the Yukon
 River.* New York: Random House.

Fielding, Mantle

1965 *Dictionary of American Painters, Sculptors, and
 Engravers.* New York: James F. Carr.

First National Bank of Fairbanks

1986 *A Salute to a Hometown Artist: T. R. Lambert, 1905–
 1960.* Fairbanks.

Fitzhugh, William W., and Susan A. Kaplan

1982 *Inua: Spirit World of the Bering Sea Eskimo.* Wash-
 ington, D.C.: Smithsonian Institution Press.

Francisco, Cyrus Peter

1990 *The Man and the Mountain: Sydney Laurence's Mt.
 McKinley.* Upland, Calif.: Lynn F. Casella Commu-
 nications.

Frederick, Saradell Ard

1972 "Alaskan Eskimo Art Today." *Alaska Journal* 2,
 no. 4 (Fall), pp. 30–41.

1980 "Inuit Sculpture: Art to Please the World." *Alaska
 Journal* 10, no. 3 (Summer), pp. 28–31.

Gerdts, William H.

1990 *Art across America: Two Centuries of Regional Paint-
 ing, 1710–1920.* New York: Abbeville Press.

Gerdts, William H., Diana Dimodica Sweet, and
Robert R. Preato

1982 *Tonalism: An American Experience.* Exh. cat. New
 York: Grand Central Art Galleries.

Goetzmann, William H., and William N. Goetzmann

1986 *The West of the Imagination.* New York: W. W.
 Norton.

Goetzmann, William H., and Kay Sloan

1982 *Looking Far North: The Harriman Expedition to
 Alaska, 1899.* New York: Viking Press.

Goodwin, Mary

1991 *Claire Fejes Retrospective.* Fairbanks: University of
 Alaska Museum.

Green, Paul

1959 *I Am Eskimo, Aknik My Name.* Illustrations by
 George Ahgupuk. Anchorage: Alaska Northwest
 Publishing.

Haines, Bruce J.

1980a "Kimura/Austin/Zielinski: Ordinary and Excellent."
 Anchorage Daily News, April 4, p. D5.

1980b "Mangus, School District Exhibits Are Both Arrest-
 ing and Rewarding." *Anchorage Daily News,* April
 18, p. D3.

Hall, Edwin S.

1975 *The Eskimo Storyteller: Folktales from Noatak, Alaska.*
 Illustrations by Claire Fejes. Knoxville: University
 of Tennessee Press.

Harder, Mary Beth

1987 "Fejes Shows Strong Feelings, Gilmore Color Im-
 ages." *Fairbanks Daily News-Miner,* July 24, p. 9.

Hargraves, Darroll

1982 "Florence Malewotuk" [*sic*]. *Alaskafest,* May, pp.
 34–41.

Harper, J. Russell

1970 *Early Painters and Engravers in Canada.* Toronto:
 University of Toronto Press.

Harrison, Alfred C., Jr.

1988 *William Keith: The Saint Mary's College Collection,* ed. Ann Harlow. Moraga, Calif.: Hearst Art Gallery.

Harrison, Thomas B.

1991 "A Man of Passion: Retrospective Pays Tribute to William Kimura's First Love." *Anchorage Daily News,* Nov. 10, pp. E1–E2.

Hendricks, Gordon

1988 *Albert Bierstadt, Painter of the American West.* New York: Harrison House.

Henry, John Frazier

1984 *Early Maritime Artists of the Pacific Northwest Coast, 1741–1841.* Seattle: University of Washington Press.

Hilscher, Herbert H.

1948 *Alaska Now.* Boston: Little, Brown and Company.

Hinckley, Ted

1965 "The Inside Passage, a Popular Gilded Age Tour." *Pacific Northwest Quarterly* 56 (April), pp. 67–74.

Hoffman, Fergus

1969 "The Active Life of Eustace Ziegler." *Seattle Post-Intelligencer, Northwest Today,* Jan. 19, pp. 10–13.

Hughes, Edan Milton

1986 *Artists in California, 1786–1940.* San Francisco: Hughes Publishing.

Hulley, Clarence C.

1970 *Alaska, Past and Present.* 3d ed. Portland, Oreg.: Binfords and Mort.

Ingram, Jan

1981 "Kimura's Paintings Are Bold, Aggressive and Rewarding." *Anchorage Daily News,* Oct. 17, p. F2.

1982 "Appel's Geological Diggings Turn Up Lode of Inspiration." *Anchorage Daily News,* Nov. 21, p. D5.

1983 "Drawing on Mood, Illusion." *Anchorage Daily News,* May 22, p. D3.

1986 "Watercolors Go beyond Wonderful." *Anchorage Daily News,* May 25.

1987 "Old and New Artistic Mediums Make for Intriguing Exhibits." *Anchorage Daily News,* March 22, p. C5.

1988 "Machetanz's Romantic Vision Popular." *Anchorage Daily News,* Feb. 7.

1989a "A Favorite Portrait of Alaska." *Anchorage Daily News,* Jan. 15, p. E4.

1989b "Mural at Family Resource Center Provides Plenty upon Which to Reflect." *Anchorage Daily News,* March 12, p. F4.

1989c "New Emotional Content to Paintings." *Anchorage Daily News,* Jan. 1, p. F4.

1990 "Lots of Kick Left in Alex Combs." *Anchorage Daily News,* Oct. 14.

1991 "Remembering Kimura as an Artist of Quiet Competence." *Anchorage Daily News,* Nov. 10, p. E2.

1992 "Exhibition Honors Art of a True Original." *Anchorage Daily News,* March 1, p. H6.

Jones, H. Wendy

1962 *The Man and the Mountain: The Life of Sydney Laurence plus an Anthology of Alaskan Prose and Poetry.* Anchorage: Alaskan Publishing.

1968 "Fred Machetanz, Artist of Alaska." *American Artist,* April, pp. 56–61, 83–84.

Joppien, Rüdiger

1985–88 *The Art of Captain Cook's Voyages.* 3 vols. New Haven, Conn.: Yale University Press.

Keithahn, Edward L.

1944 *Igloo Tales.* Illustrations by George Ahgupuk. Lawrence, Kans.: U.S. Indian Service.

Kennan, George

1910 *Tent Life in Siberia, a New Account of an Old Undertaking: Adventures among the Koraks and Other Tribes in Kamchatka and Northern Asia.* New York: G. P. Putnam's Sons.

Kennedy, Kay J.

1939 "Sourdough Artist." *Alaska Life, The Territorial Magazine,* Nov., pp. 5, 24.

Kennedy, Michael

1973 "Alaska's Artists: Theodore J. Richardson." *Alaska Journal* 3, no. 1 (Winter), pp. 31–40.

Kennedy Galleries

1967 *Kennedy Quarterly,* June.

1973 *Kennedy Quarterly,* vol. 12, no. 4.

1976 *Kennedy Quarterly,* vol. 14, no. 4.

Kent, Rockwell

1919 *Alaska Drawings by Rockwell Kent, with a Letter from Rockwell Kent to Christian Brinton.* New York: M. Knoedler and Co. Unpaginated.

1920 *Wilderness: A Journal of Quiet Adventure in Alaska.* New York: G. P. Putnam's Sons.

1955 *It's Me O Lord: The Autobiography of Rockwell Kent.* New York: Dodd, Mead, and Company.

Larkin, Oliver

1949 *Art and Life in America.* New York: Rinehart.

Laurence, Jeanne

1974 *My Life with Sydney Laurence.* Seattle: Salisbury Press.

Lawton, Joseph

1965 "Fred and Sara Machetanz." *Alaska Review* 2, no. 1 (Fall), pp. 55–66.

Lew, Karen

1980 "Keith Appel, Visual Artist." *Alaskafest,* May, p. 60.

Lynam, Edward

1949 *The Carta Marina of Olaus Magnus, Venice 1539 and Rome 1572.* Jenkintown, Pa.: Tall Tree Library.

Lyon, George F.

1824 *The Private Journal of Captain G. F. Lyon of H.M.S. Hecla, during the recent voyage of discovery under Captain Parry.* London: John Murray.

1825 *A Brief Narrative of an Unsuccessful Attempt to Reach Repulse Bay, through Sir Thomas Rowe's "Welcome."* . . . London: John Murray.

Mangus, Jane

1975 "Travels with an Artist, Marvin Mangus." *Alaska Journal* 5, no. 3 (Summer), pp. 160–67.

Matthews, Mildred

1973 "Florence Lives." *Alaska Magazine,* Oct., pp. 20–21, 59–61.

Mayokok, Robert

1951 *Eskimo Life, Told by an Eskimo Artist.* Nome, Alaska: Nome Nugget.

1959 *True Eskimo Stories.* Sitka, Alaska: Sitka Printing.

1960 *Eskimo Stories.* Nome, Alaska: Nome Nugget.

McCollom, Pat

1973 "Joan Kimura: Contemporary Artist of Anchorage." *Alaska Journal* 3, no. 4 (Autumn), pp. 226–31.

1974a "The Art of Alex Combs." *Alaska Journal* 4, no. 3 (Summer), pp. 156–61.

1974b "Artist Machetanz." *Alaska Journal* 4, no. 1 (Winter), pp. 32–40.

1976 "Ted Lambert, Alaska's Sourdough Artist." *Alaska Journal* 6, no. 3 (Summer), pp. 184–91.

1979 "Alaska's Appel." *Alaska Journal* 9, no. 1 (Winter), pp. 6–11.

McDonald, Lucile Sanders

1984 "Alaska Steam: A Pictorial History of the Alaska Steamship Company." *Alaska Geographic* 11, no. 4.

McKinney, Virginia

1982 "Pat Austin: Printmaker . . . and More." *Alaska Journal* 12, no. 1 (Winter), pp. 57–62.

McPherson, T. Massari

1991 "Pioneer Family Enriches Alaska: Kimura." *Anchorage Times,* May 19, pp. H1, H5.

Merriam, C. Hart, ed.

1901–14 *Harriman Alaska Expedition.* 13 vols. New York: Doubleday, Page, and Co. Washington, D.C.: Smithsonian Institution.

Michaels, Mary Beth

1990a "Artists Paint in the Plain Air of the Arctic Refuge." *All-Alaska Weekly,* Sept. 7, pp. 5–6.

1990b "Local Artist Likes to Push the Limitations." *All-Alaska Weekly,* Aug. 24, p. 5.

Miletich, Matt

1960 "He Digs Gold with a Paintbrush." *Seattle Times,* Jan. 31.

Mollett, Nina

1979 "Claire Fejes." *Alaska Journal* 9, no. 2 (Spring), pp. 6–10.

1982 "Energy and Humor Set Stage for Show at Alaskaland." *Fairbanks Daily News-Miner,* Sept. 16.

Morgan, Lael

1980 "An Artist's War in the Aleutians." *Alaska Journal* 10, no. 3 (Summer), pp. 34–39.

Mozee, Yvonne

1974 "An Interview with Rie Munoz," *Alaska Journal* 4, no. 2 (Spring).

1975 "George Ahgupuk." *Alaska Journal* 5, no. 3 (Summer), pp. 140–43.

1976 "Robert Mayokok." *Alaska Journal* 6, no. 4 (Autumn), pp. 242–49.

1978 "A Conversation with Eskimo Artist Kivetoruk Moses." *Alaska Journal* 8, no. 2 (Spring), pp.102–9.

Muir, John

1888 *Picturesque California and the Region West of the Rocky Mountains from Alaska to Mexico. . . .* 2 vols. New York: J. Dewing.

Muller, Nancy C.

1976 *Paintings and Drawings at the Shelburne Museum.* Shelburne, Vt.: Shelburne Museum.

Muñoz, Rie

1984 *Alaskan Artist: Rie Muñoz.* Anchorage: Alaska Northwest Publishing.

1987 *Rie Muñoz, Artist in Alaska.* Juneau: Rie Muñoz.

Museum of Fine Arts, Boston

1949 *The M. and M. Karolik Collection of American Paintings, 1815–1865.* Boston: Museum of Fine Arts, Boston, in association with Harvard University Press.

Nanook News

1971 "Honorary Degrees Go to Three," May 14, p. 6.

National Collection of Fine Arts

1978 *Contemporary Art from Alaska.* Exh. cat. Washington, D.C.: Smithsonian Institution Press.

Nelson, Margaret

1982 "Artist Machetanz a 'National Treasure,'" *Fairbanks Daily News-Miner,* Jan. 28.

Newell, Gordon R., ed.

1966 *The H. W. McCurdy Marine History of the Pacific Northwest: An Illustrated Review of the Growth and Development of the Maritime Industry. . . .* Seattle: Superior Publishing.

Nordness, Lee

1970 *Objects: USA.* New York: Viking Press.

Noyes, Leslie Barber

1990 "Claire Fejes." *Southwest Art,* Jan., pp. 82–86, 156.

Oehring, Connie

1985 "Artist Fejes Captures Reality with Air of Mystery." *Fairbanks Daily News-Miner,* July 6, p. 8.

Old Dartmouth Historical Society

1974 *R. Swain Gifford.* New Bedford, Mass.: 1974.

Ondash, E'Louise

1985 "In Search of the Arctic Spirit." *North County Magazine* (San Diego), Feb. 7, pp. 19, 30.

Operti, Albert

n.d. *Arctic Historical Paintings* (author's presentation
 copy to F. A. Lucas, inscription dated 1915). 16
 leaves of plates. Unpaginated.

1902 *The White World: Life and Adventures within the
 Arctic Circle Portrayed by Famous Living Explorers,*
 ed. Rudolf Kersting. New York: Lewis, Scribner
 and Co.

Oswalt, Wendell H.

1979 *Eskimos and Explorers.* Novato, Calif.: Chandler and
 Sharp.

Padzuikas, Paul A.

1989 *Marvin Mangus.* Exh. cat. Anchorage: Anchorage
 Museum of History and Art. Unpaginated.

Parish, Robert

1982 "Fejes Exhibit Is Simple and Refreshing." *Juneau
 Empire,* July 9, p. 14.

Paxton, Eugene

1986 "Ziegler on Glass." *Alaska Journal* 16, pp. 70–73.

Peary, Robert

1898 *Northward over the Great Ice: A Narrative of Life and
 Work along the Shores . . . of Northern Greenland. . . .*
 London: Methuen.

1904 *Snowland Folk: The Eskimos, the Bears, the Dogs, the
 Musk Oxen, and Other Dwellers in the Frozen North.*
 New York: F.A. Stokes.

1907 *Nearest the Pole: A Narrative of the Polar Expedition
 of the Peary Arctic Club. . . .* New York: Doubleday,
 Page, and Co.

Petteys, Chris

1985 *Dictionary of Women Artists: An International Dictio-
 nary of Women Artists Born before 1900.* Boston: G.
 K. Hall and Co.

Phebus, George E.

1972 *Alaskan Eskimo Life in the 1890's as Sketched by
 Native Artists.* Washington, D.C.: Smithsonian
 Institution Press.

Poor, Henry Varnum

1945a *An Artist Sees Alaska.* New York: Viking Press.

1945b *The Cruise of the Ada.* Alaska: Henry Varnum Poor.

Queener-Shaw, Janice

1987 "The Alaska Four." *Western Art Digest,* Jan./Feb., pp.
 34–41.

Ray, Dorothy Jean

1961 *Artists of the Tundra and the Sea.* Seattle: University
 of Washington Press.

1967 "Alaskan Eskimo Arts and Crafts." *The Beaver,*
 Autumn, pp. 80–91.

1969 *Graphic Arts of the Alaskan Eskimo.* Native American
 Arts 2. Washington, D.C.: Indian Arts and Crafts
 Board.

1971 "Kakarook, Eskimo Artist." *Alaska Journal* 1, no. 1
 (Winter), pp. 8–15.

1977 *Eskimo Art, Tradition and Innovation in North
 Alaska.* Seattle: Henry Art Gallery in association
 with University of Washington Press.

Reed, Don

1945 "The Crumrines, Painters of Alaska." *Alaska Life,*
 Dec., pp. 53–56.

Render, Lorne E.

1974 *The Mountains and the Sky.* Calgary: Glenbow-
 Alberta Institute and McClelland and Stewart West.

Rich, Kim

1987 "Always Wood: Juneau Artist Prefers Old-fashioned
 Medium for Her Images of Alaska Native Life."
 Anchorage Daily News, Dec. 6, 1987, pp. F1–F2.

Richardson, John, Sir

1854 *The Zoology of the Voyage of H.M.S. Herald, under
 the Command of Captain Henry Kellett . . . during the
 Years 1845–51.* London: L. Reeve.

Riley, Nan

1911 "An Eastern Artist's Work." *Alaska-Yukon Magazine*
 12, no. 2 (Sept.), pp. 113–14, frontispiece.

Roppel, Pat

1975 "Loring." *Alaska Journal* 5, no. 3 (Summer), pp. 168–78, 192.

1977 "Jules Dahlager." *Alaska Journal* 7, no. 3 (Summer), pp. 188–91.

Samuels, Peggy, and Harold Samuels

1985 *Samuels' Encyclopedia of Artists of the American West.* Secaucus, N.J.: Book Sales, Inc., Castle.

Scidmore, Eliza Ruhamah

1885 *Alaska, Its Southern Coast and the Sitkan Archipelago.* Boston: D. Lothrop and Company.

1894 "Goat-Hunting at Glacier Bay, Alaska." *California Illustrated Magazine,* April 5, pp. 537–44.

Seemann, Berthold Carl

1852–57 *The botany of the voyage of H.M.S. Herald under the Command of Captain Henry Kellett . . . during the Years 1845–51.* London: L. Reeve.

1853 *Narrative of a Voyage of H.M.S. Herald during the Years 1845–51 . . .* London: Reeve and Co.

Shalkop, Robert L.

1975 *Sydney Laurence (1865–1940): An Alaskan Impressionist.* Exh. cat. Anchorage: Anchorage Historical and Fine Arts Museum.

1977 *Eustace Ziegler: A Retrospective Exhibition.* Exh. cat. Anchorage: Anchorage Historical and Fine Arts Museum.

1982a *Henry Wood Elliott, 1846–1930: A Retrospective Exhibition.* Exh. cat. Anchorage: Anchorage Historical and Fine Arts Museum.

1982b *Sydney Laurence: His Life and Work. The Collection of the Anchorage Historical and Fine Arts Museum.* Exh. cat. Anchorage: Anchorage Historical and Fine Arts Museum.

Shepard, Lewis A.

1975 *American Painters of the Arctic.* Exh. cat. Amherst, Mass.: Mead Art Gallery. Unpaginated.

Sherman, Ro

1974 "'The Village of Klokwan' by E. J. Glave of the Frank Leslie's Illustrated Newspaper Expedition to Alaska." *Alaska Journal* 4, no. 2 (Spring), pp. 82–87.

Shuler, Judy

1977 "Josephine Crumrine Liddell." *Alaska Journal* 7, no. 3 (Summer), pp. 132–37.

Siegfried, Joan C.

1970 *Some Quietist Painters: A Trend toward Minimalism in Late Nineteenth Century Painting.* Exh. cat. Saratoga Springs, N.Y.: Skidmore College.

Silook, Roger S.

1970 *In the Beginning.* Illustrations by Robert Mayokok. Anchorage: Alaska Printing.

Simpson, Glen

1991 *Ron Senungetuk.* Exh. cat. Anchorage: Anchorage Museum of History and Art.

Sopalski, Julia

1991 "William Kimura Never Needed a Studio." *Anchorage Times,* May 19, pp. H1, H5.

Stenzel, Franz R.

1963 *An Art Perspective of the Historic Pacific Northwest.* Helena: Montana Historical Society.

1972 *Cleveland Rockwell, Scientist and Artist, 1837–1907.* Portland: Oregon Historical Society.

Stock, Pamela

1991 "William Y. Kimura Was Leader in Anchorage Art World." *Anchorage Times,* May 2, p. B2.

Stokes, Frank Wilbert

1925 *Arctic and Antarctic Paintings.* New York: Frank W. Stokes.

The Studio

1895 "A Painter in the Arctic Regions: An Interview with Mr. Frank Wilbert Stokes," 5, pp. 208–14.

Sturtevant, William C.

1976 "First Visual Images of Native America." In *First Images of America,* ed. Fredi Chiappelli. Vol. 1, pp. 417–54. Berkeley: University of California Press.

1980 "The First Inuit Depiction by Europeans." *Études Inuit Studies* 4, nos. 1–2, pp. 47–49.

Sturtevant, William C., and David Beers Quinn

1987 "The New Prey: Eskimos in Europe in 1567, 1576, and 1577." In *Indians and Europe, An Interdisciplinary Collection of Essays,* ed. Christian F. Feest, pp. 61–140. Aachen: Edition Herodot, Rader-Verlag.

Sunde, Elaine

1983 "Linda Larsen: Art and Environment an Intimate Affair." *Alaska Journal* 13, no. 1 (Winter), pp. 121–26.

Surrey Art Gallery

1983 *E. J. Hughes—1931–1982.* Exh. cat. Vancouver.

Time

1937 "Art," 29, no. 4 (Jan. 25), p. 29.

Traxel, David

1980 *An American Saga: The Life and Times of Rockwell Kent.* New York: Harper and Row.

Tundra Times

1972 "Artist to Depict Development of Eskimo from Stone Age," Nov. 22, p. 7.

Untracht, Oppi

1982 *Jewelry Concepts and Technology.* Garden City, N.Y.: Doubleday and Co.

Vaughan, Norman

1990 "With Byrd at the Bottom of the World." *Anchorage Daily News, We Alaskans.* Oct. 14, pp. C6–C11.

Whymper, Frederick

1868 *Travel and Adventure in the Territory of Alaska: Formerly Russia America—Now Ceded to the United States. . . .* London: John Murray.

Wilson, Katherine

1923 *Copper-Tints, a Book of Cordova Sketches.* Cordova, Alaska: Cordova Daily Times Press.

Wold, Jo Anne

1965 "Ted Lambert Manuscript Found: Artist Missing for Five Years." *Fairbanks Daily News-Miner,* Nov. 6.

1973 "Art Collectors Loan Paintings for Tea." *Fairbanks Daily News-Miner,* May 3.

Wood, William R.

1982 "Fred Machetanz Captures the Spirit of Alaska." *Fairbanks Daily News-Miner,* Jan. 27, p. 6.

Woods, Anne

1957 "Artist of Shishmaref." *The Alaska Sportsman,* Oct., pp. 16–17, 41–43.

Woodward, Kesler E.

1989 "Northern Art and Ethnographic Material in the Collections of Dartmouth College." *Northern Notes* (Hanover, N.H.) 1, no. 1, pp. 41–57.

1990a *Sydney Laurence: Painter of the North.* Anchorage: Anchorage Museum of History and Art in association with University of Washington Press.

1990b "Sydney Laurence." *Southwest Art,* Dec., pp. 72–79.

Yost, Harry

1970 "Machetanz—Alaska's Great Artist." *This Alaska,* Feb., pp. 13–16, 31.

 INDEX

DONORS TO THE COLLECTION

Major donors to the art collection of the Anchorage Museum of History and Art are

Anchorage Museum Association
National Bank of Alaska
Mr. and Mrs. Elmer E. Rasmuson
The Rasmuson Foundation
Municipality of Anchorage Acquisition Fund

Other important donors to the art collection are

Mr. and Mrs. Robert O. Kinsey
Anonymous
Robert Hardy
Cook Inlet Region, Inc.
Michael and Becky Dahlager
Anchorage Museum Trust Fund
Dr. and Mrs. Lloyd Hines
Edith Bullock

The museum would particularly like to acknowledge H. Willard Nagley II for his generous support of conservation services for the art collection, and for his donation to the Museum Foundation, which is dedicated to maintenance of the collection.